HALFWAY TO VENUS

A One-Armed Journey

D1421536

Anderson's Travel Companion

The Virago Book of Spirituality

Sarah Anderson's Travel Companion:
 Africa and the Middle East

Inside Notting Hill (*with Miranda Davies*)

HALFWAY
TO
VENUS

A One-Armed Journey

SARAH ANDERSON

UMBRELLA BOOKS, LONDON
2008

First published in 2008 by
Umbrella Books, 13 Blenheim Crescent.
London W11 2EE

ISBN 978 0 9542624 2 6

Cover design Nick Randall
Typeset by Antony Gray
Printed and bound in Great Britain by
Butler and Tanner, Frome

To my family, both living and dead,
who never treated me differently

Contents

HALFWAY TO VENUS

A One-Armed Journey

'Do you mind being my baby?'

I was on my own, flying to Pisa to stay with some friends in Tuscany, and lunch had arrived on the tray in front of me. My heart sank. There is no question that the world we live in is designed for two-handed people, so if you only have one hand everything is different and often more difficult. Airline meals, with everything packaged, are one of my worst nightmares.

This one was particularly difficult to get into, but I was hungry and determined to eat the great lump of meat that sat in the middle of the dish. But how was I going to tackle it? I have always hated asking people for help but I knew that if I were to eat with any kind of decorum, I would have to. So I asked the Alitalia stewardess if she would cut it up for me. She took the plastic knife and fork, knelt at my feet and, looking up at me, made her inappropriate remark.

'No, no, of course not,' I answered politely, but inside I was seething. How dare this strange young woman refer to me, a middle-aged passenger, as her baby? I'd simply asked her to cut up my meat for me; yet somehow I felt, as I always felt in such situations, that *I* had to take responsibility for *her* feelings and, by making light of her comment, ensure that *she* did not feel embarrassed. So I started making excuses for her: she was young, English wasn't her native tongue, she had probably been trying to put me at my ease – but dammit! why should *I* always be the one thinking of other people?

These were familiar thoughts, but instead of letting the remark rankle I decided this was it – the time had come to write a book about what it was like living with only one arm.

Deep down I had always known that some day I wanted to write about my experiences, but the time had never seemed quite right. Several people had made veiled suggestions that I should attempt a book, but I had always brushed their remarks aside, feeling that when the right moment came, I would know. Some of my hesitation had been because I rarely think about having only one arm; it has never prevented me doing anything that I wanted to do, and in terms of disability I think of it as relatively minor.

But the question 'Do you mind being my baby?' made me see that it is the way *other* people react that is interesting. Any limb is a part of the body, and losing one is a reminder of the death and dissolution of the body – which is perhaps why many people find my having only one so threatening.

Most of us have hands and arms and yet we probably take them for granted, not realising what an extraordinary part they have to play in all our histories and cultures. That's why I want to make this more than just a personal testimony. I want to try and make people understand how important arms are, and to give them a sense of what losing one and living without it actually feels like.

I also thought it interesting to look at how arms and hands – or the lack of them – have appeared through time, how people in history and fiction have coped with having only one arm, and how often poets write about hands, arms and touch. This led naturally on to how arms and hands are viewed in other cultures: the important distinctions between right and left hand in Arab countries, what different gestures mean, how different nationalities give various amounts of weight to their hand and arm gestures – the importance of hands in communication.

So, prompted by my own missing limb, I have gone on a journey of exploration and discovery, through literature and art and real life, about arms and their significance. And

through all my reading and travelling, perhaps I have come to a better understanding of why I feel the way I do.

By the time I arrived at my destination in Tuscany, I had filled several pages of my notebook with ideas. Little did that airline stewardess know that she was the trigger for years of fascinating research and often painful writing.

In answer to those who rate privacy above openness, I would say that I believe that the arguments for privacy can be countered by stronger ones for straightforwardness, and that the more you give, the more you get.

So I have followed Robert Lowell's advice: 'Why not say what happened?'

This is what happened.

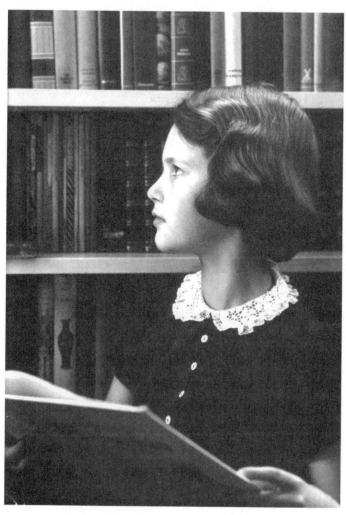

Photograph by Antony Armstrong-Jones, 1957

Childhood

I was born in St Mary's Hospital, Paddington, the eldest of four children, and grew up in Trevor Place in Knightsbridge. Our nanny was rather antisocial so we kept very much to ourselves, only occasionally meeting other children in Hyde Park for a picnic tea of jam sandwiches and tepid milk. Maybe it was because we didn't meet many other children that Elisabeth, my next sister down, and I created a world of imaginary friends, all of whom we both knew intimately. But this was very much our own world, and something we didn't share with anyone else.

We had all our meals with Nanny in the nursery except for Sunday lunch when, if my parents were in London, we would go down to the dining-room.

Apart from the odd Sunday, Nanny had every Thursday afternoon free. Elisabeth and I hated this, and I remember screaming with unhappiness when we were left alone with Mummy for that half-day. I never had any reason to think that Nanny wouldn't come back but the mere thought that she was leaving us for any amount of time seemed unbearable. Even though we saw Mummy every day when she was in London, and she certainly didn't mistreat us, it was Nanny who gave us the feeling of security and continuity.

For our summer holidays Nanny would take us to a boarding-house by the sea, at Aldwych, Bognor or Littlestone. Every day, whatever the weather, we went to the beach and dug sandcastles and paddled or swam. After swimming we would be wrapped in towels before donning Fair Isle jerseys

and being given rich tea or ginger biscuits in the shelter of a breakwater. Our parents would come down for one of the weekends we were there. I have no idea where they stayed – certainly not in the boarding-house.

At Christmas, the year I was four, I wouldn't go to sleep at night, but cried and cried. Mummy got so infuriated with me that she told Nanny to spank me – talk about passing the buck! – so she did, but still I persisted in crying. It turned out that the reason for my unhappiness was that I had just found out that my grandfather had died. He had been a comforting presence and my memory is of him sitting on the lawn in a deckchair wearing a hat and smoking a pipe in the shade of a huge cedar tree. I suspect that when his death had been explained to me I was very upset that I was not going to see him again. When Nanny, in her nineties, told me this story, of which I have no memory at all, she said that I was the only child she had ever spanked. And when I asked if she had hit me hard she said, 'Oh yes; there would have been no point in doing it otherwise.' I was surprised to hear that I had been the only child Nanny had struck during her whole working life, since most children were probably spanked from time to time. Although of course mourning for my grandfather was a terrible reason for a spanking, the shock of it probably stopped my crying and of course I didn't suffer any long-term repercussions. However, the fact that Nanny had never forgotten probably meant that she had felt guilty about it all her life.

When I was five I started having lessons at home. Nanny taught all of us to read and write and to do arithmetic; we had word and arithmetic charts all round the nursery and when a school inspector came round to insist that we should be at school he was so impressed by our level of learning that he left hastily. We had our lessons at a low wooden table, the table where I would later do my homework when I went to school.

It seems, now, an old-fashioned childhood, yet it was

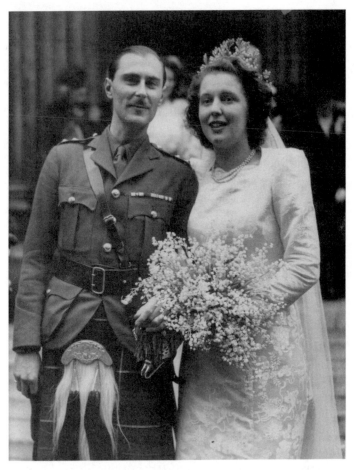

My parents' wedding at St James's Spanish Place, January 28th 1946

absolutely typical of the way upper-middle-class children were brought up in the immediate post-war years. We may have led a comfortable and uneventful life, but as children we were cocooned and safe.

One of the most exciting and memorable things that happened was the Queen's Coronation in 1953. Mummy and Daddy went to Westminster Abbey, Nanny stayed at home with James – who was then a baby – and watched a specially-hired television, but Elisabeth and I went to spend the night with my father's parents in their London house in Curzon Street. We each took a little attaché case, usually used for toys, for our night things and toothbrushes. It was the first time that we had been away on our own so it was both nerve-racking and exciting. The following day we watched events with our grandparents from a room full of people in St James's Street where, as the only small children, we were pushed to the front and had a marvellous view. The procession of soldiers and bands seemed to go on all day and, even at the age of six, I was impressed.

I started at the Convent of the Holy Child Jesus in Cavendish Square when I was seven. For the first few years, before the advent of a school bus, Nanny would take me there on the 73 bus, which went from the top of our road to Oxford Street. I was thrilled when, on the second day, we had the same bus conductor who remembered where we were going. Over the entrance to the convent was a statue of the Virgin Mary by Epstein which, although I'm sure I paid it little attention at the time, remains a vivid image.

Quite soon after starting school I made my First Communion, dressed in a long white dress and veil made specially for the occasion. There was a breakfast at the school afterwards for parents and siblings, and I was given a prayer-book as a present. Fasting from midnight before taking Communion was compulsory then, though I think a sip of

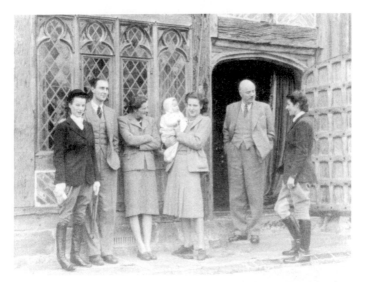

At Old Surrey Hall, my paternal grandparents' house. From l. to r. Sheila Henderson (Anderson), my father, grandmother, my mother holding me, my grandfather and aunt Fiona Wylie (Anderson)

water was permitted if necessary, but I took this rule so seriously that on one occasion I really thought I would go to hell as I had unthinkingly licked a stamp and hadn't been able to go to confession. As far as I was concerned, rules were rules and there was a black or white distinction between right and wrong. This made life quite frightening at times, but being obedient and good, something the catechism taught me I had to be, imbued it with a certain security.

At home, we were discouraged from talking about our feelings and were never allowed to criticise anyone, including a sibling, for fear of upsetting them. We were more or less told what we could or couldn't think, and I remember being left in no doubt that I wasn't allowed to feel in certain ways. This

On the beach

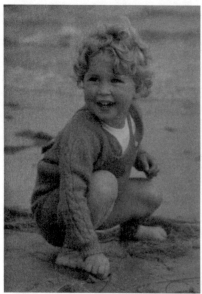

On my tricycle

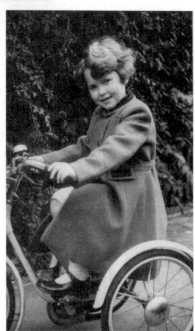

Elisabeth and Sarah as bridesmaids in 1953

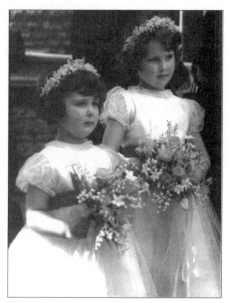

James

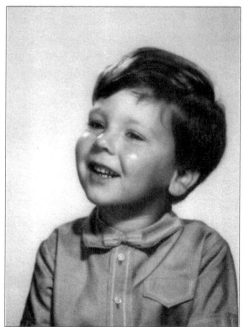

made me believe that it was wrong to disagree with anyone, and that I was wrong to want to, since they were presumably in the right and so any feelings I had would be somehow invalid.

After two years Elisabeth joined me at the school; we did everything in tandem, with me of course always slightly ahead of her. This had advantages for her as I was the guinea pig who had to try new things first, but it must also have been frustrating when I got what must have seemed like treats first too. We always had a bath together and, as the elder sister, I invariably made her sit at the tap end, occasionally demanding that she suck my big toe. At school, for the first time we made friends independently. We still had our secret and shared imaginary world, but this was now supplemented by other friends; on occasion we were allowed to go and have tea at their houses after school.

In April 1957 my second sister Camilla was born, and I instantly adored her. I was nearly ten and felt very maternal towards her; my beloved doll Virginia had suddenly been replaced by the real thing and I loved holding and feeding my baby sister, and helping to bath her. Life, not that I thought about it in these terms, seemed pretty much perfect.

Cancer Strikes

Suddenly everything changed. Just before my tenth birthday, in May 1957, a lump developed just below my left elbow. I was doing my homework one evening, at the low wooden table where I had had my first lessons, when I looked up and said, 'Nanny, my arm really hurts.'

Nanny immediately alerted my mother and within an hour we were waiting to see our GP, Dr Ledingham. I felt that a fuss was being made about nothing, so an unexpected visit to the dim and mysterious surgery at 47 Ladbroke Square seemed more like a treat than anything to worry about. Nothing much was said in front of me, but later that evening Dr Ledingham visited my parents at home and told them the sort of news that every parent must dread, that he thought their eldest daughter had cancer.

I now often walk past that room in Ladbroke Square where my cancer was first suspected. I always peer in, and absurdly am never quite sure what I will see. But now it is a bright and cheery kitchen, belonging to a friend of mine, and is no longer a doctor's dark surgery. I always feel a pang of disappointment, as if this room should somehow have been kept in aspic for me and my memories.

I remember Dr Ledingham as an exceptional doctor, but even so, the speed and accuracy of his diagnosis were extraordinary. He must have felt pretty certain that he was right – he would not have wanted to alarm my parents unduly – but since at that stage no tests had been taken, he must have acted on an inspired hunch.

The first time that I remember feeling any serious pain was a few days later at Mass at St Mary's, Cadogan Street. I whispered, 'Mummy, my arm really, really, *really* hurts.'

'Darling, take off your scarf and I'll make it into a sling for you,' my mother whispered back.

At that time in Catholic churches it was obligatory for females to wear something on their heads. I clearly remember the scarf I was wearing: it had a navy border, with boats and wavy blue lines for the sea. When it was adapted to its new purpose, I was mortified and acutely embarrassed, convinced that the whole congregation was staring at me; not only was I now wearing a sling, but I also had nothing on my head, something I thought to be very wrong.

Already, it seemed, other people were the problem. If I could just be allowed to be with my family and not have to associate with the outside world, no troubles could arise, and there would be no hospitals, no doctors and no stares. But the scarf was only a minor incident, the merest hint of the horrors that were to follow. It's lucky that we do not know the details of what is going to happen to us in advance; it would often be difficult to summon up the courage to face the future if we did. I'm not sure that I could have gone on if I had known what that first pain really meant.

Within days I went into a private ward at Great Ormond Street Hospital for Sick Children for an operation to have the first of many lumps removed.

Sir Denis Browne (1892–1967) was the resident medical superintendent at Great Ormond Street; in 1957 he was elected emeritus surgeon and in 1961 was made Chevalier of the Légion d'Honneur. At a time when most consultants thought of themselves as, and were treated like, God, Sir Denis was refreshingly different. On the non-private wards consultants with different expertise could examine any patient, but on a private ward consultants 'owned' their patients, which

could put private patients at a medical disadvantage since they could only be examined by 'their' specialist. It was therefore extremely important to be 'under' the right consultant. Sir Denis was a radical thinker who, unusually, looked on the child as a whole person, and the development of paediatric surgery in this country owes more to him than to anyone else. His apparently aloof personality hid his innate kindness. A paper written about him in 2000 by E. Durham Smith for the *ANZ Journal of Surgery* was called 'Denis Browne: Maverick or Master Surgeon?' and refers to him as someone who had 'a prickly personality and a particular venom reserved for orthopaedic surgeons and anatomists . . . but his achievements may have been possible only by one possessed of such a strong and towering character'. He was also extremely inventive; a sister on the ward at the time described him to me as a Heath Robinson figure, always dreaming up strange contraptions to help the children he had operated on to recover. Among his inventions was a glass device he invented for suctioning wounds, which was popular in New Zealand. He is a shadowy figure to me now, but I probably owe him my life.

However, at that stage, in May 1957, I was in hospital only to have the first lump removed. The private wing was on the top floor at Great Ormond Street; I had never been in a hospital before, so I had no idea what to expect. Most of the nurses wore a pink-and-white striped uniform except for the ward sister who wore blue. The same nurses were there day after day so it was possible to get to know them all. This was reassuring but it was also something I took for granted; it was a shock in later years to discover that nursing had become a far more itinerant profession and that during a stay in hospital it was rare to see the same nurse twice. My American cousin Gillian, who was seven years older than me, and living in London at the time, came and drew pictures with me in hospital. She was aware I had cancer, and understanding what

that meant made her feel upset and uncomfortable; she reckoned I knew and observed the discomfort of other people. I don't believe I did know. Or that it would have meant anything to me even if I had.

On some of my visits I was to be in a room on my own, but that first time I was in a small ward with three other children. I do not remember what was the matter with them and I am sure that we did not compare our illnesses; in certain circumstances, children can be very accepting of each other. At ten one begins to feel grown-up, so I felt humiliated at having a rubber sheet on my bed; I had long ceased to wet my bed at night, but I was told that it was in case I was sick after the operation. Although I hated using bedpans, I remember that they were specially warmed so there was not the added discomfort of having to sit on cold metal.

I loved the feeling that the pre-med injection gave me before the operation. I was still awake enough to remember being wheeled towards the operating theatre on a trolley; in fact, I have a hazy recollection of actually being awake inside the theatre and of being very impressed by the gleaming machinery and nurses and doctors dressed in green. I woke up from the operation with my left arm swathed in crepe bandages and I was violently sick and desperately thirsty. Every sip of water made me vomit more green bile into a silver kidney-shaped bowl. I do not know how long this nausea went on for, but, when I began to feel better, one of the first things I did was to ask the nurse for the piece of my tenth-birthday cake I had brought into hospital with me and had carefully put into the drawer beside my bed.

'Oh, I ate it when you were having your operation. I didn't think it was special – it was only a piece of cake,' said the nurse, seemingly without any remorse.

'But it was my *birthday* cake,' I whispered.

I can still feel the sense of betrayal and outrage; but rather

than tell her my feelings, I waited until she had gone and then cried silently at the unfairness of it. Being told that it was 'only a piece of cake' enraged me – it had taken on a symbolism way beyond its components, and no one seemed to understand this, and I was told to 'stop being so sensitive'. This was something I was often told during my teenage years; it had the effect of making me clam up and I became first-rate at hiding my feelings.

Apart from that incident, I loved being in hospital; I had no idea how ill I was, and I was spoiled and made to feel very special. I was inundated with presents, among them my first radio – dark-green bakelite with a gold dial – which I listened to under the bedclothes at night, trying to find as many stations as possible, but always ending up with Radio Luxembourg. I was told that I could have any food or drink I wanted, and although I probably said, 'I don't mind,' which was my stock answer to any question at the time, at someone's suggestion I asked for freshly squeezed orange juice, which seemed an enormous luxury. But I do remember wondering why so much attention was being given to me. After all, I only had a lump, and what was so special about lumps? I should probably have been more wary of the fuss, but even if I had been suspicious, doubtless I would hastily have dismissed any worrying thoughts and gone on pretending that this was a normal amount of attention for a girl with a lump.

After that first operation I was diagnosed as having a malignant synovioma or synovial sarcoma, a particularly virulent form of cancer. Although I am hazy about the actual sequence of events during the rest of 1957, I remember having several operations over the summer months for the removal of other lumps which kept appearing on my arm.

Whenever I came home from a stay in hospital, I was desperately unhappy and would lie on my bed in tears. I had a

big ache inside me which I did not understand and which I only seemed to be able to deal with by crying into my pillow. This would eventually numb the pain. A huge part of my time was spent longing to go back; I felt that I was understood there, in spite of the birthday-cake incident. I was in love with some of the nurses at Great Ormond Street, and wanted to please them by behaving in a grown-up manner, so the lack of emotion that they showed me was difficult to cope with. In the 1950s it wasn't thought right for nurses to give children any physical affection, but I desperately wanted to be liked by them. This was dangerous stuff because I never knew when they would be on duty again or whether they would be transferred to another ward, in which case my emotions would be left hanging in mid-air with nothing to attach themselves to, and I would be left with a battered sense of trust in people. Having so much attention in hospital made me feel more of an individual and 'special', while at home I was just part of the family. I can't remember exactly how my family reacted to my sobs. I told them I wanted to be left alone – but did I really? I thought no one could possibly understand how I felt and I hated them pretending that they did when I *knew* that they didn't. However, although I'm sure there must have been part of me that longed for someone who did understand, I didn't even consider that a possibility. I think in some way I felt unique and special in not being understood, and although this was agonisingly painful, I sensed it had to be like that. I never remember crying when I was in hospital (apart from when my birthday cake was taken). I wish I could remember exactly how the nurses treated me and why it was that I felt instantly at ease in their company and so alien and misunderstood at home. Although they showed no emotion – I felt totally understood by them.

One of the very few bonuses about going home after being in hospital was seeing my baby sister, who was only a month

old when my first lump was noticed. I adored her and loved being allowed to hold her. I had to sit down to cradle her, but if any of the grown-ups felt concerned that I might drop her, they hid their anxiety well. But apart from the pleasure of holding the baby, leaving hospital never felt like a cause for celebration. Why were they getting rid of me? I felt I was being very good, but perhaps I hadn't behaved well enough for them to want me to stay longer? It felt like a rejection and betrayal of trust and the thought of some other child going into *my* bed was almost unbearable.

Harold Russell, an American who lost both of his hands in army training in 1944, was seen by Samuel Goldwyn in an army film and was asked to star as the army veteran Homer Parrish in the film *The Best Years of Our Lives* (1946), directed by William Wyler. Russell won two Academy Awards for the film; he understood well about staying in hospitals and wrote in *Victory in My Hands* (1949): 'A hospital ward is a world by itself, shut off from all the currents and movements outside. Being in one as a patient is like being in a monastery. You have renounced the great world. Pain and suffering set you apart from the rest of mankind. There is something almost purifying, spiritually ennobling, about being sick.'

Maybe it was then that the seeds of my emotional independence were sown; I was discovering, albeit unconsciously, that it was safer to face the world on my own. The doctors and nurses I came to depend on in hospital, and who for stretches of time were so much part of my life, would suddenly not be there when I went home. Although when I was in hospital I was much visited by my parents (but I don't think by my siblings – my memory is that children weren't allowed to visit), there was certainly no provision for them to stay overnight, so it seems that, unconsciously, I transferred my emotions and feelings of belonging on to the hospital, only to feel bewildered when I was at home again for a short time,

before yet again being back in hospital. And since I did not understand why any of this was happening, I felt confused.

I had a course of chemotherapy injections at Great Ormond Street, where I had to stay as an in-patient as the possible side-effects were unknown. It became increasingly difficult to find a vein in which to insert the needle and I still have brown marks from the many injections on the inside of my right arm. My hair did not fall out, but I did feel dreadfully sick. Through good fortune, a contact in BOAC arranged to have the medication Actinomycin-D flown over specially and regularly from Boston's Children's Hospital, where it was in the experimental stages. I believe I was one of the first people in Britain to have that kind of chemotherapy. Actinomycin was the first antibiotic reported to be able to halt cancer; however, it is not widely used because it is highly toxic. Many years later, by chance, I met the BOAC pilot who had been in charge of these consignments. He had known at the time that he was bringing some special drug across the Atlantic for a little girl who was seriously ill, and was delighted to meet a healthy grown woman.

When I was not in Great Ormond Street, I was taken daily, by a rota of friends and relations, to Westminster Children's Hospital near Victoria Station for radiotherapy. Down in the bowels of the hospital I would lie alone in a green, darkened room on a cold metal table and be watched through a window as I had the treatment. But I do not remember being frightened.

It is difficult to disassociate what the hospital looked like and what actually happened to me from the television pro-grammes about hospitals that I watched avidly. *Emergency Ward 10* and *Dr Kildare* with Richard Chamberlain were two of my favourites. I was transfixed by them. But I could not have got the smell from the television programmes: the smell of a hospital remains highly evocative and charged with

memories, and can take me straight back to how I felt as a little girl. This is not an unpleasant feeling, more like rediscovering a place where I belong. Hospitals still evoke an overwhelming nostalgia of both longing and belonging. Even though the period during which I was so often in hospital in fact only lasted seven months, it was such an intense seven months, filled with so many new people and new experiences, that the shortness of the time is immaterial and the impact those months had on my life is immense.

Very soon after the initial diagnosis, my parents were told that the cancer had spread to my lungs and that I had only a few months to live. Sir Archibald McIndoe, the great plastic surgeon and a family friend, suggested we go and see a specialist whom he knew, who offhandedly said to my mother, 'There is really no point in treating your daughter; she's not going to live for more than a few weeks. So doing anything for her would be a waste of everybody's time and money.'

Naturally my mother took a violent dislike to this man, but her anger probably made her even more determined to fight for me. Too many doctors, whose profession is meant to be that of healing, treat their patients as commodities and seem completely impervious to their feelings. Without understanding what a doctor might be saying medically, a child has a good instinct for their quality of compassion or its absence. Plato understood this and said that at least a third of what a good doctor has to do is provide 'charm'. Since it is the mental attitude to a disease that is so important in whether or not the patient is cured, it is worth reflecting on a child's perspective. I never remember any doctor talking *to* me, it was always *about* me. In an HMSO survey completed in 1976 called *Doctors Talking to Patients*,[1] the following quote summed up a typical attitude: 'I will tell you what is wrong with you. I will tell you what your symptoms are, and I will tell you what to do. I am the doctor and you will kindly not forget that fact.'

In July 1957, two months after the initial diagnosis and with a death-sentence hanging over me, my parents took me and Elisabeth to Lourdes. Lourdes is a small town in the Pyrenees in south-west France where the Virgin Mary appeared to the poor peasant girl Bernadette Soubirous eighteen times in 1858. It was the first time that either of us had been abroad, so we were very excited. We were not told the true purpose of the trip, which was to pray for a cure. My parents knew France well, and I remember the thrill of driving through the Pyrenees at night huddled in the back of our hired car, and my sister's and my own terror of the great dark shadows cast by the mountains, a fear compounded by the frightening ghost stories we were being told from the front of the car. It was unbearable. It was delicious. It was my first taste of abroad.

Then came the boring part: I had to be examined by a doctor in Lourdes. I suppose this was in case I was cured, but I don't remember thinking it odd. I had been examined by so many doctors in the previous few months that it just felt routine. Since I had a heavy white plaster cast on my arm, the vital part of me, and the reason I had come to Lourdes, could not be investigated. I remember being probed in what seemed to me, even then, a very old-fashioned laboratory with lots of black metal contraptions. Then, like thousands of other pilgrims, we prayed at the grotto where the Virgin Mary appeared to the young Bernadette. We followed that by going into the baths. The old lady whose job it was to submerge people was furious when my mother insisted that my arm in its plaster cast should not get wet. My mother won.

I considered the medical examinations and immersion in the baths embarrassing, something to be endured, unaware that this was the whole point of our being there. I did not know that we were in Lourdes because I was ill; even though I could see that the whole town was full of seriously ill people, somehow I did not connect this with myself. It was being

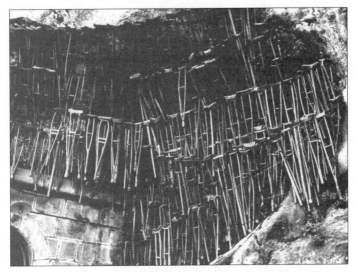

Crutches left behind by pilgrims at the grotto in Lourdes, 1937

abroad for the first time that was exciting, and this gave the trip as much point as I needed. I loved the candlelit processions, and the endless singing of 'Ave, Ave, Ave Maria' engraved itself on my memory. I was still able to listen to it on my return to London, courtesy of an illuminated Virgin Mary music box I was given.

On our return from Lourdes, the British doctors told my parents that they 'must have made a mistake' as there was no longer any trace of cancer on my lungs. Yet my arm in the plaster cast, the only bit of me not to have been submerged, was the only part of me which wasn't healed. That's something I've often wondered about.

Although there was no cancer on my lungs after Lourdes, I think that for the next few months lumps were still recurring in different parts of my arm. Unfortunately, neither I nor anyone else can remember whether or not all the lumps had been pre-Lourdes. And it makes a huge difference. If there

were no new lumps, why did they have to resort to such drastic measures? Could the medical profession not accept that I was now a healthy child? Nevertheless that summer and autumn passed in a haze of visits to doctors and continuing treatments at both Great Ormond Street and Westminster Hospitals. Ever since I'd reached ten and double-figures, my life had changed dramatically – hospitals, doctors, abroad, photographers, had all experienced for the first time, and had been crammed into a few months. I think I took it all in my stride – that is, until a memorable day in December, when I was told that I had to have my arm amputated.

Lunch had seemed very special that day in December 1957. The Christmas holidays were approaching and my mother had said that she wanted to talk to me on my own after lunch. For some reason that I have never been able to fathom, I had no feelings of apprehension as I followed her into the drawing-room; I think I thought that it was probably to do with some kind of secret about Christmas. But as she closed the door, turned towards me and, without saying anything, made a chopping motion with her right hand above her left elbow, I thought my world had come to an end. I remember screaming hysterically, 'No, no, I can't! I can't! Anything but that! I'd rather have a million operations. Please not, you don't understand. Please, please not!'

'Darling, your arm won't grow and it'll be all withered like an old person's arm. Cutting it off is the only thing that the doctors can do.'

'I don't care if it doesn't grow, a small arm is better than no arm. Don't you understand? Please, please, *please* don't let it happen,' I sobbed.

I look back now, on that hysterically screaming child being told she is about to lose her arm, as if through the wrong end of a telescope. Although the room is static and frozen in time,

the stabbing pain, bewilderment and desperation of the child I was feel as distinct and vivid to me today as they did then.

I recall feeling that if I could only put into words how much I didn't want this to happen, they would have to listen to me; and the fact that I obviously hadn't been eloquent enough I saw as some kind of failure on my part.

I don't remember how long it took me to calm down, but my mother, who told me later that she had fortified herself beforehand with several large whiskies, suggested that before going into hospital later that afternoon for the operation the following day, we might go and buy a party dress for me. Since I had always hated parties, being an excruciatingly shy child, I have never understood why going to Harrods and shopping for a party dress seemed such an exciting and soothing prospect. However, the excitement was short-lived.

The dress was made of red organza with dark-red velvet trimmings and short cap sleeves. 'Can you make the sleeves longer?' my mother asked the shop assistant.

'Well, I'm sure we can, but I can't see why you want them changed. I think she looks very pretty with the sleeves as they are,' the assistant replied.

'She's going to have her arm cut off tomorrow, so they will need to be made longer.'

I could have died with shame. How *could* my mother tell this stranger what was going to happen? It wasn't really going to happen, was it? 'Her arm cut off' sounded so casual, but the awful part was that having it talked about made it much more real. The time I had left to stop it happening was fast running out. The only possibility that I could think of was to run away, but it was December and it was already getting dark, so that didn't seem like much of an option. I felt trapped.

The day before, I had played the part of Mary in the school nativity play; both parents and staff knew about the imminent amputation before I did, and when I raised both

arms in prayer for the Magnificat, it must have struck them all that this was going to be the last time I would be able to make that gesture. And for my parents, to see their ten-year-old daughter so proud to be playing Mary in the school play, yet unaware that she would never again be able to raise both her arms, must have been almost unbearable.

The moment I arrived in hospital for the operation, scheduled for the following day, 12 December 1957, my arm was dressed in bandages and ointments. I minded this desperately as I had wanted to be able to touch and feel my left arm on my last night with two arms. I had no idea what to expect when I woke up from the operation. I didn't want to have to think about it, but being in hospital swathed in bandages meant I couldn't really avoid it. When I imagine that terrified little girl – myself – lying in a hospital bed waiting to have her arm amputated, my stomach contracts with anxiety and pain for her. I felt I couldn't ask any questions. There was no way I could have put into words what I felt, and I'm not even sure what I did feel, except fear, and that I would have done anything not to have this happening. But in 1957, surgery – the most drastic of measures – was considered to be the only option. The attitude – due largely to fear, I suppose – was simply to 'chop it off'. But the question persists: if the cancer had receded, was the amputation really necessary?

I don't remember anything about that night in hospital or even how I felt when I woke up on the morning of the operation. I must have been heavily sedated. While I was having the operation, there was another couple in the waiting-room with my parents in a state of great anxiety. It turned out their child was having its tonsils removed in a routine operation. I don't know how they reacted when my mother told them what was happening to me, or indeed if she *did* tell them. But my mother never forgot. When something major

happens, priorities fall into place. The receptionist at my dentist's surgery told me that nowadays if a child has to have a filling in its tooth, it often becomes a major incident.

When I came round from the anaesthetic I was attached to a variety of tubes and drips, like some of Sir Denis Browne's stranger Heath Robinson fantasies, and my mother was murmuring to me over and over again, 'Darling, they have taken your arm off . . . Sarah, your arm has been removed.'

It was the last thing I wanted to hear. Surely it hadn't really happened; they wouldn't really have cut my arm off, would they? My mother had been advised that it would reduce the shock and trauma to whisper this to me – but what a thing to ask a mother to do! Since I didn't want to admit even to myself that I had lost my arm, I certainly didn't want anyone else to speak about it.

I remember feelings of absolute panic – I couldn't bear to turn my head to see the appalling truth. I had no idea what the remains of my arm would look like; I'd had less than twenty-four hours to think about losing it at all. It had *never* occurred to me during those seven months that I might end up losing my arm, so the shock and disbelief that it had actually happened were immense. I had wanted it *not* to happen so much.

Part of my childish nightmare was that when I woke up from the operation there would be blood and bones visible, so I did not want to look. By not looking, I thought I could go on denying that my arm had gone. I did not want to believe it had really happened, this traumatic and painful loss. In fact, the silence and avoidance of the issue of my arm haunted me for years. 'The grief reaction, particularly denial, is a very common response to amputation,' Bob Price says in *Body Image*, and denial is especially useful as a 'holding position' for children as it gives them time to create explanations for the change for themselves.

It was a minor relief that my left side was furthest from the door in my hospital room, because I thought it meant that people wouldn't notice I had only one arm. I wanted everyone to join in this denial, and up to a point I was successful because, apart from my mother murmuring to me as I woke from the anaesthetic, no one ever actually said anything about it afterwards. Silence was the convention. Freda Long, the ward-sister at that time, told me recently, 'As nurses, we were not so aware, as we are today, of the need for openness in discussing feelings.'

I was never able to ask what they had done with my left arm. Perhaps it was just thrown away with the hospital rubbish or maybe chucked into an incinerator to burn. I'm sure it wasn't buried. All thoughts as to what had happened to it were hateful. It really bothered me that I didn't know, and that was another question I was never able to ask. At that time, all I knew was that I wanted it back as part of me, attached to my body in its rightful place. There is something very elemental about wanting to know what has happened to a body part. In Carson McCullers's *The Heart is a Lonely Hunter*, Willie, who has lost both his legs, says: 'I just wish I knowed where my f–f–feets are. That's the main thing worries me. The doctor never given them back to me.'

And when Jill Ireland, author of *Life Wish*, woke from having a mastectomy, she wrote: 'I found myself wondering where it was, what they had done with it. I would like to have buried it. I mourned it like the loss of an old friend.'

I am sure that to begin with I was kept sedated, but that didn't stop the feeling of powerlessness and horror that I felt in my waking moments. I felt that I must look so odd, and I worried about how I could possibly lead a normal life. Normal to me meant a life with no changes. I don't think I ever worried about not being able to do practical things; from the very beginning

the only thing that concerned me was what other people might think of me now that I looked so different. Since I felt unable to voice this concern, no one reassured me. Until the amputation I had never considered that there was anything really wrong with me; being in hospital had been my first contact with real illness, and although being there had made me realise that there were many people far worse off than me, still it felt like a safe environment. There was a small boy there with what must have been hydrocephalus; he had a gigantic head, which made him top heavy, and he would drag himself round the wards, using his arms on the floor to balance himself. I found the sight both disturbing and fascinating. There was also a skeletally thin girl of about fourteen, probably suffering from anorexia nervosa. I couldn't understand why she wouldn't eat, especially since her food looked so much more interesting than what the rest of us had. I was constantly being asked if I would like any food from home, and while I hated being singled out for this attention, I envied the girl who was fed special meals.

My parents bought me a puppy as a present; they were allowed to bring it into the hospital to meet me. Tinker was a West Highland terrier, an adorable looking bundle of white fur; but he was very over-bred and bit everyone on sight. I ended up hating him. In fact, I'm not sure if I ever really liked him; I wanted my arm, not a dog.

I can't remember whether I fell over, or even whether I was expected to fall, as I clunked around the ward attached to all my tubes. I don't remember if I was given any physiotherapy. In general, post-operative patients were kept in bed much longer in those days, but I don't know how long it took before I was encouraged to walk. I wonder if I found the thought of walking frightening; the doctors and nurses may have worried about my balance, but I don't know if their concern was passed on to me. It must have been very difficult, though vital, for my family to let me do things without helping me. From the

beginning, my family colluded in not assisting. My cousin Gillian remembers my father getting me to light his cigarette and him having to make a real effort not to help me. The paradox is that they must have wanted to help, but realised that not-helping would be the most beneficial in the long-term. And of course they were right.

When I came out of hospital the first question my five-year-old brother James asked was: 'What have they done with your arm?'

I was speechless and didn't know what to say, and wished more than anything that he hadn't asked; I think it was then that I began to realise how ghastly things were going to be. If only I had felt able to make a joke at that moment, perhaps the years of dreading any reference to it might have been different. Comparing myself to Captain Hook would probably have been beneficial to both myself and James. But even now there is a stubborn little voice inside me which says it doesn't see why it should always have to be me (or indeed any other disabled person) who has to help other people out of their embarrassment and make them feel comfortable.

Even after the amputation I had no idea what was wrong with me; I certainly was not told that I had cancer, but even if I had been I'm not sure it would have meant anything to me. What would the word cancer have meant to a ten-year-old in the 1950s?

Lucy Grealy writes, in *In the Mind's Eye*:

Someone said, 'Before Lucy had cancer.'
Shocked, I looked up. 'I had cancer?'
'Of course you did, you fool, what did you think you had?'
'I thought I had a Ewing's sarcoma.'

There was an assumption that Lucy, although only a child, would have known that Ewing's sarcoma was a form of cancer. But why should she? She says no one had ever mentioned the

word 'cancer' to her. I certainly would not have understood what it was. In *Illness as Metaphor*, Susan Sontag says that cancer still 'arouses thoroughly old-fashioned kinds of dread'. In the twentieth century cancer replaced tuberculosis as the dread disease which secretly invaded the body and was not understood.

My parents must have known for quite a while in advance that I was going to have to have my arm amputated. A cache of letters from their friends, which my mother gave me much later, is full of support and sympathy and thoughts of them and me on that December day. The expectations of some are humbling: 'One thing, at least – what a truly wonderful character she will develop through all this suffering – she will be a woman worth knowing one of these days.' And another describes a wonder-woman: 'I don't know whether it will comfort you to hear that one of the happiest people I know is a young married woman who lost her right arm in a motor accident in her teens. She now looks after her own home and two strenuous boys; drives the car, sews beautifully, and is always cheerful and happy. So try not to grieve too much for Sarah; she may also grow up to be a finer person because of this misfortune.' Someone else wrote that, 'Her courage and philosophical acceptance of the whole thing are, I think, quite amazing.' Whatever I felt, I evidently never complained, for another letter says: 'Isn't it splendid she has been so uncomplaining and a model for other people to see.' The British stiff upper lip was already in place.

We spent Christmas every year with alternate sets of grandparents. That year, soon after I came out of hospital, just days after the amputation, we went to stay with my father's parents in Sussex. My grandmother gave me a pale-green Olivetti typewriter for a present, a grown-up one, not a child's model. I think the intention was to ensure that I could continue to be

able to write, not that I had a problem holding a pen – I was right-handed and it was my left arm that I had lost. I still have the very non-committal pages of the diary I typed that winter, with the date in red and the rest in black. The entries are all about going for walks, and the weather; it tells me nothing about what I was feeling.

There seemed to be lots of parties. One little girl of about six, who seemed to be at all of them, pestered me incessantly.

'Where's your arm?'

Silence from me.

'Where is it, where is it?' she persisted, tugging at my sleeve and trying to feel where the arm was meant to be. I couldn't stand it, but had no idea how to cope with her and spent my time trying to escape. When this was noticed by an adult I was more or less told that I had to put up with it – since there was something 'not quite right' about her. There was a convenient shiny white grand piano in my grandparents' drawing-room which made an excellent place of refuge and I fled under there whenever I could. But had I been asked why I was hiding, it would of course have been an unanswerable question. This little girl was remorseless in her questioning, and she made me acutely uncomfortable. Of course, I now realise that it was in part my discomfort which was transmitting itself to her and encouraging her in her ceaseless quest for an answer.

Two months after I had had the amputation, I was taken with my cousin Michael on a recuperative holiday to Switzerland. Many people thought that my mother was crazy to take me skiing with one arm; they said I would not be able to balance properly. They were all proved wrong, and I went skiing almost every year for the next twelve years until I broke my leg. My mother was a practical woman, and before I went skiing she would tuck my empty flapping sleeve into the belt round my waist. I hated this. I think I imagined that if my

34

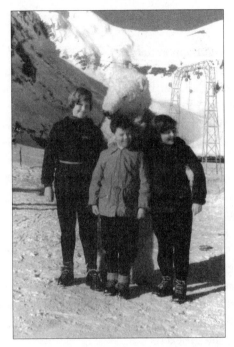

With James and Elisabeth in Villars, 1959

sleeve were allowed to hang loose, people would not notice that it was empty. There was a man dressed as a white bear who wandered around the village having his photograph taken with people; if he hugged my left side closely enough to him, I reckoned no one would be able to tell from the photographs, which were displayed for sale in the village, that I had only one arm. I was given my first wristwatch on that holiday; the leather strap had to be changed for an expandable band, but I felt proud of being able to put on my watch by myself.

When we returned from skiing, my five-year old brother said: 'But you've still got two legs.'

'Of course I have – don't be so silly – why shouldn't I have two legs?'

'Well, last time you went away you came back with only one arm.'

He seemed disappointed.

Much harder than skiing was having to re-learn how to ride a bicycle. Perhaps this was to do with the fact that it was something I had to re-learn, rather than do for the first time? I was determined to learn to do this as soon as possible and I remember the thrill of getting over the terrible initial wobbles and being able to pedal off on my own. But there were terrifying moments: one morning I was riding my dark-red bicycle, accompanied by my sister on her green one, down the long hill outside my parents' cottage and I suddenly found that I couldn't stop. I was terrified and, screaming hysterically, I fell off at the bottom, sustaining nothing much worse than grazed knees.

My poor sister Elisabeth had thought that I was going to be killed and had rushed back to the house in a total panic: 'Sarah's fallen off her bike at the bottom of the hill and I think she's dead,' she shrieked.

It must have been extremely hard for her being cast in the role of protector when she was two years younger than me. I knew that I was all right; it was she who needed the reassurance and comfort that were probably given to me. Now I have a bicycle with both brakes on the right-hand side, but no adjustment had been made to the brakes on that red bicycle I had as a child.

Until then, nothing in my sheltered life had made me feel different from anyone else: I had felt safely invisible, cocooned in my family. A few people like being different from others; from the very beginning I hated it. There is generally an instinctive fear of the different, and of being different, and from the moment the lump on my arm was discovered, I ceased to blend in with the crowd, or rather I *felt* that I ceased to blend in. This feeling of being different, which endured

until my early twenties, was one of the worst, most negative, aspects of the whole experience. Ironically, it would probably also have been the easiest aspect to deal with and could possibly have been turned into something positive. I did not want to be stared at; I just wanted to curl up and be safe, to find a place where no one would look at me. Our house in Trevor Place had two odd little staircases creating two circular routes, making it ideal for hide-and-seek, a game that I came to enjoy more and more. I loved hiding in womb-like nests under tables or behind furniture and being in tiny enclosed spaces where I couldn't be seen.

I have no recollection of whether or not I went to school during those summer and autumn terms; my school friends were told that I was away and not to mention my absence when they saw me, although they were asked to pray for me. What on earth were they told – to 'pray for Sarah, who is mysteriously away . . . '? Evidently they were not even told that I had been in hospital. Whose decision was this denial of reality? For the adults in my life to encourage my contempories in a conspiracy of silence cannot have been healthy.

In a typically English way, when I returned to school, after my skiing holiday and for the first time since the amputation, I was treated as if nothing had happened. Of course in some sense this pleased me, as I had decided, probably unconsciously, that I did not want to be singled out for special treatment, and both staff and pupils followed my lead. The nun who taught needlework considered allowing me to do embroidery on a frame rather than the dressmaking that everyone else was doing, but I struggled with cutting out patterns and using a sewing machine like everybody else. Sewing machines then really were two-handed affairs; one hand was needed to turn the handle and the other to hold the cloth being sewn. Material, rather like toast, is inclined to slip around when it's being cut, and a little finger is not enough of an anchor; a heavy weight on

the material helps, as does leaning on it with my left shoulder. But I wouldn't have liked doing that, as it looked odd and drew attention to my lack of a left arm. I think I just eyed the material and willed it to be still! I did manage to produce some mediocre-looking clothes.

Evidently I also insisted on doing high jump – in fact, it wouldn't have occurred to me not to – and a nun wrote a worried letter to my mother hoping that I wouldn't do 'irreparable damage if I fell on the short arm'. 'Short arm' – I wonder how long she'd taken to think of that euphemism? My meat was cut up for me at meal times in a very inconspicuous way by my classmates, who seemed to know instinctively when I needed help; and another nun wondered whether I had practised walking in a special way, as I seemed in some way to disguise the fact that I had one arm. I certainly hadn't. I did all my lessons, including eurhythmics, during which – I found out later – the teacher would keep her fingers crossed that my balance would be all right. I do not remember balance ever being a problem, which is odd considering the sudden loss of weight and bulk on my left side.

The headmistress of my day school in London wrote to me about ten years ago to say that she had never known anyone to be as plucky as I was then, and how I would never ask anyone for help unless it was really necessary. I'm not sure that I was plucky at all; I just didn't want to stick out.

Elisabeth was initially very protective of me, but she soon realised how independent I was and ceased to worry. She told me that when we were sent off for our daily walk to Hyde Park, people would often stare at me and she would wait until they had passed and then turn round and stick out her tongue at them. I didn't know about this at the time, but I love her for doing it.

Reality Kicks In

Although at the time it would not have occurred to me on a conscious level, there can be a problem of identity, and an emptiness, for those who are healed after a long illness. It is as if when they have an illness they are 'someone' and are 'special', but when they are better their status changes, and they feel ordinary and 'no one'; this creates a void. We are conditioned to associate sickness with rewards such as being given presents and flowers, so for some people there is every incentive to become and remain ill. There are few decisions to take in hospital – one is protected from the real world – and many people become very needy and dependent. Those who are ill get a lot of attention and there is pity for those who want it. As James Thornton writes in *A Field Guide to the Soul:* 'Are we ready to live without suffering? Few of us are. Most of us clutch our suffering close and think it is the most important thing about us . . . Are we not very like Shaw's Don Juan in *Don Juan in Hell,* afraid that if we let our drama go we will become beatific but bored? . . . If we unclutch our suffering, we lose the map of who we think we are.'

I think I felt bewildered, without of course being able to verbalise it. Inevitably there was also a feeling of being let down now that I was better. Everyone was pleased that I was well, yet the reality of what I was left with was a missing arm (which I hated and couldn't talk about), a feeling of rejection (I wasn't going back to hospital) and an odd sense, since I didn't know that I had been seriously ill, that I was meant to feel grateful for these things, which I neither wanted nor liked.

Proof that my parents had faced up to the fact that I might die was their decision to have me professionally photographed; the pictures would be a lasting record of how I had looked. They asked Tony Armstrong-Jones – later Lord Snowdon, but then a little-known photographer – to come and take pictures of me. For some of the shots I wore just a towel, which I thought odd, but everything in my life at that time was strange, so I posed uncomplainingly for what turned out to be a series of beautiful photographs. Creating a record of a living person in their prime for posterity is fairly customary; I had just reached that stage too young.

Since I didn't die my parents did not need the photographs to remind them of a dead child, but they are still a reminder that I once had two arms. They show me as a very pretty, innocent-looking and trusting child with no visible signs of illness, and many of them show both my arms. The majority of people looking at a picture of this child would not be struck by the significance of the left arm – the arm that I became so desperate to keep and yet which, unbeknown to me, was soon to be cut off. When I see those pictures now I sometimes find it hard to believe it's me – I am so used to living with one arm that it's difficult to remember that I ever had my left arm; although the opposite also applies and I am sometimes surprised that I do only have one arm. And yet there is also a feeling of real loss and of thoughts about how my life might have been different. Photographs are the only remaining evidence of me with two arms and I guard them jealously, sometimes feeling the need to show people that I was once like them – an 'ordinary' child with two arms. 'Look,' I often feel like saying when I show them to people, 'I was born as a normal baby – just like you.' All photographs capture moments but the photographs taken of me up until the age of ten are proof – and while I was growing up I needed that proof – that I had once been like everyone else.

But that was painful in itself, because of course I still wanted to look the same as everyone else and a photograph was a cruel reminder that, although I had once been the same, I no longer was. I am still very self-conscious about having a photograph taken which shows that I clearly have only one arm – if I am wearing a bathing suit I automatically turn my left side away from the camera. Indeed I am wary of people who want to take any photograph of me which makes it obvious that I have lost an arm.

I lived the rest of my childhood and adolescence in a web of silence. It was as if having one arm was a secret – a visible secret, but none the less a secret – a conspiracy in which I was a willing participant. And there is no question that this denial suited me. It was therefore impossible for me ever to ask any questions about how things might – or would – be different for me in my new one-armed state. And because it was a secret, for many years I couldn't accept the reality of what was.

Because I would not talk about it, on some level I was not accepting that I had only one arm. Superficially it might have appeared that I had accepted it, but on a deeper level I was in total denial. I did not want anyone to see me as different and so I shut off that whole part of myself which would have allowed other people to know how I felt about it. The more I armoured myself against the world, the more unable I was to show my vulnerability. Amputation is like an iceberg: seven-eighths of the problem is submerged.

I could be extraordinarily sullen and withdrawn as a teenager. Retreating into oneself is a known tactic for managing stress, and this is often followed by outbursts of rage or periods of depression that may manifest themselves in sullenness. During my sullen periods, I rejected any sympathy or attempts to understand what was going on. I knew that no

one could understand what I felt like, and I wanted to be left alone. I craved privacy. It must have been very difficult to know how to treat me; it would have been hard for my parents to assess whether forcing me to do things was the right course. They were working on instinct and I did nothing to help them. I don't think I ever let them know if I liked or disliked anything; I gave everything the stock answer, 'I don't mind.' And I really don't think I did mind; I just wanted to be invisible and anonymous and not to have to bother about thinking for myself.

The reality was that it was as if an enormous physical barrier had been erected between me and everything else. I felt that if I asked a question not only would I have to face the reality of the answer, but I would be making myself too important, drawing too much attention to myself. Talking about myself seemed wrong. In some sense I didn't consider I had the right to have the sort of attention focused on me that asking and answering questions would entail. I'm sure Catholicism was mixed up in this: by making myself that important, I would be guilty of the sin of pride. It's not that I accepted what was happening to me passively and as the will of God – far from it; I would have done anything to have kept my arm – it was talking about it that seemed wrong. I remember this so clearly because that inability to ask about what had happened to me continued right through my teenage years. I never even raised the subject. From the very beginning I did not want anyone to know about my having just one arm. In my denial, I felt silence was my best ally.

Apart from the devastation about the way I felt after the amputation, I had lost much more when I lost my arm than I could possibly have imagined at the time. Although I refer to having lost my arm, of course – much more vitally – I had lost my hand. We use our hands for grasping, holding and manipulating, but also for feeling and expression. Hands

and arms have both a social and a functional purpose and we use them to help us to articulate, to communicate and to show affection in both work and play.

The Roman rhetorician Quintilian wrote in AD 80:

> . . . other portions of the body merely help the speaker, whereas the hands may almost be said to speak. Do we not use them to demand, promise, summon, dismiss, threaten, supplicate, express aversion or fear, question or deny? Do we not use them to indicate joy, sorrow, hesitation, confession, penitence, measure, quantity, number and time? Have they not the power to excite and prohibit, to express approval, wonder or shame? Do they not take the place of adverbs and pronouns when we point at places and things? In fact, though the people and nations of the earth speak in a multitude of tongues, they share in common the universal language of the hands.[1]

Maybe for all these reasons the hand was a specially favoured ornament among the Romans and was used extensively on household articles.

But it is perhaps the fact that, as Quintilian observed, through them a universal language can be spoken that distinguishes them above all from other parts of one's body. It is when it comes to communicating, whether hugging, touching or talking, that I most miss having two hands; I feel that although my way of communicating with one hand is often understood and appreciated, it would be enhanced if I had two.

Different nationalities give various amounts of weight to their hand and arm gestures and for centuries the hand has also been used worldwide as a gesture of defiance. Italians use their hands a lot in conversation and these gestures have changed little in a hundred and fifty years; a book published in 1832 by Andrea de Jorio called *Gesture in Naples and Gesture in Classical Antiquity* shows that many of the gestures were, and

still are, obscene. The *manu cornuta* is the gesture in which the little and index fingers represent horns; a carved *cornuta* hand was found at Herculaneum, and it can also be seen in San Vitale in Ravenna, in Indian art, and in Shakespeare's *Merry Wives of Windsor* and *Much Ado about Nothing*; it was used as a protection against the evil eye, and in secular use a cuckold was recognised by being pointed at with the *manu cornuta*. Because the evil eye can be communicated by touch, the hand as an instrument of this touch has always been regarded with intense interest. In the Ashmolean a small amulet from Umrît in Syria, said to be Phoenician, shows the thumb between the first and second fingers, a gesture described by Ovid as the *manus obscoena*. It has been suggested that this movement runs in families and that five per cent of adults do it involuntarily. I know that I do. This obscene gesture commonly known as the *mano fica* is *faire la figue* in French – many nationalities use the

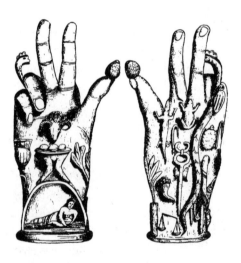

Various symbols on a bronze hand in a Mano Pantea gesture in the British Museum from the collection of Rev. Payne Knight from The Evil Eye *by Frederick Thomas Elworthy*

same hand gesture but refer to it differently: in Italian *far la fica*, in Spanish *hacér el higo* and in English we say we 'don't care a fig'. Long before the Christian era the *mano pantea*, in which the first two fingers and thumb are extended, was used against the evil eye – the Museo Archeologico Nazionale in Naples has an example from Pompeii.

Psychologically, losing an arm is a far greater loss than losing a leg and, interestingly, those who show an early acceptance may not be those who come to terms with it best overall. It's hard to know whether or not I accepted what had happened – in one way my denial was a strange kind of acceptance, but of course on some deeper level my denial was possibly injurious. The loss of an arm often produces feelings of inadequacy and for this reason the patient may need a great deal of psychological support. Nowadays an average of nineteen people with different skills are available to help and advise someone who has had an amputation. In the 1950s, when it happened to me, there was no one. It was a question of muddling through on my own and finding the best defence strategies for myself.

What we know of our own bodies tends to be discovered by our hands and hands are what connect our bodies, through touch, to the outside world. The hand is the essential part of the arm, and without it an arm is assumed to be pretty useless – but, having recently seen people use their handless stumps, I'm not sure that this is necessarily true. Apparently we use our hands for around a thousand different functions a day – so only having one doubles its work; as a result, hands are very vulnerable and are more likely than any other part of the body to be injured (Ann Oakley, *Fracture*). There is an eloquent, mysterious link between hand and brain, and also in the way that the hand acts in harmony with the eye. Matisse wrote about the intricate relationship between an artist's will and his hand:

If I trust my hand when it draws, it is because when I was learning to use it I strove never to let it get the better of my feelings. I feel it very clearly, when it paraphrases there is a disagreement between us – between my hand and something in me which seems to be submitted to it.

[Quoted in Bolloch's *The Hand*]

As Henri Focillon put it in *Éloge de la Main*, it is the hand that carries out what's in the mind:

I do not know whether there is a break between the manual order and the mechanical order; I am not too sure, but the tool at the end of the arm does not contradict the man, it is not an iron hook screwed into a stump; between them, there is the god in five persons which runs through the entire scale of greatness, the hand that built cathedrals, the hand that illuminated manuscripts.

And Paul Tabori continues this theme by writing that the hand is:

The masterpiece which no artist has equalled, no inventor has ever duplicated. All that Man has achieved on this earth has been a projection and prolongation of his hands. Even as he reaches out for the stars, he cannot do without his ten fingers, his miraculous thumb, his sensitive tactile nerves. It is the clearest, most unequivocal symbol of our humanity.

[Paul Tabori, *The Book of the Hand: A Compendium of Fact and Legend since the Dawn of History*]

Hands are a witness of who we are – a labourer's hands reveal hard work, a lover's hands express tenderness, and the fragile hand of a baby instinctively grasps its mother's finger for reassurance, just as a mother plays with her new baby's fingers. These roles for hands are not something we think about consciously – that is, until we lose one and we can't do

something like hug a loved one or a child. Children know a lot about hands, since, as Nabokov wrote in *Speak, Memory*, 'they live and hover at the level of our stature'. However rather extraordinarily (and shockingly) nine out of ten people, when shown photographs of hands, are unable to recognise their own among them (Ann Oakley, *Fracture*).

Every culture and religion emphasises that what gives the hand its importance is the fact that it is the most direct link between our inner selves and the outside world. Keri Hulme, in *The Bone People*, demonstrates the importance of hands on every level: 'But hands are sacred things. Touch is personal, fingers of love, feelers of blind eyes, tongues of those who cannot talk.'

Fingertips have a finer touch discrimination than almost any other part of the body; losing a hand effectively cuts that discrimination by half. Using sensitive parts of one's body for communication is a natural custom; animals cultivate friendship by using their most sensitive parts for touching. In humans, lips and tongues are more sensitive than fingertips, but hands are sensitive enough for friendship, before the boundaries are crossed into the intimacy of lovers. By way of compensation for the loss of a hand and of one's fingertips, the sensitivity gradient does actually change, and there is an increased sensitivity in a stump. But this is not much use in daily life. In fact, I have often had reason to curse that increased sensitivity – bumping into something with my stump by mistake can be excruciatingly painful.

Not only are our hands the dominant organ of our tactile sensibility – almost everything we wish to learn about a new object, which we cannot glean by our other sense organs, we learn from testing with our hands – but, as Frederic Wood Jones in his book *The Principles of Anatomy as Seen in the Hand*, states:

The hand as the expressor of emotional states affords a

study in itself; . . . the 'expression' of the hand is a thing impossible to define, and yet it is a very real factor. It is more easily noticed by its absence; and it is often very astonishing to see how utterly unlike the real hand is even the most perfect plaster cast.

If it is true that a plaster cast can never be like a real hand, although Rodin's 'Praying Hands' come close, it must be because a hand is so alive and full of expression. The differences in shape, texture and general appearance of the hands of individuals are as great as they are of the faces. Certain kinds of hand seem to belong to those with certain types of faces; in much the same way that the life and character of someone can be seen in their face, so the hand is the index of the mind. Just as no two faces are alike, so are no two people's hands or feet identical.

We can tell a lot about someone from their hands, what they look like and how they use them. A painter I know is fascinated by hands and what their movement tells her about people; she always draws a hand to accompany her signature. Goethe noted that his friend Lavater, author of *L'Art de connaitre les hommes par la physionomie* (1775–78), 'looked at the hands not the face; and he saw extraordinary subtleties in them'. And of course drawing and painting portray hands powerfully, from Albrecht Dürer's 'Praying Hands' to Joán Miró's 'Elegy of the Hand'. Hands are also extremely important in portraits and are often as expressive as faces: in *Ce qu'on voit dans les rues de Paris* (1858), François Victor-Fournel observed:

A man of substance seldom has himself painted without his hands, unless it is against his will. For him there is no such thing as a portrait without the hands: it is something incomplete, like a legless cripple. He is preoccupied to the highest degree by the position and expression of the hands.

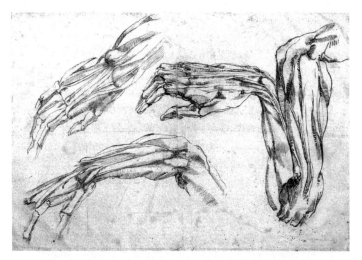

Théodore Géricault 1791–1824: Anatomical studies of the musculature and bones of the lower right arm

Hands have also inspired writers and film makers: in 1942 Gérard de Nerval's book *La Main Enchantée* was turned into a film by Maurice Tourneur called *La Main du Diable* in France and *Carnival of Sinners* in America.

Palmistry, chironomy (the art or science of gesticulation or of moving the hands according to rule in oratory, pantomime, etc.), counting and deaf-and-dumb language are just a few of the things for which the hands are essential. Sign language is also an understood method of making contact (which, contrary to popular belief, has nothing in common with deaf-and-dumb language) and both bookies and auctioneers use their hands as their major form of communication.

Possibly because I am compensating for the loss of an arm, friends tell me that in a very un-English way I use my right arm and hand a great deal when I'm talking. In a wonderful passage in *Zorba the Greek* by Nikos Kazantzakis, Zorba wonders of his English friend: ' "While you are talking I watch

your arms and chest. Well, what are they doing? They're silent. They don't say a word. As though they hadn't a drop of blood between them." ' I love the idea of 'silent hands' – and how telling that we English, by not using our hands, markedly reduce the extent to which we communicate.

One of the little things I have always yearned to do is to be able to cross my arms. Crossing arms seems to me to produce a completeness of one's body. The body language of crossed arms is defensive and means something different, but it is the joining of the two arms or hands that I miss. I long to be able to lace the fingers of both hands together and to play the games that children play with their hands.

'Sarah, come and join in our game. Here, hold my hand.'

An embarrassed silence as the speaker realised I had no hand.

'Never mind, I'll hold your sleeve instead.'

I couldn't say no – but inside I curled up with shame. I didn't want my sleeve held. I didn't want to play the game. I wanted to go home. I couldn't vocalise any of the things I felt; I knew I couldn't hold hands in party games and that I looked different from other people, but I was incapable of either saying what I couldn't do or admitting that there were things I found difficult. Also, when people started to play games such as 'Here is the church, Here is the steeple', there would often be an awkward silence as they realised that I could not join in. Either they would continue and I would feel desperately left out, or they would stop which made me feel equally awkward. Worse, they would try and adapt it for me, which I hated.

'Let's do it together – come and join your hand with mine,' a grown-up would begin bravely, but on seeing my sullen face and hearing my mumbled, 'No, thank you,' the offer would be withdrawn.

Once a hand game had started there seemed to be no solution – nothing made me feel included and comfortable. And still there would be the wall of protective, but stifling, hush

around mentioning that I couldn't play because I had only one arm; they never said anything and I certainly never did.

Many expressions and phrases bandied around in daily conversation use 'arms' or 'hands'. Most, such as 'a bird in the hand is worth two in the bush', 'clean hands and pure heart', 'the long arm of the law', 'cold hands, warm heart', 'lend a hand', 'many hands make light work', 'living from hand to mouth', 'to be hand in glove', 'the hand that rocks the cradle rules the world', 'the hour is at hand', hardly register on my sensitivity scale. But if someone says – which they often do – 'I'd give my right arm for X,' my hackles go up. In *Lost Camels of Tartary* by John Hare, the author asks, 'Do you ever take foreigners on your expeditions? I'd give my right arm to go with you.' The reply he gets is, 'There's no market in Moscow for a foreigner's right arm, even the Mafia aren't interested in them.' When Nelson first met Lady Hamilton in Naples, he wrote to his wife: 'Up flew her Ladyship and exclaiming, "O God, is it possible?" she fell into my arm more dead than alive.' It is interesting that he wrote 'arm' rather than 'arms'; changing a conventional expression to suit one's own needs is quite difficult. I am always aware if people use an expression with 'arms' or 'hands' when they are referring to me. Most use the plural, but I can sometimes sense that, as they say it, they are aware of their error but are too embarrassed to make a change.

Touch is seen as a sign of healing in many cultures. 'Healing by touch' can be traced back to the priest physicians of Ancient Egypt and Babylonia; it stems from the belief that certain people are born with superior powers. The Emperors Constantine, Vespasian and Hadrian all cured with their hands, as did King Olaf in the *Edda* (collections of old Icelandic writings). The Bushmen of the Kalahari put healing hands over the bodies of their comrades, the Navajo flutter diagnostic hands, and of course Jesus used his hands for healing many times.

For more than seven hundred years the anointed kings of France, Scotland and England were regarded by their subjects as miraculous physicians; it was thought that a mere touch from them would cure physical illness. In *Macbeth* (Act IV, Scene3), Shakespeare has the doctor say of the king:

> ' . . . There are a crew of wretched souls
> That stay his cure: their malady convinces
> The great assay of art; but, at his touch,
> Such sanctity hath Heaven given his hand,
> They presently amend.'

In Britain, from the time of Henry VIII, a gold coin was given to each person 'touched' by the king; this became known as the 'touch piece' and was preserved and worn as an amulet. Elizabeth I and James II made the sign of the cross over scrofulous swellings and both Charles I and Charles II stroked the affected part of an ill person. Astonishingly, in 1682 Charles II 'touched' eight thousand five hundred sick people. Did these monarchs ever fear that they might get ill themselves? Or did they believe that the divine right of kings made them immune? It's odd to think of our own monarch having people brought to her to have their illnesses cured, yet the late Princess of Wales had much the same effect on sick people. Those she visited in hospital felt better after her visits; her touch gave them some kind of comfort and help. And when our Prime Minister or the American President do walkabouts, the crowds surge forward in an attempt to touch them.

I used to think that by missing school I had missed out on learning the crucial key to life. So much of what we understand is dependent upon knowing some critical point; if we do not know it, we cannot hope to understand a new concept or idea, and yet if we do know it, it is often something that we take for granted and that we believe everyone must know. For a long

time I thought that the vital point that would explain life had been divulged in my absence. I did not believe that this had been done intentionally, but since the teachers had forgotten to teach me the key, they would have assumed I knew it. Were the 'I don't minds' and 'I don't knows' that plagued my teenage years due to the fact that someone had forgotten to give me the vital clue? I would infuriate people by not having an opinion about anything, but I didn't want to be any more different than I already was, and the thought of choosing something which was not what the other person may have wanted was too risky.

When a child is ill, it automatically affects the rest of the family; in ours, it was Elisabeth who was most affected. She and I had always done everything together and now, for the first time, I was often away in hospital and getting an unwarranted amount of attention. Since everything I did she did two years later, perhaps she imagined it would be her turn to be ill next. No doubt she felt confused and jealous. Since even I had no idea what was happening, she, aged eight, certainly didn't either. At one point she was sent to stay with an aunt and uncle; although this was probably done with the best of intentions, actually it made her feel unwanted and miserable. She told me, years later, that she had longed for a lump on her arm too so she could be like me.

During my illness I suspect that on the surface my parents' lives went on much as before, with my father going to work daily. But my mother told me that one evening, as they were going out to dinner and had reached Hyde Park Corner, she suddenly burst into floods of tears. They never made the dinner party.

Although my mother remembers breaking down only once, she had friends to talk to about what was happening. During the war my father had been both a prisoner and badly injured and, although he lived until 1991, soon after my cancer diagnosis he developed a truly appalling skin allergy that he had

for the rest of his life. No one seemed to have a clue what he was allergic to; one specialist suggested that it might be sunlight, so we lived in darkened rooms; another thought that it might be aluminium saucepans, so all our cooking utensils were changed. But still the itching went on, occasionally alleviated by vast doses of cortisone. I think it is very possible that my illness was instrumental in his prolonged ill health. He had few friends and found it very hard to communicate; whenever I think of him, I feel an agonising knot of unresolved feelings in my stomach, since while I never doubted that he loved me and was proud of me, he could certainly never communicate what he felt. My heart aches for this thoroughly decent man who was probably never able to express his distress to anyone at what was happening to his child. This meant that everything was internalised and I don't think it's too fanciful to think that his grief could have been translated into his mysterious allergy. But of course this was never discussed, and he never openly showed his anguish about my cancer. Causing him this suffering would have made me – on an unconscious level – feel bad and in some way responsible for it. His presence was certainly a support for all of us, but he probably felt very unsupported himself.

When you lose a limb you have to adjust to the different way you think about yourself; you have to contend with the shock or dismissiveness with which other people might treat you, and you have to be prepared for a shock when you look at your naked body in the mirror. Now I rarely feel less than a whole person, but there is still the odd occasion when I glimpse myself in a mirror and am shocked by my one-armed appearance. Is it that when I look at myself in the mirror it is as if my right arm rather than my left is missing? More likely it is the fact that I have forgotten that I only have one arm, and a mirror is a rude reminder. Everything we see in mirrors is distorted but

generally it is the closest we get to seeing ourselves as others do. And of course it is that look which others see all the time.

I was concerned about looking and being different, but where does this need to conform come from? The theory of body image has indeed grown in importance, although from the beginning of Genesis (3:7), when Adam and Eve 'knew that they were naked', it has been impossible to ignore the body. Everywhere we see images of the ideal body: in advertisements, films, television, magazines. And gyms and health clubs are full of mirrors to remind everyone of how they look.

When we meet someone, we automatically assess how they look, and often wonder what they are thinking of us. Of course, what other people think of you can be completely different from how you think of yourself. But the reality is not what you'd like but what *is*. One's image of oneself, and the way other people perceive one, differ. We all form a picture of our bodies in our minds but having a limb amputated distorts this image. 'When this integration is weak, disruption of the body image through surgery or amputation may precipitate blatant psychotic or delusional behaviour. Even in well-adjusted persons, however, the almost universal reaction to such a loss is that of grief, accompanied by depression and anxiety.'[2] With hindsight my delusion was that I thought that other people would not notice that I only had one arm.

But adjusting to the inner loss means accepting and coming to terms with a new external body image, which is something I didn't even attempt as a child, especially as no one ever referred to my having lost an arm. This meant that provided I avoided seeing myself in a mirror, and was with people who never mentioned my arm and who let me do everything, I felt no different from before and therefore safe. Inevitably, there is an immediate confrontation with the outer world long before we have learnt ways to cope with the illness or accident internally. And this can be terrifying.

However, if you don't meet the outer world head on it's worse. In *Triumph of Love*, Leona Bruckner wrote about a wealthy couple in the States whose child's arms had to be amputated and who were so grief-stricken that they nearly went insane. They bought a secluded place in the country, built high walls around it and provided tutors for the child. Not surprisingly, the child became completely uncontrollable. She also mentions a case in South America in which the family of a girl who had one arm would not refer to it, believing it was a sin to do so. Of course we do not know how the 'outer world' is going to react, and how we perceive this outer world is intimately linked to our sense of 'self', to our beliefs, attitudes, emotions and behaviour. The burden always seems to lie with the disabled or bereaved person: again and again it is the way the person with a disability reacts that paves the way for other people's reactions.

A visible handicap is a constant challenge. Those with a disability are regarded by most people with a certain degree of fear, pity or revulsion; the fact that this reaction is based on the observer's own anxieties and fantasies is irrelevant. The way we look has a profound effect on our social lives and after a change of body image, of whatever kind, there is a difficult period of adjustment and vulnerability, especially for children. It is unsurprising that those people who feel secure and loved for themselves before becoming disfigured or changed in some way seem more capable of adjusting to the loss. It is hard to explain what it feels like to be shunned for being different, and to be made to think there is something wrong with the way you look. Practically, having one arm makes little difference to my life, but I am sensitive on the occasions when it does, and I am acutely aware that other people suffer daily rejection for looking different. But we all have some kind of handicap – mine just tends to be more visible than some others. On one occasion I was with a friend who was a diabetic, but he hadn't

told me. Mid-afternoon he woke from a deep sleep and started behaving so strangely that I became terrified and fled from his house and got on a train back to London. When I arrived home there was a message from him apologising for his behaviour. I rang him back and he told me that he was diabetic and that this was the reason for his odd actions. I was furious with him and told him that it was ridiculous to hide a disability – I couldn't, so why did he? If he'd told me, I would have known that all he needed was a sugar fix. It only occurred to me later that since I had spent much of my life in denial too, who was I to preach to him?

However, the kind of thing that doesn't help in coming to terms with having only one arm is the kind of information put out by Scope (the new name for the Spastics Society) in a booklet called *Stop Press!* published in 2000. Among the pejorative terms they urge journalists not to use about disabled people is 'one-armed'. I'm baffled by this. I spent my childhood years not being able to say it and now that I can admit to it, it's deemed politically incorrect. Would I really tell someone that I am 'an upper limb amputee' or 'transhumeral'? Although, to be fair, the Limbless Association at Queen Mary's Roehampton has said that these terms are not necessarily to be used in every-day conversation.

From the time I came out of hospital as a child I was worried about what I looked like, although I never said anything to anyone. I thought I would always have to wear long sleeves; these at least would help maintain the pretence that what couldn't be seen might still exist. Trailing from shop to shop for clothes during the school holidays with my mother was a regular ordeal; nothing ever seemed to have sleeves long enough for me.

'What about this dress, darling? Its sleeves are long enough.'
'I don't mind,' I'd mutter.

'Well, do you like it or not?'

'I don't know.'

'You must know whether you like it?' said my increasingly exasperated mother.

'Well, I don't,' I'd say stubbornly.

'Shall I buy it or not?'

'I don't mind.'

And so this agonising charade would continue from shop to shop. My poor mother. I must have passed my indecision about clothes shopping on to my sisters, because they too would stand in changing-rooms with hunched shoulders, full of 'don't minds'. The range of clothes was small then, in comparison to what is available today. I was too shy ever to wear anything sleeveless – I was frightened of being stared at and of upsetting people.

My American cousin Gillian told me recently that she had dreaded seeing me in a bathing suit for the first time. Why had it been so frightening? Probably it was a fear of the unknown. Other people's discomfort would certainly have increased my own, and concealment would have added to the fear in both them and me. Once she had seen me in my bathing suit, she had thought, 'So what?' If you keep a secret from a child it becomes 'unspeakable'; once spoken it loses its power. In the same way, once I had appeared in a bathing suit, it was obvious that there was nothing very frightening about it or me.

The fewer clothes one is wearing the more one's figure is assessed: swimming pools, the beach and health clubs are prime locations for this. Swimming pools are prime sites for hurtful remarks, since so much of one's body is on display and people seem to think they can ask what they want. I heard about a small child being questioned remorselessly by a stranger about whether she had been born with a missing limb and, if so, why. It's a huge liberty to ask such personal questions, but somehow people feel that they can take that liberty with 'disabled' people

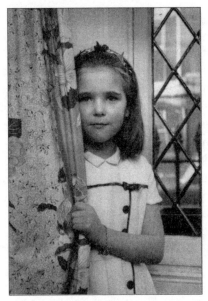

Camilla

as if they weren't fully human and didn't have feelings. Many people have no conception of this – sometimes strangers assume they have a right to predict a gloomy future for someone with a disability. A child with one arm in America was recently told by an unknown man that she would have no prospect of a job or of getting married – two uncalled-for and distressing remarks, which, although they showed complete ignorance, were none the less painful.

Sometimes one has to remind oneself that there is nothing to be ashamed of in having a disability, that one has done nothing wrong. This may seem bizarre to anyone who is able-bodied, but there is a very strong urge to apologise and somehow to take the blame. There was a cartoon pinned up above the scales in my health club: 'Judy was delighted – having her hands amputated put her down to her ideal weight.' I found this offensive, but instead of ripping it off the wall, I

cravenly left it there. Still, I was glad to see that somebody had removed it by the following day.

At WeightWatchers ™ one of the rules is that you have to have at least ten pounds to lose before they will allow you to join. Although I felt slightly overweight when I attended my first meeting my weight fell into the acceptable category for my height, so the only way I was able to persuade the woman to agree to my joining was by debating the weight of an arm. How much does an arm weigh? Neither of us knew.

Although the majority of the population know that they will never match the so-called ideal image, if you have a disability you know that you are not even in the running. However, a surprisingly enlightened attitude meant that Theresa Uchytil, born with no left hand, became Miss Iowa in the Miss America 2000 contest. She said: 'Really, it's the attitude you have. If you work hard and really believe in what you're doing, you have mind over matter.' In her photograph she made no attempt to disguise her lack of a hand and her success must surely be seen in a much wider context than a purely personal victory. Even though winning a beauty pageant has never been my ambition, and even though beauty competitions are not exactly part of 'normal' life, the fact that the contest was won by somebody with one hand does confer a normality on amputees.

Only one friend ever enquired if I wore anything without sleeves and if not why not; her question, asked as we were walking down Bond Street, really shook me. I had taken for granted that I could never wear anything without sleeves and had always passed over sleeveless clothes in shops, but I had no problem with short sleeves that made it obvious that I had one arm. She made me reassess why I had thought that it would be wrong. I think I felt that I would be upsetting people's sensibilities or ideas of how one should look, and this would have made me embarrassed. Luckily, in a way, now I don't have to face the issue about sleeveless clothes as I feel too old and

flabby. But oddly, I have rarely felt awkward when I wear a bathing suit: in my mind there is a clear distinction between the appropriateness of what to wear when, and the thought of walking down Bond Street in a sleeveless dress, which would have been almost as difficult for me as appearing nude in public, was impossible. Alexander McQueen was guest editor for the September 1998 edition of the style magazine *Dazed and Confused*, in which all the models were physically disabled – challenging the assumption that you have to be young, thin and preferably blonde to succeed in the fashion world.

As David Guterson wrote about Ishmael Chambers in his novel *Snow Falling on Cedars*:

> He was keenly aware of his pinned-up sleeve, and troubled because it troubled other people. Since they could not forget about it neither could he . . . He could never tell if they were relaxed enough about his arm to say what they were really thinking. He sensed their need to extend sympathy to him, and this irritated him even more. The arm was a grim enough thing without that, and he felt sure it was entirely disgusting. He could repel people if he chose by wearing to class a short-sleeved shirt that revealed the scar tissue on his stump. He never did this, however. He didn't exactly want to repel people.

I wanted to find out if David Guterson knew anyone with one arm, as he seemed to write about it with such understanding. I sent him a letter to which he replied that he had only once briefly known a young man with one arm who he reckoned seemed perfectly adjusted to it. But he added, 'Who knows what he really felt?'

Sometime during that first year I sat and passed the eleven plus in the top group. I had been due to go to boarding school in September 1958, but I was now given the choice of

boarding or staying on at day school in London. I chose to go to boarding school as planned, and in September 1958 I arrived at St Mary's Convent, Ascot. I found it baffling that any plans might need to be changed now that I had only one arm; after all, I didn't want anything to be different, and since my decision was to try to ignore it, I wanted everyone else to forget about it too.

We had been sent detailed lists of the school uniform to buy at Harrods. I was so anxious to get everything on the list, so as not to look different, that we bought the galoshes as stipulated. Naturally, when I got to school I discovered that no one else had paid any attention and had brought their wellington boots from home. This, combined with my having strap, rather than lace-up, walking shoes, made me feel acutely and uncomfortably different. I could probably have learnt to tie shoelaces – there is a method, but I did not know this at the time. We also had to wear ties, which I could not tie on my own, so I had a piece of elastic inserted at the back of mine so that I could then pull it over my head. As a result I always had a perfect-looking tie – unlike my schoolmates whose ties were always in a mess. I did not really like this – being the arch conformist, I wanted my tie to look untidy too. Two prefects had been told to help me make my bed each morning; I hated their interference and I succeeded in getting rid of them within the first week. I can't remember how, but I probably rushed to make my bed each morning before they arrived and so, without referring directly to my arm, I was able to show that I did not need their help.

I imagine that the following letter I wrote from school when I was eleven must have been extremely worrying for my parents:

I stayed in bed today. I have just sort of collapsed like I did in the holidays. I can't eat anything and the nuns get cross.

I probably just had flu, but I suspect that any illness would have rung alarm bells. But after I left hospital, with the exception of one or two check-ups at the time, I never saw any doctor about anything to do with my arm again.

During childhood and adolescence the only times I thought about my arm were when people asked awkward questions, and at school they never did. I neither particularly liked nor disliked school, and maybe the reason I found it so easy to adjust was because I was used to the institutionalisation of hospital; I was pretty average at everything and being average ensured that I never stuck out. One of the huge advantages of school was that it was a very protected environment; the outside world didn't impinge. Once I had established that no one was going to ask me about my arm I felt secure and, amazingly, during my five years there, no one ever mentioned it. I wondered whether my classmates were curious or whether they didn't even think about it, but I have recently discovered they were told by the nuns not to mention it and apparently didn't talk about it behind my back. One friend remembers having been so indoctrinated by her mother (who was a friend of my mother's) *not* to mention it, that she blotted the whole thing from her mind. The advantage of all this was that I never really thought about my missing arm. It was only later, and sometimes in the holidays, when I had to contend with the rest of the world, that I discovered that I was totally unable to deal with questions about what had happened. Since the age of ten I'd had to deal with the outside world, and the way I had perfected that inevitable contact had been through denial. As long as I pretended there was nothing different about me I was able to draw others into the same conspiracy and my wall of silence proved to be very effective.

I did not play hockey at school, but I played everything else including tennis, rounders and netball; one year I was even in

the school swimming team. It was considered uncool to love sport, so I had to find a balance between proving I could do it, yet pretending not to enjoy it. At school one of the few things I was told I could not do, and which I did not question, was to wash my own hair, and so my fortnightly hairwash was done by one of the nuns. I probably accepted this so readily because my mother used to go regularly to the hairdresser, and I assumed that a weekly visit to the hairdresser would become part of my own lifestyle. Now that I wash my hair practically every day, I find it very strange – and oddly pathetic – that I never tried to do it for myself at school, especially when I was desperate to try to do everything else.

Each year the fifth form would put on a play, and when it was our year to do it I was the only one in the whole class not to be given a part. I was mortified.

'Why aren't I in the play? I'd really like to be,' I asked the nun who was directing it. I was fifteen and knew I had a good speaking voice as I was always chosen for one of the lead roles when we read plays aloud in English classes. The nun who directed the play was my form mistress, who always chose me to read in English.

'Don't worry; you can understudy the main part,' she told me, as if that would make me feel better. It did – a bit. But I thought she was probably banking on the lead appearing on both nights that the play would be performed. I was convinced that I had been left out because it would be embarrassing to have me on stage in front of the parents.

Later I found out how much my sister Elisabeth suffered at school because of me. She was told by the nuns how wonderful I was, which, as well as being untrue, was something that was never said directly to me, and something I certainly did not want said behind my back. It must have been hell for her, feeding all her insecurities and putting her in a turmoil of mixed feelings: loyalty, defensiveness and jealousy. At the time

I thought it would have been better if we had gone to separate schools, although now it feels good that we have a shared past.

I remained very resistant to growing up. Every summer we had new sandals bought for us, but when I was about fourteen my mother announced I was too old to wear sandals during the summer holidays. I was devastated. This seemed to mark the end of childhood, to indicate that I would have to take my place in the real world, a move I dreaded. Unconsciously, I suppose, I knew that as a child I was looked after, whereas as an adult I would have to take charge of my own life and make my own decisions; there would be nowhere to rush back to when the questioning got tough.

Of our sandal-wearing summer holidays, Littlestone is the place I remember best, partly because I regularly dreamed about it. Every January, from the age of about nine to fifteen, I had the same dream. I was locked into the bathroom of the boarding-house while an army of stereotypical tin soldiers with tall black hats rushed upstairs and tried to break down the door with their bayonets. I crouched, terrified, inside. Tin soldiers could certainly be seen as phallic symbols, trying to break down my resistance and adolescent fear of men and growing up.

I was also told that in future I would have to wear stockings rather than white socks at parties. Struggling with stockings and suspenders proved to be awful and I longed to wear my safe white ankle socks again. Fashion was not so invasive then as now; nevertheless, on those rare occasions at school when we were allowed to wear our own clothes, I remember always feeling dowdy in my sensible pleated skirt, shirt and cardigan. The school uniform consisted of pale blue shirts and navy tunics, and although some girls wore it with more aplomb than others, there was certainly not the peer pressure that goes on today. For some special event at school, I remember spending what seemed like hours trying to trap the top of a

stocking in the suspender. I would never have asked for help for something like this. Not only would I have found it embarrassing, but I knew that I needed to be able to do these things when there was no one around to help me. My room-mates never asked if they could help when they saw me struggling, and for that I was – and am – grateful. With the exception of putting on stockings, I don't think I took longer to dress than anyone else. And those early struggles ensured that I did indeed learn to do pretty well everything for myself.

Getting one's first period was something that was not actually talked about but was nevertheless looked forward to. I watched other girls coming out of the school dispensary clutching packets of Dr White's sanitary towels – proving that they had 'started' – but it was not until I was fifteen that I was able to collect my own. For although I did not want to grow up, and starting to menstruate was an irrefutable sign that childhood was over, I longed to get my first period so as to be the same as my peers. Getting my first bra was equally memorable; I remember the pride – after a day spent shopping in London – of sitting at my desk with hunched shoulders in the hope that the strap would show across my back. I never remember worrying about how I would fasten a bra; I had seen my room-mates hook theirs at the back, but it seemed obvious and natural to me to do mine up in the front and swizzle it round.

However, perhaps I should be thankful that I did not grow up in America. It is far easier to cope with having one arm than to have a face that everyone stares at; much of the time my 'disability' goes unnoticed, but if your face is disfigured it is impossible to hide. Lucy Grealy, who grew up near New York, had half her jaw removed because of cancer; the experiences that she relates in *In the Mind's Eye* were markedly different from mine. She was made fun of at school, mostly by boys. 'The cruelty of children is immense, almost startling in its

precision,' she writes. However, different age groups evidently have different responses. When she was slightly older and working in a riding stable, no one asked her directly what had happened for three years.

I don't know how I would have coped had I been made fun of at school; no doubt I would have established some kind of defence mechanism. Lucy Grealy went through a stage of paranoia when 'every whisper I heard was a whisper about the way I looked . . . Partly I was honing my self-consciousness into a torture device, sharp and efficient enough to last me the rest of my life. Partly I was right: they *were* staring at me, laughing at me.'

In his book *Stigma*, Erving Goffman defines stigma as the situation of an individual disqualified from full social acceptance. Society certainly does have a way of categorising people and there is an assumption that to be a full member of that society there is a 'normal' way to be. When either a stranger or someone with a disability appears we are instantly aware of their differences. We tend to believe that a person with a stigma, in this case a physical deformity, is not quite human and in order to be more fully accepted there is a tendency for the person to try to hide the defect. Some stigmas are more visible than others, but it is up to the stigmatised person to put others at their ease.

This doesn't mean that an amputation or any other 'difference' should be ignored. In fact, with an amputation it is important to acknowledge and to give time to mourning the loss of a body part, but it is also important not to use the loss as a crutch or a vehicle for self-pity. A fine, but necessary balance. Because I had problems accepting my loss, by definition I could not use my loss as a prop, or cast myself in the role of victim. I believe that never having succumbed to the role of victim is something positive, so perhaps denial does have its merits.

The devaluing of those with disabilities is no new pheno-menon: most research literature on appearance has shown that what is beautiful is good, and that those who are beautiful are happier, more successful, more interesting, warmer and more sociable. In 'Objective Bodily Damage', in *Body Images*,[3] Norman R. Bernstein states: 'People with obvious deformities are disadvantaged in their social relations. A disfigured person is forcibly required to give more attention to his/her body image by his/her surroundings. People stare.' Being stared at is acutely uncomfortable – I'm rather prone to staring myself and I often find I'm doing it almost unconsciously. What is it about difference that we find so riveting? Is it that we want to know what happened? But why would we necessarily want to know what happened to a stranger? It's the same sentiment as slowing down on a motorway to gawp at a crash. Or is it *schadenfreude*? What is it that we want from others' mis-fortune? Bad news does sell – we know that from television and newspapers – however, it does seem to me to be a real flaw in human nature.

The Ancient Greeks, whose ethos was perfection, believed deformity was a sign of inferiority; the Hebrews treated those with a handicap as sinners and the priestly code of the Old Testament barred the physically imperfect from the priest-hood. Physically deformed babies were cast into the wilderness and the early Romans granted the father the right to destroy his imperfect child provided he got his neighbour's approval. However, perhaps things are changing; in a recent survey, when children were asked whom they liked best from a picture of a group of their contemporaries, including a physically handicapped child and an obese child, the obese child was chosen last.

Although the world is now becoming more homogenised, in the past the ideals of beauty were varied and to some extent

this still applies. In China the ideals of female beauty concentrate on the superficial (fluttering gestures and set mannerisms), the artificial (painted eyebrows, bound feet, coiffed hair), the peripheral (fingers, feet, fans) and the sartorial. Beauty is far more formulaic and there is even less room for manoeuvre than in the West. In Ancient China it was believed that defects of character could lead to body deformity; in one story greedy fisherfolk developed preternaturally long arms. In sixteenth-century China, the body was perceived as a replica of the universe, the four limbs representing the four seasons, and the Chinese had an expression for awkwardness – to act 'with seven hands and eight feet'. Missing a limb would not fit in with this ideal, but the Chinese are one of the few races who have never openly mocked the deformed; they believe that a person's fate is ordained by heaven and that the handicapped are usually provided with compensations. In nineteenth-century China, medical missionaries were only allowed to amputate a limb when they gave an assurance that the severed limb would be saved so that it could be buried with the body after death.

Did I use my arm as an excuse for a feeling of alienation? Adolescence is difficult enough without having a disability to add yet another dimension to those feelings of difference and awkwardness. In *Out on a Limb*, Louise Baker writes:

> The years from fourteen to eighteen are probably the darkest ones that a handicapped person must struggle through. Adolescence is not only a period of mercurial moods, it is also a period of great conformity . . . Adolescent boys are precisely the conformists that adolescent girls are. My male classmates all picked carbon copies for girlfriends.

Oddly, there seems little room for individualism in the modern world, although this has changed a great deal since

I was a child. Peer pressure is an extremely powerful force. I desperately wanted to conform and to be the same as everyone else but I was, although I could never have said it, an amputee. The word 'amputate' has a finality about it; if you cut something it can heal, but if you amputate a body part it's gone for ever.

As recently as the 1970s John Lennon recorded what would be now considered a politically incorrect version of Paul McCartney's *Yesterday* in which he inserts 'amputee' to rhyme with 'half the man I used to be'. Of course this was long before McCartney met Heather Mills.

The reality is that the loss of a body part is equivalent to the death of that part, and grief, depression and anxiety are the universal responses to that death. Denial is one recognised way of dealing with the bereavement; prolonged depression is another. When I was writing this book I did at times feel very depressed without understanding why. I was sent the following fax by a woman analyst I had met and with whom I had discussed the book and my depression:

> If you will allow me to say this: there will be a lot of sorrow you will have carried coming from the body. Memories of pain and despair are carried in the muscles and nervous system and these surface as that critical, destructive voice that is at the root of the paralysis of depression. If you make a friend of these memories and acknowledge what the body has had to carry, there will be less conflict and suffering. The body's instinctive response to life is joy, but if this impulse has been cauterised by an early experience like yours (affecting the sympathetic nervous system) there will be a lot of healing needed to take away fear and restore joy.

Of course there have always been people who have had to contend with missing limbs lost in battle or, in rarer cases, through disease or illness. A limb might be amputated as a punishment, as indeed is still the case for people found guilty

of adultery in Muslim countries. Are they given medical care afterwards? Hands were chopped off in the conflict in Rwanda between the Hutus and the Tutsis. Reading about these cases sets my teeth on edge – it's almost as if I can feel the victim's pain, shock and outrage, a real empathy. In her book *Too Close to the Sun* Sara Wheeler relates that in August 1917 more than 300 Russian soldiers shot off their left hands so that they wouldn't have to return to the front.

Despite the trauma of my own amputation I imagine my operation was fairly safe, which before the relatively recent discovery of antiseptics it would not have been. Amputations were performed successfully during the Mochican Empire in Peru which flourished in 500 BC – an extraordinary feat. Statues from the civilisation show people with amputated legs, noses and arms; the practitioners had somehow solved the

Apparatus for healing arm fractures, illus. from the 'Feldtbuch der Wundartzney' by Hans von Gersdoff c.1540. Woodcut by Hans or Johannes Ulrich Wechtlin (c.1480–1526)

71

problem of bleeding both before and after an operation. In most countries this was still a problem two thousand years later when, to avoid haemorrhages, amputations were only performed if the limb was gangrenous. We don't know why the Mochicas used to amputate, whether as a punishment or to cure disease, but the sculptures, which also show people with illnesses or deformities such as tumours, leprosy, blindness and obesity, show an extraordinary psychological expressiveness and realism. How the Mochicas managed their operations remains a mystery. We shall probably never know whether they had discovered cauterising or practical ligaturing; how they made the pain bearable or how they coped with the shock which often follows amputation. It is possible that they used the coca plant as an anaesthetic, but how they managed to avoid infection is another unknown.

Infection was still killing amputees a hundred years ago in the West. Until recently, in most cultures, medicine did not have the know-how to deal with the after-effects of an amputation, such as excessive bleeding, gangrene and shock. There were exceptions. In the Indian classic the *Rig Veda*, composed in the second millennium BC, there is a reference to 'sages' who accompanied wandering Aryan tribes with healing herbs. They used these herbs to heal the stumps of amputated limbs and used the soma plant to alleviate pain. They also knew the importance of cauterising wounds.

We know that the Ancient Greeks had learned to use tourniquets, surgical drains and wine or vinegar for antisepsis when embarking on an amputation. Hippocrates of Cos (460–380 BC) wrote an essay called *On Joints* in which he describes amputations, but in the first century AD a Roman, Celsus, describes amputation, saying that it 'involves a very great risk for patients'. So it seems that the Romans were possibly already losing the medicinal art acquired by the Greeks. There is a painting in the Wellcome Foundation attributed to the Master

SS Cosmas & Damian performing the 'miracle of the black leg'
attributed to Master of Los Balbases, early sixteenth century

of Los Balbases, Burgos, *c.*1495, showing St Cosmas and St
Damian, the patron saints of doctors, whose dates are unknown
and who practised medicine without asking for fees, grafting a
black leg on to a white man's body. The miracle is the painless
amputation of the ulcerated leg of a Christian verger, and the
substitution of the undiseased leg of a dead Moor.

73

In the fifth century AD it was recognised that sedation was necessary before an operation. 'If anyone is to have a member amputated, cauterised, or sawed, let him drink an ounce and a half of mandragora in wine, and he will sleep until the member is taken off, without either pain or sensation.'[4] And yet in Europe, at the beginning of the nineteenth century, amputations required brute force; for an amputation at the shoulder, an assistant or friend would support the patient at the shoulder, while another stout body held a sheet to support him against the pressure of the surgeon: 'It requires decision and rapidity; and the knife is to be handled more like a sabre than a surgeon's scalpel.'[5]

Although I was 'incomplete' in the eyes of the world, physically I didn't *feel* incomplete. I had a phantom limb. Jill Ker Conway wrote in her book *True North* that when she first met her husband, who had lost his arm in the Second World War, he had 'the proper low-key British approach to his war injuries (clearly visible in his empty right sleeve) . . . I asked him how he came to be so severely wounded, and what it had been like to cope with life with one hand.' Later, when she had got to know him better, she writes about ' . . . the nervous energy consumed by ignoring the difficulties of life without a right hand, the bizarre but persistent experience faced by all amputees of a "phantom limb".' The experience of a phantom limb can in a way be strangely comforting. In Oliver Sacks's book *A Leg to Stand On*, when he has an accident he feels that his broken leg is missing:

> I had lost my leg. Again and again I came back to these five words: words which expressed a central truth for me, however preposterous they might sound to anyone else . . . I was now an amputee. And yet not an ordinary amputee. For the leg, objectively, externally was still there.

My phantom hand, rather than whole limb, feels more hand-like than my real hand. Being aware of one's body parts is atypical; it is often only when you hurt yourself that you are conscious that your knee, hand or toe is there. A phantom doesn't give you that escape. It is a constant reminder that the body part you once had, an arm in my case, exists or rather existed. This can be reassuring; I am often deceived into thinking that I still have two arms. In *The Body in Question*, Jonathan Miller writes: 'It is as if the brain has rehearsed the image of the limb so well that it insists on preserving the impression of something that is no longer there.'

Over time a phantom usually changes shape and gets smaller and, although I am not really aware of it, my phantom has probably shortened and now it is almost as if it is within my stump. If I had worn a false arm the likelihood is that my phantom would not have shortened because my body would have been tricked into thinking that I still had a full-length arm.

Often only islands or bits of missing limbs are felt, for example just the thumb or index finger instead of the whole hand. In my case, although it is the thumb that is the prevalent part of the phantom, if I concentrate hard on my phantom hand I can conjure up my other missing fingers. Phantom limb experiences vary considerably, ranging from a precise and distinct replica of the lost body part to a transient, vague, tingling feeling. The feeling of my phantom does not bother me; it is like mild pins and needles, but I gather this is rare after nearly fifty years as phantoms often disappear with time, although sometimes they can reappear. My missing left hand feels half clenched and, if I focus on it, I feel as if I can open my fingers very slowly, stiff with long-term disuse. Ishmael Chambers in David Guterson's novel *Snow Falling on Cedars* has a phantom limb:

The stump of his amputated arm throbbed, or more

precisely it was as if the arm were again but half-numb, a phantom limb. His brain apparently did not fully grasp – or still disbelieved – that the arm was gone . . . Whatever there was to feel in his arm, pain or anything else, he wanted to feel it, he didn't exactly know why.

Phantoms can often be rigid, and in the position the limb was in when it was lost, almost as if the phantom is trying to preserve the last moment in which the limb was still present. It is said to be important that the limb to be amputated is not bent in an unnatural way during the operation, as this can affect the pain of a phantom limb – of course no such niceties can help someone who loses a limb in an accident or in war. Seymour Fisher writes in *Body Image and Personality*: 'The amputee somehow resists picturing his mutilated limb as it really is and persists in holding on to a picture of his limb as it previously was.' And indeed why not? Nelson evidently suffered a good deal of pain, having agonising spasms in his stump and complaining to Sir George Magrath about the 'coldness of the knife' and in a letter to Sir Andrew Snape Hamond that 'I suffer a good deal of pain, owing to cold falling on it' (*The Dispatches*, Vol 2, 8 September 1797).

Our bodies take time to adjust to such changes; it is almost as if the phantom is the outward sign of the inner difficulty in adapting to a sudden defect. I find that reading or writing about phantom limbs makes me very aware of the presence of my own phantom limb, the pins and needles feeling increases in intensity the harder I think about it and becomes more like a crawling-ant sensation, whereas for most of the time I do not notice it. The feeling of the phantom is increased by internal stimuli such as yawning, defecating or having an orgasm, and most amputees have associated movements in the healthy leg and arm when ordered to move their phantom. The phantom limb can also itch and feel prickly, but the itch is permanently

just out of reach which can be incredibly frustrating. There was a case of a paraplegic patient who had full sensory loss but when he subsequently had a leg amputated he experienced a phantom limb.[6]

Phantom pain can be agonising; the sixteenth-century army surgeon Ambroise Paré was the first person to describe it. It is unrelenting and sometimes can become intolerable. It can be so bad that some patients contemplate suicide. Seventy per cent of amputees suffer phantom-limb pain and it is often because of the pain that the phantom limb feels more real than a real limb. Sometimes the pain is such that it can be a real hindrance to successful rehabilitation; descriptions of it bear little or no resemblance to any previous sensory experience. The limb often feels as if it is in a painful, distorted position – 'It's like my nails are digging into my phantom hand . . . the pain is unbearable'[7] – and there is often a feeling as if the hand or foot is squeezed and fingers or toes clenched. In an amputation, with the cutting of the nerves which has to take place, it is not surprising that the pain has been variously described as a feeling of sore spots, a stabbing sensation or like an electric current; it is the most radical form of nerve injury possible. Think about it. When a limb is amputated, all the nerves are cut; just imagine the pain of that. Some people suffer from 'nerve storms', with attacks lasting up to two days. Occasionally I have an acute stabbing pain of almost unbearable intensity, but it only lasts a moment and is thankfully very rare. The ulnar nerve in my right elbow once shifted out of place, and when it caught on my sleeve or I knocked it, I literally screamed with the pain. The thought that some people might have to bear this kind of pain habitually is almost unthinkable. Perhaps unsurprisingly, bitterness and self-pity are more evident in those who suffer from phantom pain.

There is very little that is effective in getting rid of phantom pain. Acupuncture can sometimes help, and also drugs that are

used to counteract epilepsy and depression; a combination of an antidepressant and a narcotic like methadone can bring relief, but often they have no effect on the most severe pain. In an article in *Scientific American*,[8] Ronald Melzack wrote:

[The] phenomenon of phantom limbs is more than a challenge to medical management. It raises doubts about some fundamental assumptions in psychology . . . we do not need a body to feel a body . . . In short, phantom limbs are a mystery only if we assume the body sends sensory messages to a passively receiving brain. Phantoms become comprehensible once we recognise that the brain generates the experience of the body. Sensory inputs merely modulate that experience; they do not directly cause it.

Farabloc, a new anti-pain product invented by Frieder Kempe, sounds hopeful and has proved very successful. It looks and feels like an ordinary piece of linen but contains extremely thin steel fibres. It works through a shielding effect which protects damaged nerve endings. It stimulates blood circulation, aids muscle relaxation and can be applied for muscle strain and some arthritic pains.

Despite the scientific recognition of phantom pain and the testimony of many thousands of amputees, including myself, the *Canadian Journal of Psychiatry* published an article in the 1980s stating that phantom limbs were the result of wishful thinking. Of course it must be hard to imagine if you have never experienced it, but that should not deny or question a phantom's existence. As happens with many symptoms which doctors haven't experienced themselves, amputees are often told by their doctors that their phantom pain is pure imagination. Patients want logical explanations for something which is so real, and do not like being told that their pain is 'in the mind'. Nelson believed that his phantom limb was proof of the existence of the soul; if he could lose his arm and still

feel it, he felt sure that the whole person would go on existing after the body was dead. For Descartes phantom limbs were 'useful proof of the way that the body can trick the mind: the body's deception is what produces the moral superiority of the thinking self ' (Ann Oakley, *Fracture*).

V. S. Ramachandran, author of *Phantoms in the Brain*, believes that the phantom might arise as nerves reorganise themselves in those parts of the brain which are maps of the body (a quarter of the brain's body map is devoted to the hands); he has done experiments aimed at eliminating phantom-limb pain by using a virtual-reality box made by placing a vertical mirror inside a cardboard box with its lid removed. The patient is then asked to place both the good hand and the phantom hand side by side through holes in the box; the mirror gives the illusion of two hands. As a result of this experiment, paralysed phantoms have been known to move and painful phantoms have hurt less. He has even performed the successful amputation of a phantom-limb with this method.

Many neurologists have seen phantom limbs as the manifestation of a central body image process.[9] Some were so convinced of this central origin, and also of the precise brain localisation of phantom sensations, that they attempted to relieve painful phantoms by the removal of the equivalent part in the brain. Some of the patients operated on in this way obtained relief, but the overall results were inconclusive.

People born without limbs can have phantoms of absent structures, although this is unusual. Bernard Schoenberg's results show that children born without limbs, or those who have an amputation before the age of six or seven, are unlikely to have phantoms,[10] although this is disputed by Ronald Melzack.[11] This is probably because before that age a child does not yet have a convincing body map. At ten I was just older than that, but I am not sure whether I have always had a phantom arm. I suppose I have, but since the first ten years of

my life with only one arm were lived in a denial of the reality, I cannot be certain. I would never have admitted to having a phantom limb or phantom pain, and indeed no one asked me, but at the same time the feeling of having a phantom would have been reassuring. There is a suggestion that a reluctance to let it go completely may be one of the reasons for feeling a phantom limb. I would have felt my arm was still there. The change came when I went to America where I acknowledged my loss of arm and its phantom presence for the first time.

Schoenberg goes on to say that if the mourning process for a lost limb is unresolved, complications such as a persistent phantom, the denial of a phantom, or a painful phantom might occur. But he says that this phantom pain, however intolerable, may actually be keeping anxiety and grief at bay. No matter how distressing the physical pain, it may be easier to deal with than the emotional pain that can be experienced after an amputation. The sheer intensity of phantom pain does not allow time for any emotional pain. And so the re-entry into 'normal life' after an amputation trauma can be indefinitely delayed by an unconscious attachment to physical phantom-limb pain. All I wanted when I came out of hospital was for life to go back to what it had been like before. This would help explain the contortions of agony I felt whenever anyone did ask about my arm. My world view was that I was no different from what I had been, or from anyone else. Questions on the subject exposed this myth. Silence preserved it.

Some of the latest research has shown that a general anaesthetic does not stop the body feeling pain. Therefore, if an amputation is performed, the brain registers the pain at the time of the operation and this persists as phantom pain afterwards. However, if a local anaesthetic is given as well, it prevents the nerves from sending pain messages during surgery, and there is far less risk of phantom pain. In a study in Denmark half the patients were given painkillers and a nerve

block three days before surgery, and half were treated normally. A week after surgery only three of the eleven patients who had had the pre-surgery painkillers and nerve block had phantom-limb pain, compared with nine out of fourteen in the untreated group. A year later there were still clear differences. In *The Textbook of Pain*, Professor Patrick Wall writes: 'It seems that after an operation the body is still reacting to the pain it felt during surgery. But if you can prevent the nerves from getting excited in the first place you can limit or get rid of the delayed pain.' There are several rather convincing case reports that suggest that post-amputation pain is more likely to occur in patients who had pain in the limb before amputation and the pain is often the same kind of pain. Personality type seems to affect it too: rigid self-reliant personalities are more likely to have persistent pain and depression.

Another disorder is alien-hand syndrome, a rare condition which can occur after a stroke and leaves the patient with one hand which acts in a completely different way from the other. This makes simple tasks like getting dressed a complete night-mare. While one hand will be pulling up a pair of trousers, the other will sabotage the attempt and pull them down again. Supermarket shopping turns into a horrendous ordeal: an object taken off the shelf by one hand is immediately put back on the shelf by the other. Usually part of the brain has had a lesion; the condition can sometimes improve slowly, but I never saw it suggested that amputation might be a solution, something I would have thought preferable to the constant battle between left and right.

There is probably some merit in considering a limb's final destination. V. S. Ramachandran quotes a case in *Phantoms in the Brain* supporting the theory that what happens to amputated limbs is important, and a belief which goes back thousands of years is referred to by Sigmund Freud in *Totem*

and Taboo: that there is a magical bond between the wound and the weapon that inflicted it. In my own case the 'weapon' was the surgeon's knife and my wound, which has now settled into spasmodic phantom-limb pain, does indeed have a metallic edge to it. No matter how hard I try I cannot conjure up any affection for or attachment to the instrument that cut off my arm but I suspect that the knife – or was it a saw? – that was used in my surgery had already been used on other people and probably went on to be used on many more. I do, however, feel a strong link with and almost fondness for the surgeon who performed the operation, something that according to Pliny might explain my lack of pain. In his *Natural History*, Pliny observes: 'If you have wounded a man and are sorry for it, you have only to spit on the hand that gave the wound, and the pain of the sufferer will be instantly alleviated.' What harmed you can also heal you, as a proverb states: 'The hand that gave the wound must give the cure.' If the cut-off limb is maltreated, the person may feel the injury. If my arm was burned in an incinerator, as I suspect it was, did this make the pain after the operation worse? J. G. Frazer in the *Golden Bough* writes that 'things which have once been in contact with each other continue to act on each other at a distance after the physical contact has been severed'. Therefore some believe that the fate of the severed limb continues to affect the person of whom it was once part. Psychics claim to see auras of missing limbs and in esoteric terms phantoms are regarded as 'subtle, astral or etheric'. William James[12] felt that even with congenital defects of the extremities a phantom limb might be felt in an ancestral way. In his book *Seven Experiments That Could Change the World*, Rupert Sheldrake, who has done many experiments on people with phantom limbs, says that if the mind is extended within and beyond the body, there is no need to confine the body image to the brain or even the nervous tissue; it exists beyond the stump. He believes that

the body is organised and pervaded by fields and there is an inherent memory as well as a collective memory. He regards the fields of phantoms as morphic, and proposes that the fields are located just where the phantom seems to be.

Evidently leprosy sufferers do not have phantoms. This would seem to suggest that since with leprosy the body changes gradually, the body schema can keep up with alterations in body shape over time. With a sudden amputation the body schema is left way behind and a phantom results; its persistence indicates how long re-learning takes under these conditions.

Unlike Sacks, whose condition was temporary, I rarely feel the lack of an arm in a physiological sense. Sacks implies, in a sweeping generalisation, that all amputees have a disorder of body image: 'Patients with strokes, with paraplegias, with severe neuropathies – phantoms of amputees; patients with various pathologies and injuries, but all having in common severe disorders of body image'. I don't agree. I seldom feel that my body is incomplete and I do not feel a 'disorder of body image'. If I'm struggling with a huge number of parcels, I might curse and swear but I rarely think, 'If only I had two arms . . . '. Maybe my feeling of completeness is because of my phantom limb, and maybe because I grew up having only one arm my body feels complete to me. However, possibly my body only feels complete if I am not thinking about it.

Having two arms was something I had taken – as I imagine most people do – completely for granted. As with many things, it was only through the experience of being separated from my arm that I realised what I had lost, and this took time. Father Laurence Freeman OSB said in a talk a few years ago at the Monastery of Christ the King, Cockfosters, that, 'We define ourselves by what we have lost.' The chord that this struck with me was inevitably that of my own physical loss and I began to think about the possible ways in which I defined the world differently.

Getting to Grips

For the amputee, dealing with the world is not just about conquering a physical disability. That bit is easy. A disability needs time, and the first step after such a trauma is to try to encourage the inner world to adjust to the disability. This might take years. What happens in the outer world is a process of re-learning how to do practical things and – which is much harder – learning how to deal with people. All my life it has been people, rather than situations, that have brought me up short and unsettled my belief that I am the same as other people.

When living with a disability it is fundamental to try to live without the fear of what other people might think. Bernie Siegel writes in *Love, Medicine and Miracles*: 'Getting well is not the only goal. Even more important is learning to live without fear.' I have a poster of the Burmese Nobel Prize winner, Aung San Suu Kyi, which reminds me: 'Fear is a habit. I'm not afraid.' Maybe it was the experience of near-death – albeit unconscious – which has shown me that there is nothing in life to be really afraid of.

However, fear is a two-way deal. Most people, through fear, do not know how to react to people who have had a recent bereavement. This applies to an amputation as much as to a death. People feel awkward and afraid and cannot cope with hearing the truth, or about the possible pain; as a result, the recent amputee has to pretend that everything is fine. Both parties become game players. The concerned but fearful questioner will often tell the amputee about somebody else's

illness or other worst-case scenarios – how well these strangers have managed their disabilities and how they have climbed Mount Everest, won an Olympic medal or swum the Channel. The recipient of these 'consolations' can do nothing except agree that they too will try to conquer their disability and that it's not too bad really. I don't want to downgrade the achievements of such determined people, but their conquests are not the kinds of things you want to be told about. Sometimes you just want people to understand that losing a limb can be bloody awful, that you need to rant and rave about it, and that you don't always want to be positive and have to agree that by next year you too will be attempting to climb a mountain.

Sometimes it is important not to be helpful in the face of a tragedy, but to acknowledge powerlessness. Achievements do not alter the fact of disability. In her book *Perspectives for Living*, Bel Mooney quotes Anna Haycraft: 'I suppose if you lose a limb you come to terms with it but it's never going to come back.'

In a similar way the grief of tragic events does not disappear, but it can make you look at life in a new way. This is an individual's choice. An extreme example of learning to look at life in a positive way, whatever it throws at you, occurs in *Grace and Grit* by Ken Wilber; he said of his wife Treya who was dying of cancer: 'Death, if anything, is the condition of having no future. By living in the present, as if she had no future, she was not ignoring death, she was living it.' Treya herself said: 'Because I can no longer ignore death, I pay more attention to life . . . Exceptional patients don't try not to die . . . they try to live until they die.' Death, after all, is only a passage.

Although I had no role models, and indeed would have hated it if I'd been told that 'so-and-so with one arm can do X or Y', I became very adept at working out how to do things on my

own. Children are extremely adaptable and, with my parents encouraging me to do everything by myself, I soon learnt that there was nothing I couldn't at least attempt to do on my own.

Certainly on a day-to-day basis there is little I cannot do, but people I know sometimes try to imagine what it must be like to have one arm and list the things that they think they would find difficult. These are mostly things I would never even think about, such as cleaning my teeth, driving a car, typing, swimming or opening bottles of wine. When I had to do these things for the first time, I must have had to use my imagination to find a solution. That is one of the reasons why I think that it is easier for a child to adapt; my first attempts at so many things were all done with one arm, so although I may have had to exercise creativity and lateral thinking to invent a specifically one-armed approach, I did not have to unlearn and re-learn new methods. Now I do all these things without any difficulty – in fact, I don't even think about them. On a practical level, I don't know what I'd do with another arm – I feel that it might even get in the way – and as for how I look, my body map has so adjusted to the absence of one arm that I feel it would take a lot of readjusting to know that people would be looking at me differently. Of course there is a part of me that would love to be able to hug people properly, and not to have to contend with stares and stupid questions. It would be a fascinating experiment to live the last years of my life as a two-armed person, mostly in order to gauge other people's reactions. Having another arm now wouldn't change the person I have become, or detract from the battles I have had to fight, so I would be able to keep the benefits I have accrued.

I tend to use my teeth a lot to hold things – much to dentists' dismay – but I do it automatically and reckon I know instinctively how much pressure to exert. Toast can tend to scoot round the plate while it's being buttered, but the trick is to try to use soft butter and only to put it on a small part at a

time, while the little finger can prove useful as an anchor for a particularly recalcitrant piece. Not having my left arm means that I cannot touch most of my right arm, so if I want to massage cream on to my hand or elbow, I have to put the cream on to one of my legs and rub my arm against it, using that part of my leg as my other 'hand'. I file my nails by holding a nail-file in my hand and twisting it round (although an unthought-about bonus is half-price manicures!). Hanging a picture used to be a question of willing the nail to stay in the wall until I reached for the hammer – then I thought of sticking the nail to the wall with Blu-Tack and suddenly it was easy.

I'm glad I wasn't taught how to do any of these things and found out how to do them myself; that approach has continued into the present and into all parts of my life. I have always maintained that the best way to learn how to use a computer or the Internet, or to do accounts or anything new is to teach oneself. Fear of new things is something I often notice in other people. But there is nothing to be afraid of. It's only now that I see the link between having had to work things out for myself as a child and having continued to do so as an adult. I have an innate confidence that I will be able to teach myself anything I want. When you have to think of ways round practical problems for which most people have a model or example, it means that you automatically think laterally, and this has huge benefits for every new life-situation, whether it be putting toothpaste on a toothbrush (I hold the brush under my stump), learning how to construct a website or working out how to solve a problem. This ability to think laterally, and to have a different approach from most people to everyday problems, was something I hadn't really thought about until recently. But it is an extremely positive aspect for anyone who is 'different'.

Having some kind of disability means spending time, albeit unconsciously and in all kinds of subtle ways, making oneself into someone who is able to cope in a world geared to the able-

bodied. This affects all areas of life, from self-image to practical tasks, and to assessing other people's reactions which are often curiously negative. My self-image was helped by my denial. Believing that I was the same as I'd always been was good for the ego, but would often leave me bemused and hurt when other people so blatantly thought, both then and now, that I wasn't. One of the hardest things was trying to gain enough self-confidence not to mind the insensitive reactions of other people. A friend remarked at a funeral that of course she'd always thought of me as an outsider. Me, an outsider? I was outraged and, subsequently, depressed. I had always thought I fitted in so well. But other people, who were the ones who counted, obviously didn't think so.

The constant necessity to prove that the 'disabled' person is capable of the simplest tasks means that so much of life becomes a struggle. When I was growing up I was so in awe of authority that I believed it when I was told I couldn't do certain things, like wash my hair or tie shoelaces. Other things which I was told I couldn't do of course I knew innately that I could, but it all made everything just that much harder. My parents assumed I could do most things; it was other people who thought negatively of my abilities. Every time someone said I couldn't do something it underlined the fact that they knew I had one arm, and of course this I didn't want to accept. It was always push, push, push; no wonder all I wanted to do at times was curl up in a ball and hide.

As a child, going to the theatre was a nightmare. One friend remembers that I needed help putting on my glasses at the theatre (I can't imagine why) and that I would reach across so that she could help me, rather than having to ask the boy next to me for help – we often sat boy, girl, boy, girl at these end-of-holiday 'treats'. Worse still was the friend who insisted on sitting next to me so that she could 'lend' me one of her hands

to clap with. I found this acutely embarrassing but, feeling that it was churlish to refuse, I would go along with the charade of being grateful. I only wish I had known then about the Zen art of 'one-hand clapping'. There is one advantage – I can never inadvertently clap in the middle of a piece of music, which people sometimes do.

The sort of thing that never happened at school occurred in the holidays: at a smart dinner party, in my teens, one of the waitresses whispered to me, 'Your food is being cut up for you in the kitchen.'

I mumbled thanks.

'Don't you want anything to eat?' asked one of my young neighbours.

'Here, take my plate,' said someone else. 'I'll get another – they must have forgotten you.'

'No, it's all right,' I mumbled. 'It's coming later.'

'Why? I don't understand,' persisted the boy on my right.

'Oh, I see,' said the boy on my left, obviously having just noticed that I had only one arm. He glared at my right-hand neighbour. I was left feeling utterly miserable – speechless anyway in front of boys – and the fact that my lack of an arm had been noticed compounded my feelings of inadequacy. I suppose it was considerate of my hostess to think of cutting up my food for me, but I hated her for it; I would rather have struggled using just a fork than go through this kind of agony.

In *Physical Disability, A Psychosocial Approach*, Beatrice Wright says, 'Serving steak to someone unable to use both hands because he or she should be treated like anyone else would more certainly call attention to the disability than had a more manageable main dish been planned.' However, if I had ever discovered that a menu had been chosen with me in mind, I would have felt mortified. And I would have had to express gratitude whilst silently hating those who were acknowledging my lack of arm.

Now, on the whole, if I am in a restaurant and feel like eating a steak, I will go ahead and order it and ask my companion to cut it up for me. I have discovered that there is an immediate intimacy in asking someone to do this. On one occasion, while having dinner with an old friend, I did order steak and he began to cut it for me. We were both completely thrown when the waiter came up and asked if he was cutting my meat for me because I was a baby (this theme of asking for help branding one as a baby seems pervasive). But there are still times when, depending upon who I am with, I will order something which does not need cutting. If I am at a dinner party, seated between two people, and there is something that needs to be cut, I usually instinctively know who I will ask. Sometimes it is just a matter of asking the person to whom I am currently talking, but if I feel that that person might feel awkward about it, I have to manoeuvre the conversation so that it becomes possible to ask my other neighbour without the first person feeling marginalised.

Handstands and cartwheels would seem to be impossible with one arm, although when you watch something like the *Cirque du Soleil*, you realise that almost nothing involving the human body is impossible. I certainly do not sit around moping because I cannot do handstands or cartwheels, but I do sometimes feel a pang of envy when I see someone doing a handstand and wish I could at least have tried it. If I had two arms I would be unlikely to be turning cartwheels round Hyde Park, but I do miss knowing what it would feel like.

As I had to start learning to live with one arm as a child, most of the methods I used, both practically and emotionally, were instinctive. It is only now, fifty years later, that I have discovered that I coped by using universal mechanisms. On the emotional front, I had thought I was unique in wanting to deny the reality of an amputation, in not wanting to be helped, in feeling the necessity of becoming fiercely independent and in

not wanting to be considered different. But I now know from my research that I was not unique, that these are all common and widespread reactions. However, I would probably have hated to be told that the things I was feeling and doing were 'normal'. I *knew* that no one could understand what I was going through, and I did not want them to. I needed my feelings to be unique.

I have found that learning how to deal with this independence has been a constant battle running through my adult life. I know that my seeming competence and control can often frighten people, and I still find it hard to ask for practical and emotional help. I feel asking is a sham, almost as if by asking I am consciously making myself pathetic. I can empathise with Louise Baker, whose autobiography *Out on a Limb* is a lively account of how she learned to live with one leg: 'In my childhood and teens, I am sure I was very rude in my constant huffy refusals of any kind of aid. I have grown more mellow, more sensible, and, I believe, more kindly.' She rightly concluded: 'People simply glow with pleasure when they help the handicapped, and I have a theory that it is only decent to let them have their silly fun.'

As if endorsing my own reluctance to ask for help, Beatrice Wright writes: 'The person with a disability is sometimes in the position where it is necessary to ask for help. If receiving help signals devaluation, not only will one defer asking until help becomes absolutely necessary but the request will be made self-consciously or at best apologetically.'[1]

There is always a dilemma, too, in not being able to distinguish between people's reactions to me as a woman as opposed to as a woman who has only one arm. When I was younger, and sometimes even now, I would leap to my feet on a crowded tube for anyone older than me or anyone struggling with children. Although I know that it is unusual now for a woman to be offered a seat, and I have only rarely been offered

one, I often wonder, as I hang on to a strap, try to read a magazine and struggle with packages – recently I was even carrying a crutch – all very obviously with one hand, what has happened to any kind of thoughtfulness or courtesy. People damaged by thalidomide were refused exemption from the congestion charge. A reporter followed one man with tiny arms on to a crowded tube where he was unable to keep his balance or hang on to a strap; not a single person helped or offered their seats and Ken Livingstone's office was reported as saying that there were to be no exceptions to their ruling.

With any kind of disability, there are many things that you have to fight just that little bit harder to achieve. About twenty years ago I wanted to learn to scuba-dive. I tried several organisations in London but the moment they heard that I had only one arm they refused to teach me. I might well have given up at that stage, but I had a friend who was so incensed on my behalf that she found a teacher for me. I did the basic pool training with him but did not have time to qualify properly by doing the open-water dives. This did not stop me diving in Key West, Belize and Australia, but it was always a hassle to prove that I could dive and I determined to qualify properly by getting my Professional Association of Diving Instructors card one day. When I tried more recently I had no problem finding an organisation to teach me. I started again from scratch; the first weekend was spent in a swimming pool in Bayswater. This was boring but bearable; the open-water dives done in a quarry pit in Leicestershire were a nightmare. Most of the skills required to get the PADI certificate are easy enough to do with one arm, but I knew that I would find taking off the weight belt and putting it back on, twenty feet down in a murky quarry pit on a freezing November day, impossible; I said so. I was allowed to have help with the weight belt for the test and went on to get my certificate. In the car park at the quarry pit, where there must have been at least five hundred cars, the man in the

Kitted out for diving in the Red Sea

car next to us also had one arm. I asked him how he had managed to cope, and he said a friend helped him on and off with his weight belt and to carry his tank, and as he would never go diving alone, which no one ever should, he had never had any problems. When I first wore a wetsuit I could not understand why I always felt cold. I soon realised that cold water was getting into the suit through the empty left sleeve and was flooding over the rest of my body. Tying the sleeve tightly with a piece of string solved the problem.

The following folk-tale, *The One-Handed Girl*,[2] demonstrates the perceived difficulties of living with one hand, notwithstanding its happy ending. A boy cuts off his sister's hand

when he is chopping down a pumpkin tree, although she had warned him: 'If you cut down the pumpkin you shall cut off my hand with it.' Having bathed her arm and put healing leaves on it, she hides from her brother in the woods and at night she climbs a tree to hide from lions and panthers. When she realises that she will find it difficult to earn a living with one arm, her courage fails her and she starts to cry. A prince finds her crying in the tree and asks her to go home with him. She says: 'I cannot come home with you for I do not like anyone to see me.' The prince then calls for a litter with curtains for her and when he gets back to the palace tells his parents that he wants to marry her: 'For no other woman pleases me as well, even though she has but one hand.' The story says: 'Of course the king and queen would have pre-ferred a daughter-in-law with two hands,' but they agree to the marriage. The girl's brother finds out about this and is furious and jealous and lies to the king about the reason that she has only one hand, resulting in her being dismissed from the palace. She makes friends with a snake who leads her to a lake; her baby disappears into the waters of the lake and the snake tells her to put her handless arm in the water to find him. She says: 'What is the use of that when it has no hand to feel with?' But she does what she is told, and the moment her handless arm touches the baby, her hand grows back. When the prince eventually finds her again, he does not recognise her, because she has two hands.

I didn't read this until I was much older but I know that I would have hated the story had I read it as a child. If I had been given it I would have wondered why, and been hugely upset that I was being compared with the maimed girl, and I would have resented the princess whose hand grew again when I knew mine never would. Or maybe it would have given me some kind of false hope that my own hand might have grown back too. But now I understand the psychology of the story.

I think that if you are constantly told that you can't do something but you know instinctively that you can, in a paradoxical way it can make you very strong. I don't know about the psychology of this, but what I do know is that the older I get the more powerful my core belief in myself has become, and the more determined I am to prove to the world that there is nothing I cannot do. This struggle can be exhausting at times; but if you stop pushing for even a short time, the pity of other people tends to start flooding in. I have been advised not to carry anything too heavy as this inevitably puts my body out of kilter. But, paradoxically, if someone asks me to help them carry a heavy bag, I usually do so. I would find it extremely hard to say, 'I'm not allowed to,' whilst watching them struggle. One of the few times I have refused was at an airport with one of my goddaughters and her mother. I always travel with things I can manage but there was a heavy bag – not mine – that needed carrying.

'I'm not going to carry it,' I said.

'Why ever not? You've got a free hand,' said my twenty-five-year-old goddaughter.

'Because as you know I've only got one arm, and I have been advised not to overuse my remaining arm by carrying heavy things. Anyway, it's not mine.'

'Well, I've only got one back,' she retorted. 'So why should I put that at risk?'

Unquestionably the feeling of being able to do anything – I used to force myself to do banal things like going to the cinema or concerts on my own, or to eat in a restaurant alone (something many of my contemporaries still wouldn't dream of doing) – adds to the richness of my life. It is one of the more positive aspects of having one arm, although the downside is that I have a certain intolerance of people who persist in saying they cannot do X or Y and refuse to try or to change

95

their ingrained attitudes of resistance. I discovered that learning to take risks could be stimulating and exciting; there is something very British about not taking risks, probably to do with the fear of ridicule and failure. By risk-taking I mean anything from making a difficult telephone call to starting a business; I am not talking about climbing Mount Everest or sailing up the Amazon.

Disability can certainly be used as a hook on which to hang inadequacy; often when a disability is 'corrected' the person who has leant on their disability feels cast adrift. How do they cope in a world where they are now 'normal'? There is safety and reassurance in the known, and that includes being different if that is what one has been familiar with; coping with the known is always easier than having to deal with the unfamiliar. Although swimming might have been thought of as difficult, I was told by my parents that of course it wouldn't be a problem and so, as I was determined to live up to their expectations of me and to my unconscious expectations of myself, of course it was not. Even today, when I tell people that I swim regularly, they often look amazed and ask how can I possibly swim in a straight line and why don't I go round in circles? I never doubted my swimming abilities. In a letter to my parents from school I wrote: 'Next Wednesday is my bronze life-saving exam. I think I can do the swimming bit, but the hard thing is land drill and answering questions.' I was consequently flabbergasted when I was talking to a man about swimming and as he knew where I swam, he asked if it hadn't been suggested that I join the disabled swimmers' club rather than swimming when I wanted. This remark silenced me and I just stared at him.

This sense that I was able to do anything I wanted was a valuable lesson and has stayed with me. Of course there are things I don't like doing and dread, but often I only have to take a deep breath and I find that most things are possible or at

least try-able (an exception is heights; my vertigo unfortunately gets worse the older I get, and it seems to be one of the few things I cannot talk myself into conquering). So, having really thought through what I can and can't do, I find it doubly distressing to be refused help when I ask for it. However much I think I have adjusted, and however little thought I give to having one arm, there are still people and situations that totally throw me. A few years ago I was carrying a pile of books in the Reading Room at the British Library and I asked a member of staff if he would please open the door for me. He refused. I explained that I only had one arm and that it was impossible for me to pull open the door while carrying a pile of books, and he still refused. Even after forty years with one arm this incident made me feel angry, certainly, but also dreadfully upset. I wish I could have just felt angry, and made some cutting remark, but it was the tears that prevailed. However, more recently in the new British Library a member of staff noticed that I had one arm and asked whether it would make it easier for me to be able to take my bag into the Reading Room where bags are not normally allowed. I accepted with alacrity and now have a letter giving me special permission to do so.

A while ago I was in a garage buying a new bulb for my car headlight. I paid for it and asked the man behind the counter to undo the difficult packaging for me. Packaging is one of my biggest daily nightmares – some of it seems to have been designed with maximum inconvenience in mind. The man refused: why did I need help? I explained that I had only one arm and he still said no. Again, instead of feeling angry, I felt hurt and upset. However, someone in the queue heard all this and offered to undo the packaging for me.

Back in the early days, I did succumb to minor feelings of paranoia. I felt that there was a conspiracy of silence and that people were not telling me the truth. Which, of course, was

the case. It was not that people were lying to me; it was that I had never been told what had happened. The not-knowing what had been wrong with me and why I had had to have my arm amputated made me panicky and became more and more of an obsession. When I was in my late teens it was something I did not know how to deal with and I felt that I could not ask about it.

Writing about these things now makes me wonder about this teenage creature who seemed to think that the whole world was interested in her and her one arm. Undoubtedly my obsessive feeling of not wanting to be thought different was heightened by my inability to talk about having one arm. It was not until I was nineteen that I plucked up the courage to ask my parents what had happened. During the whole of one long car journey I tried to bring myself to speak. I dug my nails into my hand and made vow after vow to ask before we went round the next corner. The corners came and went and still I couldn't ask. As we arrived at our destination, I made a final dig into my hand with my nails and blurted out, 'What happened to my arm?'

It was an enormous relief just to ask the question. This was probably the first time I had *ever* said or asked anything about my arm.

'I've often wondered why you haven't asked before,' said my mother. 'You had a very rare form of cancer and it seemed that the only solution was to cut off your arm.'

'Do they know why I got it? Did they have to cut it off? Will I get cancer again?'

The questions stumbled over themselves; now that I had broken the taboo about asking, I wanted to know everything. But we soon got out of the car and the subject was changed. I wanted my parents to take the initiative and to go on talking about it – and me – for a long time. But they didn't.

What had I been frightened of? I don't think it was the word

'cancer', nor, since I had never thought of myself as still being ill and had never been given any intimation that I was, was I worried that I only had a limited time to live. In some way I was still frightened of claiming too much attention talking about myself seemed as wrong at nineteen as it had at ten – and I still felt guilty at the prospect of asking too many personal questions. So although I then knew that I'd had cancer, I didn't know much else and it took years of snatched conversations to piece together what had really happened.

When I did eventually discover what kind of cancer I had had, when it turned out to be synovial sarcoma, a particularly virulent form of cancer, I also discovered that this form of cancer accounts for less than one per cent of all the soft-tissue sarcomas. It is rare in adults and even rarer in children, rarer in girls than boys and is three times as common in legs as arms. It is known to be one of the most aggressive and fastest growing of the soft-tissue sarcomas. Sarcomas usually grow outwards from their initial site and tend to infiltrate the adjoining tissues and structures. They generally spread along tissue planes, but can often be found in distant sites. In a study carried out in New York,[3] only ninety-five cases of synovial sarcoma were discovered in fifty-two years and only ten per cent of these were in children. Crocker and Stout write that the initial symptom is pain, which I certainly had, and an invasion of the adjacent tissue, even bone, follows. One of the histopathologists on my case referred to it as an 'undifferentiated tumour', i.e., very aggressive and prone to early metastasis, but for the same reason susceptible to control by radiation and chemotherapy. Metastasis, or spreading, can occur throughout the bloodstream and the lungs are almost always involved. Of the patients in the forty-three case studies, twenty-two died; there were three with sarcoma of the elbow and one with sarcoma of the forearm.

It is suggested that many of the cases may have been

preceded by an injury. It would be impossible to find out whether this was so in my case. There was no obvious injury to pin it on, but had I had a bad fall at school? It is now generally accepted that synovial sarcoma is probably derived from a primitive mesenchymal precursor cell.[4] Alternatively there is 'growing evidence of distinct chromosomal abnormalities in the sarcomas, which is a further and powerful indication of the genetic aspect to the tumours. For example, there is a [chromosome] translocation t(x;18) in nearly all instances of synovial sarcoma.'[5] It is only recently that I have even begun to think what might have been the cause of my cancer. Was I genetically predisposed to a synovial sarcoma? Does that mean a recurrence is a possibility? I doubt whether at the time anyone knew what – according to Schmidt – recent research has shown, i.e., that: 'It is well known that late metastases and late recurrences may even develop after twenty years.' This is surprising as after the amputation I think I only saw a doctor once during my teens and never afterwards. Statistics may be boring to other people but not to those who are constantly weighing up their chances of survival, or who, having survived, feel themselves to have somehow proved the statistics wrong. I did prove the statistics wrong, and I have met doctors who refuse to believe that I could have survived synovial sarcoma.

An orthopaedic surgeon told me that in the whole of his career he'd only seen one instance of synovial sarcoma, and added under his breath, 'and of course it tends to recur.' 'But not after fifty years,' I said, at which he remained silent – something which even after all those years I found rather unnerving. However, nothing I've read suggests that it does reoccur after that long.

Was Sir Denis a butcher or a saviour? I had never really thought that there might have been an alternative to amputation, so I was shocked when I read that, ' . . . it has seemed to us that a well-planned attempt at wide local excision,

if this is feasible, should be used wherever possible, since, if successful, it leaves an unmaimed individual and seemingly has just as good a chance of success as has treatment by amputation'.[6] This was written in 1959, two years after I had my arm amputated, and seems to imply that amputation might not have been necessary. I read the article in 1997 and it was only then that I began to mourn my arm. It's unbearable to think that the amputation might have been avoided. The final decision to amputate must have been made by Sir Denis, but the thought that he might have made this decision through undue caution is horrendous. So, although I have great respect for him, I'll never know whether he was my butcher or my saviour – or both?

Although modern medicine is technically sophisticated and claims a scientific basis for the notion that disease is natural and not a cultural phenomenon, have our attitudes really changed that much? Isn't it still true today that disease can be seen as retribution for an unhealthy life? Bad diet and lack of exercise are blamed for many illnesses, and the attitude that a promiscuous lifestyle deserves both AIDS and herpes is still not uncommon. To believe that you have caused your own illness because in some way, unconsciously, you have warranted it, means that you are blamed for being ill; thus you, the patient, are made to feel you have deserved it. However the mind does have far more power over our bodies than we think, as Dr Franz Alexander wrote: 'The fact that the mind rules the body is, in spite of its neglect by biology and medicine, the most fundamental fact which we know about the process of life.'[7]

At a 'new-age' talk on curing oneself of cancer and of the necessity of taking personal responsibility for it, I asked a question about children who get cancer. My question obviously made the speaker uncomfortable; I was given extremely short shrift and told that the same rules apply for

children as for adults, and that children should learn to take equal responsibility for both getting and curing their illnesses. I do think it is important to take responsibility for any illness in the same way as it is important to take responsibility for one's life, but young children have not yet reached a stage where they *should* be held responsible for their lives. It is true that many people with a cancer diagnosis do not want to confront the problem, but, as Ivan Illich wrote in *Medical Nemesis*: 'Health is a personal responsibility and a task in which self-awareness aids success.'

I believe that we can control *how* we respond to what happens to us, but not *what* happens to us. I can readily identify with Ken Wilber's approach. In *Grace and Grit*, he says: 'In our Judeo-Christian culture with its pervasive emphasis on sin and guilt, illness is too easily seen as punishment for wrongdoing. I prefer a more Buddhist approach where everything that happens is taken as an opportunity to increase compassion and to serve others.' He goes on to say: 'I do believe we can use the crises in our life for healing.' And his wife Treya, who eventually died from cancer, said: 'When I say I'm grateful for this recurrence, I mean it. Something wonderful has happened.' And, later on, that illness: 'Has set my destiny in motion . . . I wouldn't have found these depths within me but for this cancer.' On a more prosaic level, Jill Ireland in *Life Wish* agrees that: 'Cancer had tremendously rewarding sides. I became closer to my friends and family.'

An astonishing theme that runs through books written by people who have been seriously ill is that they are thankful for the experience and would positively choose to go through it again. Adults who have a brush with death and recover generally value the world in a different way, and even those who are terminally ill often have a new appreciation of life. Finn Carling, who suffered from cerebral palsy, wrote: 'We, the cripples, know what life is really worth, since we've been

fighting for it every minute of our lives. Therefore if I could have changed my distorted body into a normal one, I wouldn't have done it.' Teresa McLean, who has written books about the difficulties of having both diabetes and epilepsy, says: 'I do not think suffering is good for you . . . I think it is a perversion of Christianity to want suffering.' Nevertheless, she goes on to write: 'I would not hesitate to have children, even if every member of my family since creation had been diabetic, because I think it is always better to have life, however troubled, than not to have it . . . I would say that over the years diabetes has given me more than it has taken away.' Disability can be a form of empowerment because it gives one a different sense of perspective: 'A perspective of one's surroundings and above all of oneself shorn of pretence, particularly as regards one's own mortality,' wrote David Beresford in the *Observer* on 3 October 1999. Any experience can be made into a challenge and can be the trigger in helping one grow spiritually beyond oneself, and it is this opportunity for which people are grateful. An ability to transform adversity into an enjoyable challenge must be one of life's greatest gifts, despite its obvious difficulties

Transformation, or the trick of turning one thing into another, is well known to us through fairy tales and myth. A talisman is often needed for this transformation, but in the case of an illness, the illness can itself become the catalyst for transformation or change. In Bel Mooney's book *Perspectives for Living*, which started as a series of radio programmes, Christopher Booker is quoted as saying after the murder of his sister in Thailand: 'Death certainly can enhance and enlarge our lives,' something which presumably was very difficult to see at the time. He also said: 'The more one is in touch with one's centre, the more deeply one is aware of this web of meaning and coincidence and symbolism and omen.'

It is only very recently that I have really begun to understand this. These people, the very opposite of victims, have a

huge amount to teach us. I think it is summed up well by Harold Russell, who lost both hands, in *Victory in My Hands*:

> I don't think I'd ever willingly lose my hands, if I had it to do all over again. But having lost them, I feel that perhaps I have gained many fine things I might never have had with them . . . The important thing is that this seeming disaster has brought me a priceless wealth of the spirit that I am sure I could never have possessed otherwise. I have enjoyed a life that has been full and rich and rewarding, a life that has had a meaning and depth it never had before. I am very grateful . . . People frequently marvel at the things I can do with my hooks. Well, perhaps it is marvellous. But the thing I never cease to marvel at is that I was able to meet the challenge of utter disaster and master it. For me, that was and is the all-important fact – that the human soul, beaten down, overwhelmed, faced by complete failure and ruin, can still rise up against unbearable odds and triumph.

The 'marvel' was his ability to meet the challenge, and it was that, rather than what he was able to achieve physically, which was extraordinary.

A visible wound is evidence of having gone through a devastating experience and survived. It shows others your strength, but this strength can be both alarming and threatening to them. The illness that can bring a greater self-acceptance can also produce a resentment and – ironically – an envy in others, an envy of the 'luck' or appreciation of life that those who have had close encounters with death sometimes appear to have. I have often been told, rather accusatorially, that I am 'so lucky' and although on many levels I know this to be true, as I have always had somewhere to live and have never been short of food, it makes me angry and is something I always vehemently challenge. These material things are not what my fellow middle-class accusers mean. So what are they really saying?

Perhaps there is in truth something enviable about a close encounter with death.

Cancer, or any other major illness or trauma, can be used as a learning process and it is the way in which it is dealt with that is relevant. Mihaly Csikszentmihalyi, in *Flow: The Psychology of Happiness*, says: 'Many lives are disrupted by tragic accidents . . . Yet such blows do not necessarily diminish happiness. It is how people respond to stress that determines whether they will profit from misfortune or be miserable.'

'Everything in life that we really accept undergoes a change. So suffering must become Love. This is the mystery. This is what I must do . . . I do not want to die without leaving a record of my belief that suffering can be overcome. For I do believe it,' wrote Katherine Mansfield in her *Letters and Journals* on 19th December 1920.

Brushes with mortality can bring with them a previously unacknowledged appreciation of life. *A Course in Miracles* states that: 'Those who are healed become instruments of healing.' It is, however, important not to thrust one's beliefs or experiences of healing on to others; there is a wise Sufi saying: 'If you offer words of the spirit to one who does not ask for them, you waste the words; but if one asks for words of the spirit and you do not offer them, you waste the person.'

Some time during my teens, when I had finished growing, I was asked if I wanted to have a false arm. I said yes, but I wonder whether I really ever did want one, as I never remember liking the thing and I never remember having it at school.

Prosthetics have a long history. Some have been found in India dating back to 3500 BC; Herodotus describes a wooden foot being fitted, and artificial arms have been found buried with Egyptian mummies. The Stibbert Collection in Florence has many fifteenth- and sixteenth-century prosthetics, including the Alt-Ruppin hand which has a moveable wrist, a

rigid thumb and flexible fingers (I'm glad I didn't know about this museum when I was in Florence). My new arm was made in Paris; my parents must have been told that this was where the best arms were made, and I went several times for fittings. The place I went to, off the Champs Elysées, was more like a grand flat than a hospital or laboratory and I only ever remember seeing one man there; he was dressed in a dark suit, and there wasn't the throng of technicians in white coats that I thought laboratories should have. The arm was light and simple to use; it attached on to my bra and there was a button at the elbow that made the arm bend when it was pressed. I enjoyed the trips to Paris with my parents (and sometimes my sister), but had no real interest in the arm. It was purely for cosmetic purposes and it certainly looked extremely lifelike; I was even able to paint the fingernails.

Artificial hand in the time of Ambroise Paré

My feelings about the false arm were paradoxical: I was hoping not to have my loss of arm noticed, yet when I had a false arm I hated wearing it. I certainly did wear it relatively often during my late teens; I can't remember what sort of occasions prompted me to do so or whether it was my mother who suggested when it would be appropriate, but I do not think that it was something I ever felt comfortable with. I thought I ought to like it and felt guilty that a great deal of money was being spent on something I felt so ambivalent about. A friend remembers seeing it in my cupboard and that we discussed whether or not I

should wear it to some social function. This memory of hers (rather than mine) would explain one reason why I would not have liked the false arm: friends referred to it, thereby drawing attention to it and challenging my belief that no one really noticed that I had one arm. But even at the time it seemed unnatural to wear it; I wanted people to accept me for *me*.

What was instinctive at the time has now become something I believe intellectually. I feel there is no point in trying to pretend you are something you are not. Lord Nelson evidently never wore a false arm: in pictures he is always seen with his loose sleeve pinned to his uniform. Wearing a false limb, unless it is functional, makes the person feel that they are not all right as they are, and that they ought to try to be and look like the norm. A prosthesis, or false limb, is often meant to restore self-confidence, but by emphasising that there is a 'right' way to look – like everyone else – it can actually diminish that confidence. It does *not* make one part of the norm; it is a disguise that makes one appear other than what one is. If a false limb is worn to protect other people from something they would rather not see, then denying them the 'horrible sight' is denying reality. In a world where we are used to scenes of violence on the television there is still an inbuilt assumption that people need to be protected from that which is unpleasant for them. And there is no question that there are many people for whom the sight of someone with one arm or one leg is disturbing. But they only have to deal with their on-the-spot reactions and feelings; they are not the ones who have to deal with the living of it. An acquaintance who lost his leg in a motorbike accident was in a swimming pool one day and a woman said, in his hearing: 'People like him shouldn't be allowed to swim here.' That kind of remark is so unexpected and so hurtful that instead of being able to produce a suitable response, it merely produces a stunned silence.

If someone prefers to wear a false limb for purely aesthetic reasons then that is their decision, but it is different from wearing a limb for functional purposes. A false limb can sometimes be, after all, a very useful tool. Henry Viscardi in *Give Us the Tools* talks about a young naval veteran who had lost his hand and was able to use his false hand to do something others couldn't: 'He did fine in the kitchen of a big hotel. He could slip his steel hook into scalding water and fish out dishes the other workers couldn't touch.' I would never want to wear a false arm now. I cannot think of any way that it could be useful to me, and I see no point in pretending that I have two arms when I have not. If you are comfortable with yourself then others will feel comfortable too. As Harold Russell says: 'Self-respect and real pride are better fed by achievement than by concealment.'[8]

Prosthetics have taken on a whole new meaning for some. Long gone are the days when clumsy wooden limbs necessarily replaced a missing arm or leg. But of course high-tech prostheses are still very much for the privileged few. In most parts of the world amputees who are victims of landmines or military action still have to put up with clumsy false limbs. If they're lucky, that is. There are several wonderful organisations, like The Cambodia Trust, which supply limbs to landmine victims, but thousands of people are still losing limbs to landmines, so the demand for new limbs is constant and those supplied are fairly basic, aeons away from the latest bionic developments. The expectations of the disabled in Third World countries are very low. The simplest things have to be explained, but the reality is that having a false limb often enables people to work again and can therefore be life-changing. The joy of seeing a small boy being able to kick a ball with his new false leg is indescribable. Being disabled means having bad karma in Buddhism and therefore victims of landmines and polio are often badly neglected. At treatment

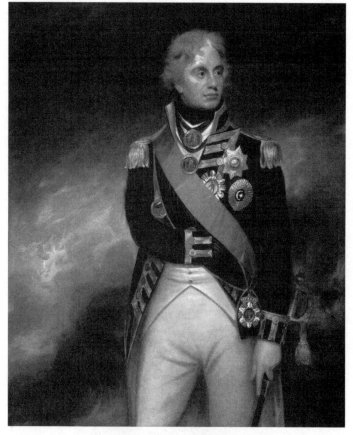

Horatio, Viscount Nelson (1758–1805) by Sir William Beechey
(1753–1839), 1801

centres they are, for the first time in their lives, with people who care about them and are not treating them as suspect.

In Cambodia, where adults have to travel many miles to one of the three fitting centres, it is essential that the fitters get it right first time, as the expense of coming twice to a centre can be impossible for a poor farmer who has to pay someone to look after his land while he is away. Growing children will

probably need a new limb every three to six months. There are forty thousand landmine amputees in Cambodia and fifty thousand polio victims. The idea behind projects such as The Cambodia Trust is not to make the disabled feel special, but rather to 'level the pitch'. Those who have lost only one arm to a landmine are not given a new limb, but double-arm amputees are fitted with prosthetics. In the film *Kandahar*, a man who has had his hand blown off asks for a false hand. The fitter at a Red Cross limb-fitting centre explains that they only have legs, and asks him if he walks on his hands. Undeterred, the man persists and manages to get a pair of false legs just in case he loses his real ones.

3 & 4: artificial arms invented and made by M. L. Matthieu;
5: forearm with articulated hand, thumb and index finger

While waiting for a flight to Rome at Heathrow, I sat opposite a woman wearing a cosmetic arm. Through her shirt I could see where it was attached at the shoulder and the hand had curled fingers rather like the one I'd had. As I watched her, surreptitiously I hope, she started to look for something in her

bag, and I recognised the way she did it; she fumbled. There seems to be a definite one-handed way of doing things. But I didn't like it. I didn't want to look like her. She seemed so conspicuous. Or was it that I felt slightly resentful? Having one arm is my prerogative, my specialness, and I didn't want to have to share that with anyone else. I was on my own so I couldn't ask anyone if they'd noticed, but I'm pretty certain they wouldn't have. I wonder if she noticed me. I now regret not talking to her.

Louise Baker, in *Out on a Limb*, describes how she did not like wearing a false leg. 'On a leg I feel conspicuous and crippled. On crutches I don't.' I have a friend who does wear a false leg; she sees it as more of a challenge to wear a false limb than not, feeling that crutches give a kind of security, that they are indeed a 'crutch'. She has described the insensitive way in which some professionals discuss and fit false limbs in Britain; an ugly appendage with no feeling is about to become part of your body, and this traumatic occasion should be treated with sensitivity. Yet often there seems to be no appreciation of the importance of the occasion for the amputee. I don't believe that anyone who has not lost a limb can really understand this; I imagine they think that a false limb is just something practical, to be worn or not. But if you stop and think what your leg or arm means to you – rather than taking the fact of having two of each for granted – then you might begin to have an idea of how important a fitting for a new one would be. I recently heard someone comparing her false legs to adopted rather than biological children.

Limb replacement is obviously still full of unfeeling fitters who seem not to take into account what a sensitive and traumatic role they are playing in an amputee's life. In the *Guardian* in February 1979, the writer Judy Froshaug described her own first false hand: 'It was horrid. Covered with garish pink plastic, a rigid first finger and thumb – though the latter

was sprung so that you could hold a piece of paper – and three jointed wooden fingers. There was a little square hole set in the palm into which a specially designed fork would fit.' Seeing her trying to eat with this evidently produced hysterical laughter in her family. We laughed a lot in my family and had many 'in' jokes, but I don't think I would ever have allowed my family to laugh at anything to do with my arm. It was a totally taboo subject, very much a no-go area. Not that it was ever an issue among us; my denial rubbed off on the others, and it was simply never mentioned. Unlike me, Froshaug persisted in wearing her false hand almost every time she went out, until she broke her other hand when she was seven months pregnant. Six months later she realised she hadn't put it on at all, and never did again. Jill Ker Conway, first woman president of Smith College in America, wrote and told me that her late husband, John Conway, who had only one arm, stopped wearing his artificial hand because he kept leaving it behind when he was staying somewhere for the weekend.

It was reported in April 2000 in the *Independent* that the Giddings family from Hampshire were in a restaurant in South Africa when a bomb exploded. Their young daughter Laura had to have her foot amputated and her first question on being told that this was going to happen was: 'Will it ever come back?' Her parents promised her the very best limb they could find and were horrified by what was initially produced, a prosthesis 'like something off a shop dummy'. By sheer persistence they found their way to Dorset Orthopaedic who within weeks supplied her with a £2500-foot which she liked.

I heard about a case in America in which a seven-year-old child with one arm stopped wanting to wear his prosthesis at school. His mother agreed to this, feeling that since there was nothing he could not do with his one hand, there was no point in making him wear something that made him feel self-conscious. The school authorities told her that if she didn't

force him to wear it, the social services might be contacted, she could be had up for neglect and there was a possibility that she would lose her son. Luckily the mother was able to get many letters of support from one-armed people who didn't wear prostheses and the case was dropped.

One of the arguments that the occupational therapist at the school tried to use was that the boy's not wearing a prosthesis meant his body would not develop evenly. This was clearly misguided information as one woman responded that she had worn a prosthesis for thirty years, yet the side of her body missing the limb was definitely smaller and less developed. On the contrary, she said, doing things actively with the stump would be the best way to develop the muscles. The amputees she knew without prostheses were the ones with the more evenly balanced bodies.

Leona Bruckner, whose son was born without arms, writes in *Triumph of Love* of a conversation with a doctor who said:

> I will not try to minimise the difficulty of lacking arms. A loss of legs is bad enough but, after all, legs are just a means of locomotion. When a man loses his arms, he loses much more. He cannot grasp or manipulate, his means of self-help are drastically reduced. These things cannot be completely replaced and that is why so many amputees are disappointed with the prostheses at their disposal.

And, perhaps most importantly of all, a prosthesis cannot feel. Thus the direct link between the brain and the outside world does not exist.

When we were clearing out my parents' house I found my false arm in the attic and realised I had not worn it for over thirty years (although a friend whom I have known for only twenty years swears I was wearing my false arm when we first met). I had forgotten that it had three hands for differing occasions; I'm not at all sure how I was supposed to pick which

one to wear when – the fingers are in the same position and my life- and love-lines are the same length in all three. One has the merest hint of blue veins on the back of it; very much a young person's hand. I was loath to throw it away, so now it languishes in one of my own cupboards.

Some people go to extraordinary lengths to get a new hand: in 1998, convicted fraudster Clint Hallam, a New Zealander, was the first person to receive a transplanted hand. Having initially lost his hand in an accident, he had it reattached; however, this did not work out and he scoured the world looking for a surgeon who would perform a transplant. Eventually he persuaded a team of doctors in Lyons in France to give him a new hand, but instead of this improving his life it actually worsened it; he had to take huge amounts of immuno-suppressant drugs, which were expensive and which gave him diabetes and permanent diarrhoea. The doctors blamed his lack of success with the hand on his not taking the correct drugs, but in February 2001 he managed to convince the surgeon, Mr Hakim, to amputate his hand again. Hakim, who seemingly understood his patient well, agreed on condition that he would not speak to the press in order to earn money from his story. I know I would not like to have to take strong immuno-suppressant drugs daily to sustain an arm that I didn't really want. Yet Hallam had fought so hard to get his new hand.

In 2000 the first double-hand transplant took place, again in Lyons. The recipient had lost both his hands in an explosion in 1996, so four years had elapsed. The operation took seventeen hours and involved fifty medical staff in a complicated procedure in which the donor and recipient bones were pinned together before the two sets of tendons, arteries, nerves and skin were all fused.

Prosthetics have now leapt into the bionic age. A fully flexible carbon-fibre bionic arm costing a £100,000 has recently

been developed. It has a motorised shoulder, rotating wrist, contracting fingers, imitation skin and a microchip that translates thought-processes from the brain. It enables the wearer to do everyday tasks including tying shoelaces; it seems it is as near as possible to the real thing. I wonder whether I would have liked to experiment with this? Looking back at my feelings about false arms, probably not, even if I could have afforded to.

In June 2001 the first bionic hand to be prescribed on the National Health was given to Stephen Ball, who lost all his fingers to frostbite after surviving two nights on a mountain in Alaska. This bionic hand was the result of a seven-year development project funded by the National Health Service in Scotland. Its electrodes sense the tiny currents of electricity produced when he uses the muscles in the palm of his hand and these are translated into finger movements. With funding, it could become routinely available to patients on the NHS.

The *Daily Telegraph* of 2 February 2007 reported that an American woman fitted with a bionic arm controlled by thought alone was able to carry out tasks four times quicker than with a conventional prosthesis. She said that her 'original prosthesis wasn't worth wearing – this one is'. The arm operates by targeted muscle reinnervation (TMR), which involves re-routing the nerves that once controlled the patient's arm to a patch on the chest where they grow into muscles. She has also regained the sensation of having her hand touched – that is the only aspect of a bionic arm that I find remotely appealing. Dr Leigh Hochberg, a neurologist at Massachusetts General Hospital, said that early results were positive and: 'An important step forward in the seamless integration of replacement limbs into the body'.

In John Irving's novel *The Fourth Hand*, journalist and womaniser Patrick Wallingford has his hand eaten by a circus lion in India. Irving and his wife Janet had had the idea for the book while watching the real-life hand transplant, carried out

in Lyons, on television. In the novel, Wallingford is ashamed of his stump and hides it under the desk when reading the television news. He becomes desperate for a transplant and eventually gets a new hand from a recently dead man, Otto. The widow, Doris, demands that Wallingford make her pregnant and also insists that she wants to go on seeing the new hand after surgery. While she is pregnant she places Otto's hand (now attached to Patrick) on her belly, but takes no interest in Patrick, who predictably falls in love with her. He has to have the hand re-amputated and the rest of the book is his attempt to see his son and to marry Doris.

I feel that somebody else's transplanted hand or arm would always be alien, and I found Lise Leroux's surreal novel *One Hand Clapping*, which is set in the future, deeply unsettling. In the book, body parts are attached to people who act as hosts, and in one instance, because the woman is desperate for touch, a 'hand bud' is implanted below a breast. After three weeks the initial hand has grown enough to be removed and ten more are implanted; the heroine falls in love with one of them and determines to find the man whose hand it once was. In the 1962 film, *Hands of a Stranger*, a famous concert pianist loses his hands and as replacements has the hands of a murderer grafted on to him with devastating results.

However, despite all these new-fangled bionic arms, my antipathy to false limbs remains constant, carried over from the past when wearing a false arm would have been an admission that I only had one arm. Now, as well as seeing it as an encumbrance, I feel that it would make me look like a person that I'm not.

A friend asked me hypothetically whether if I could have my other arm back tomorrow, would I want it? I paused before answering – and to be honest I really don't know. She was stunned by my hesitation, but David Beresford wrote in the *Observer* (October 1999):

A friend of mine, an Africa correspondent, also has Parkinson's. One night we were having dinner together in Johannesburg. 'You know, the strange thing is that if a guy came up to me with a pill that was guaranteed to cure Parkinson's, I would take it,' I said uncertainly, 'but I would hesitate for a moment before taking it.'

This enables me to understand the testimonies written by those with terminal illnesses who wouldn't change their experiences. It is a question I sometimes think about but to which I don't have an answer. I still don't know. This same friend referred to me the other day as being disabled, and I felt hurt. She assured me that for most of the time she forgets that I have only one arm, but when she does think about it she thinks of me as 'disabled'.

'But being dis-abled means "not being able". I *am* able – you know there's nothing I can't do.'

I hate the label and it makes me cringe. But why? What is it about the word and the image it conjures up that makes me shudder? Is it that I still haven't really accepted that I have only one arm? Or just that I don't want a label attached to me? I think I feel that there's an element of whingeing and victimhood attached to the 'disabled world' – and that's something I want no part of. I was reassured when I asked my sisters whether they ever thought of me as 'disabled', that they answered in unison, 'No – you're just you!'

I have learned a great deal about other people from the way they react when they discover I have only one arm. There are those who fuss and continually ask if they can help, and there are those who completely ignore the issue. The middle way, the one that anticipates my needs without making an issue of it, is of course the best, but it is also presumptuous of me to assume that anyone *should* know when *I* need help.

I have found that allowing myself to be helped can be

extremely nice, but it has to be done in an unfussy way and most people seem to be able to do that quite naturally: 'It is the history of kindnesses that alone makes this world tolerable'.[9] An immediate intimacy is forged between the person helping and the person being helped. It is impossible for me to stand, hold a drink and to eat at the same time; at buffets I always have to find somewhere to sit down – which suits me fine as I never like standing if I can sit – but at drinks parties when food comes round I either have quickly to find someone with a spare hand or somewhere to put my glass or miss out on the food. I have often seen delicious and tempting trays of food retreat into the distance, especially frustrating for a greedy person like myself. At one particular party I went to, a waiter immediately assessed the situation, and every time he came round with a tray full of food he took my glass from me and held it while I helped myself. It was a simple yet thoughtful thing to do and made a difference to the whole evening for me.

When I went on a trip to Antarctica, walking around the ship in very rough seas was something I hadn't considered was going to be a problem. It was; hanging on to the bars on either side of the corridors with both hands was seemingly the only way to get round as the ship pitched every which way. I did find it difficult, but somehow I managed. As for going down the ladder into a zodiac in a massively rolling sea – I found that potentially terrifying, until I realised there were huge Russian sailors waiting at the bottom, who literally picked me up by the scruff of the neck and threw me into the waiting boat.

The issue of making people feel guilty and embarrassed is fairly complex. It is extremely easy to play the guilt card, and possible to use the lack of a limb to one's advantage by making oneself into a victim; I have succumbed to the temptation on the odd occasion, but have always felt shoddy afterwards. It's

Antarctica: the ladder from the ship to the boat, 2005

In Antarctica, 2005

simple to embarrass people, and in certain circumstances saying, 'But I've only got one arm,' is a quick and effective method of doing so. Once, in a shop, I unconsciously bumped into a youngish woman who started shouting at me that I should look where I was going. As I had not even felt myself knock against her, instead of ignoring her tirade, I could not resist telling her that I only had one arm and it must have been my empty sleeve that had brushed against her. Of course this immediately distressed her, but I felt cheap and that I had scored a hollow victory. Another tempting retort when someone says, 'Can I give you a hand?' is 'I only wish you could.' This makes most people feel extremely embarrassed.

On the whole cancer in fiction is of the invisible type, as in Eric Segal's *Love Story* and Anna Quindlan's *One True Thing*, and so, in many instances – unless the person with the cancer chooses to talk about it – it can remain invisible and unremarked upon. But for those who have lost an arm, the experience tends to be not only life changing but also very visible – this gives an interesting insight into how writers must regard the experience. Most people I talk to are unaware that there are any one-armed or armless characters in fiction at all; I actively look for them, but even I am surprised by how prevalent they are. In Act II, scene 5 of *Titus Andronicus*, Shakespeare's bloodiest play, Lavinia has both her hands cut off and her tongue cut out by Demetrius and Chiron, who then cruelly taunt her:

> Write down thy mind, bewray thy meaning so,
> And if thy stumps will let thee play the scribe.

They go on to remind her that she has no hands to wash, and could not even kill herself as she has no hands to help her 'knit the cord'.

When Marcus finds his niece in this state he says:

Speak, gentle niece, what stern ungentle hands
Hath lopp'd, and hew'd, and made thy body bare
Of her two branches – those sweet ornaments
Whose circling shadows kings have sought to sleep in?

When Titus discovers what has happened to his daughter, he wants to cut off his own hands, but then her remaining relatives vie for the privilege of having their hands cut off too. While they go to find an axe Aaron cuts off Titus's left hand, at his request, and has it sent to the Emperor. The Emperor dismissively sends it back with the heads of two of Titus's sons. Titus has some revenge by killing Chiron and Demetrius and making their mother Tamara eat them baked in a pie, while Lavinia holds between her stumps a basin to catch their blood. (Vivien Leigh was playing Lavinia in a performance of *Titus Andronicus* when, by mistake, she dropped the stick which she was using to write the names of her torturers – since she had also had her tongue cut out – thus prompting Noël Coward to call her 'butter stumps'.) Eventually Titus kills Lavinia too. At the end of the play the stage is covered with blood, severed hands and heads. Watching the film *Titus*, I felt the audience flinch when the axe came down on Titus's hand – Lavinia's amputations had happened off screen – and I think I probably felt the horror more than anyone else.

Just as I did when I saw Tim Piggot-Smith play the creepy character Ronald Merrick in the television adaptation of Paul Scott's *The Jewel in the Crown*. Merrick had to have his left arm amputated above the elbow after trying to save Teddie Bingham's life.

Stories about one-handed people are found all over the world and are remarkably similar. In *The Girl Without Hands* by the Brothers Grimm, the devil wants a miller to cut off his daughter's hands. The miller replies, 'How could I cut off my own child's hands?' but with a minimum of persuasion

he does. The daughter asks for her maimed hands to be tied behind her back and she sets off on a life of wandering feeling that she can no longer stay in her own country without hands. The king, who sees her eating fruit with her mouth and protected by an angel, has silver hands made for her and marries her. When the king goes away, the devil intercepts their loving letters, substituting evil ones, so the girl once more has to leave her abode, this time with a child tied to her back. She is protected by an angel for a further seven years, before the king finds her again. By this time her hands have grown again, but she has kept her silver hands as proof of who she is.

Deformity is another word I find hard to accommodate. In John Hawkes's *The Blood Oranges*, there is a one-armed photographer called Hugh: 'Fiona had failed to comment on his obvious deformity, which to me was the most interesting thing about him.' It may seem odd to find someone interesting *because* of having one arm; this is something I have learned to accept is not only a possibility but also in some peculiar way something to relish. There is something memorable and special about being different. Hawkes writes: 'But his arms, or rather that lurid combination of arm and partial arm, most held my attention.' And further on he writes of 'the odd magic that Hugh somehow extruded from his injured arm'. He makes use of his disability: 'Hugh was trying to use his pinned-up flipper to fence his way through the darkness and sullenness of her suspicion.' I feel physically sick when I read the word 'flipper' used to describe what's left of Hugh's arm. It seems so undignified and somehow patronising. When Nelson became agitated he used to waggle his stump in excitement and the seamen would say: 'The Admiral is working his fin.' I have not come across any word that I feel comfortable using; I hate 'stump' as much as I hate 'flipper', 'fin' and 'paddle', and I don't think that I have ever used any word to describe the small part of my upper arm which remains.

In a short story called *One Arm*, about a boxer who loses an arm in a car crash, Tennessee Williams attempts to analyse what someone without an arm must feel. He sees him as a flawed Greek statue or god, writing, in the first paragraph: 'Now he looked like a broken statue of Apollo, and he had also the coolness and impassivity of a stone figure,' and, in the final paragraph: 'For it had the nobility of some broken Apollo that no one was likely to carve so purely again'. But Williams has the boxer say of himself: 'I was a boxer until I lost my arm . . . I guess I stopped caring about what happened to me. That is to say I had lost my self-respect.' The boxer also excited other people with his lack of arm: ' "You God-damned cripple," he used to groan to himself. The excitement he stirred in others had been incomprehensible and disgusting to him.'

Leona Bruckner realised early on that it is 'they' – other people – who are the problem. Even the medical profession can be appallingly insensitive. When her baby was born, she was told by the doctor in attendance: 'The child is a monstrosity. He has no arms.'[10] And when pregnant women saw the baby, they thought the mere sight of him would cause their child to be born with no arms. This was in America in the 1950s; superstition and human nature had barely changed since the times of the ancient Greeks and Romans.

Bruckner asks, concerning her son: 'Should we feel shame because of his lack of arms? . . . Would they taunt our daughter for having an armless brother?' In fact, her daughter, aged three at the time of her brother's birth, quickly learned to accept the way he was. 'My brother just doesn't have any arms because he was born that way.' Most children with disabilities are extraordinarily inventive in working out ways to do everyday tasks; very few like asking for help or indeed feel it necessary.

In *Out on a Limb*, Louise Baker defines handicap as being 'a race or contest in which, in order to equalise the chances

of winning, an artificial disadvantage is imposed on a superior contestant'. This is totally at odds with the misconception that a physical disability should equate with mental slowness. She also writes about her grandmother whose 'complete lack of tact' had ensured that no one would ever be able to embarrass her granddaughter. Maybe it was because she lived in America that she was constantly asked about her accident. She was not defiant enough to be able to say: 'It's none of your damn business,' so she began to invent more and more dramatic accident scenarios. But she always found that it was children's direct questions which really ruffled her: 'Mama, where's that lady's leg?' If an adult asks the question, once they have heard the answer that is probably the end of it. They might respond in different ways, often with embarrassment, but the matter is soon closed. Some children of three or four ask hundreds of questions, others go on and on asking the same question stubbornly refusing to believe the answer, while others seem to take everything in their stride and hardly notice, but most want to know what happened and whether or not it hurt. I have always found children difficult to deal with. If they ask where my other arm is and I tell them that I only have one arm, they think I am lying and giggle and ask where I've hidden it. It was many years before I was able to understand what Harold Russell meant when he says: 'The only way I could expect to feel at ease with them [children] was if they felt at ease with me, and the only way for them to feel that way was for me to be at ease with myself.'[11] Jill Ker Conway told me that her husband John had many wonderful stories about children's responses to his empty sleeve. 'Come on. No kidding. Where is it?' they would ask and – from a very socially responsible little girl, when told that his right hand had been blown off in the war – 'Isn't it lucky it wasn't your head?'

When children imitate another child's or person's disability, which happens quite frequently, it is a form of bullying. A

response to this kind of bullying is to put up a shield of defensiveness. This pretence of external invulnerability is often enough to put off any tormentors but it gives no hint of the internal emotions. However, these weapons learnt as a child can often form the defence mechanisms of an adult; I know that much of my seeming invulnerability was in place long before I had any rational idea of what I was doing. Not that I was bullied – perhaps my strong defensive wall precluded it – and I know that I certainly never felt a victim.

An article in the *Daily Telegraph* on 14th February 1996 cites a case in which a man – whose right arm was amputated after a wall collapsed on him when he was seven, and who had been tormented by a gang of youths for three years because of his 'manifest handicaps' – finally lost his temper and stabbed one of his tormentors to death. The article mentioned that there was obscene graffiti about him in the area, and that whenever he went to the local shops youths made it their business to abuse him. I find it horrific that he was tormented because of having one arm and that the youths picked on him as a target for their aggression because he was physically different.

Most children want to know how certain things are done, but once they have established what they need to know to their satisfaction, they can be very accommodating. Other children have an ability to taunt which can annihilate any self-esteem. Unquestionably physical appearance is often the most readily available information we have about a stranger, and, since society idolises 'normal' standards of physical functioning and appearance, people with a disability may prefer to try to hide whatever is different about them. One little girl asked her grandfather why I always walked around keeping my arm warm inside my shirt. Children notice when things are different, but can often be very accepting when something is explained to them.

Beatrice Wright writes[12] that if the concealment of a disability is not possible, as in the case of a missing limb, as long as the person feels inferior because of it, he or she will try to act as though the disability makes no difference and will outdo themselves in maintaining normal standards so as to appear as much like a non-handicapped person as possible. This description fitted me to a tee.

Various simple gadgets were given to me as I was growing up: a sewing frame that clipped on to the table and a playing-card holder were unpretentious enough for me to accept. A fork with a sharp edge I also thought reasonable, because it looked like a normal fork, but I baulked at a scissor-like device for cutting meat, because it looked odd. In 1998 I met a woman at a party who had read about me in a magazine; she told me that her grandfather, who had lost his arm in the war, had had a set of cutlery specially made for him. All, bar one knife, had been stolen, but she wondered whether the remaining knife would be of use to me. It is. I don't know why its odd shape (a short piece of metal juts out at an angle of forty-five degrees from the end of the knife) should make it so much more effective than an ordinary knife, but it does. Lady Spencer, wife of the First Lord of the Admiralty, had a special combination knife and fork made for Lord Nelson, which is on display on the *Victory* and which he used for the rest of his life.

After all those operations during the summer months of 1957, I had an increasing number of scars. There is something heroic about scars won in battle, and had I been a boy I might have been encouraged to be proud of them. But I never was. Scars or disabilities won on the battlefield can indicate bravery, while others not only act as a reminder of the past but can also give the past a validity.

What I find disconcerting is the widely held belief that losing a limb somehow diminishes one's potential. Many

WILLS'S CIGARETTES.

CONTINUOUS FINGER BANDAGE

Continuous finger bandage no. 48 from the 'First Aid' series of Wills's cigarette cards, 1913

historical figures led lives seemingly unaffected by losing an arm. When Lord Nelson received a grapeshot wound through his elbow at the Battle of Tenerife in 1797, he exclaimed, 'I am shot through the arm, I am a dead man!' But Captain Sir William Hoste, the surgeon, wrote in his report: 'He underwent the amputation with the same firmness and courage that have always marked his character.' Nelson was asked if he would like his arm to be embalmed and sent to England for burial, but he replied: 'Throw it into the hammock, for burial at sea, with the brave fellow who was killed beside me.' Straight after the accident, in July 1797, Nelson did question his own abilities, writing in a letter to Sir John Jervis: 'I am become a burden to my friends and useless to my country.' As a child he was naturally left-handed but had been forced to learn to write with his right hand; this would explain the apparent ease with which he re-learnt to write. Nelson lost his arm on July 25th and by the 26th he was taking an active part in running the squadron again. However, subsequently he became depressed, thinking himself useless, and by August 1797, in another letter to Sir John Jervis, he wrote: 'A left-handed Admiral will never again be considered as useful, therefore the sooner I get to a very humble cottage the better, and make room for a better man to serve the State.' Was he

persuaded to go back into active service or was it his own determination? He had been a sickly child and then went on to lose both an eye and an arm, so it is possible that his leadership qualities are partly attributable to overcoming poor health. Admiration for him reached such a pitch that it became the fashion in London for women to wear an eye patch and to walk around with their arms in slings.

If someone loses an arm when they are already established in their career, few will question their ability. It is when you haven't yet proved yourself good at anything that people assume you will be incapable of various tasks. Lord Raglan's right arm was struck by a bullet as he stood beside Wellington at Waterloo, and had to be amputated. He bore the operation without a word, and when it was over he said: 'Hallo! Don't carry away that arm till I have taken off my ring.' After Waterloo he was made a colonel and then became ADC to the Prince Regent. It is said that in 1854, aged sixty-five, he had the strength and vigour of a much younger man. Sir Adrian Carton de Wiart (1880–1963), a British general who was active in the Boer War and the First and Second World Wars, lost both an eye and a hand and was wounded four times. He was a flamboyant character who loved action and – rather surprisingly, since he claimed, 'Politics and soldiering are like port and champagne, they don't mix' – he was made Churchill's personal representative to Chiang Kai-shek.

The Swiss-born novelist and poet Blaise Cendrars, a *caporal* in the Foreign Legion, lost his right arm fighting in Champagne in 1915, for which he was awarded the Military Medal. He had to learn to write with his left hand and, in the introduction to his *Complete Poems* (translated by Ron Padgett), Jay Bochner writes:

Despite the pain and sense of loss his amputation causes him throughout his life, he is private and discreet about it in

his work. For example, a full volume entitled *La Main Coupée* (literally, the severed hand) does not discuss his own arm, though he is himself on stage at war throughout. The left hand becomes, in the signature to letters, his familiar '*la main amie*', the friendly hand.

He did, however, work on Abel Gance's film *J'accuse!* recruiting mutilated veterans for the final scene in which he rises with them from the battlefield to show the civilians the carnage that has been wrought.

Cendrars's writing was so altered after he lost his arm that his work is very easy to date. His friend t'Ser (t'Serstevens) used to lend him his other hand for clapping – how I'd hated that! Ten years after he was wounded he wrote: 'I can't bear a false arm, my stump hurts.' Later his mistress bumped her breast and a tumour formed; she refused to go to the doctor so he operated on the lump himself, using his left hand, teaching himself from the writings of Ambroise Paré, the sixteenth-century army surgeon who was the first person to describe phantom pain. 'It was the first time in my life that I had held a blade in my left hand! Today, thirty years later, you can examine that breast, that adored breast . . . and it does not bear the slightest scar' (*Lice*). Although he is discreet about the loss of his arm in most of his work, *Lice* has a surreal passage:

Planted in the grass like a huge flower in full bloom was a scarlet lily, a human arm streaming with blood, a right arm severed just above the elbow. The still-living fingers were digging into the soil, as if trying to take root there, and the bleeding stem was waving gently in the air to balance itself.

Did Cendrars see his own arm blown off and land some-where like this? Was it just a bizarre fantasy that made him imagine what it could have looked like? Or might it even be what he would like to have happened? Since he'd had the

misfortune to lose an arm, it might as well have a surreal end.

The pianist Cyril Smith, who was married to Phyllis Sellick, suffered a stroke in 1956. However this did not stop him playing – pieces were adapted for them to play with three hands and Malcolm Arnold's *Concerto for Two Pianos* (three hands) Opus 104, which they premièred at the Proms in 1969, was dedicated to them.

Harder to imagine as a career for someone with one arm is that of a jazz musician. Wingy Manone (1900–82) lost his right arm in an accident as a child. He began to play the trumpet on a riverboat at the age of seventeen and became a fine lead trumpeter, singer and bandleader. More recently Rick Allen, the drummer for Def Leppard, lost his left arm in a car crash in 1984 but went back to playing with a special foot-pedal. I learned the piano at school and loved it initially. For the first few years I was taught by a nun who adapted pieces for me to play with one hand and agreed that it was pointless for me to learn to sing scales in preparation for an exam I had no intention of taking. Sadly, as I got older I had a different teacher who adapted nothing for me and made me sing scales, something I found myself incapable of doing. Reluctantly I gave up my piano lessons. Not that I would have had a career like the Austrian pianist Paul Wittgenstein (1887–1961), brother of philosopher Ludwig, who lost his right arm on the Russian front during the First World War. He was a prisoner of war in Omsk in Siberia and was repatriated in 1916. After the war he developed an extraordinary piano technique for his left arm alone, overcoming difficulties which two-handed pianists would have found formidable. He commissioned left-hand piano concertos from Richard Strauss, Maurice Ravel, Sergei Prokofiev, Erich Korngold and Benjamin Britten, and gave the premières of all of them except for the Prokofiev which he found unsuitable.

Yoneko-Oishi, a Japanese geisha at the beginning of the

twentieth century, who took the professional name Tsuma-kichi, was also known as the 'Armless Beauty'. At the age of seventeen she had both her arms cut off by a man who killed everyone else in the household in the middle of the night. She went round Japan singing, and found that many in her audiences, who initially came to hear her out of pity (or curiosity?), soon came to admire her. She eventually got tired of touring, realising there were still those coming to see her *because* of her lack of arms, and opened a restaurant; she also learnt to paint and to write poetry using her mouth for brush and pen. She married a painter, who told her: 'In view of my profession and my character I cannot marry an ordinary girl.' She left him after having two children and lived quietly with her daughter as a Buddhist nun.

Frieda Pushnik, who was born in 1923 without arms or legs, was known as the 'Armless and Legless Wonder'. She toured America for six years with Ripley's 'Believe it or Not!' and in 1943 was hired by the Barnum & Bailey circus where she spent thirteen years before 'freak shows' were outlawed. Pushnik enjoyed circus life and said that she never felt exploited; after her act was banned she disappeared from public life and was never heard of again. It's hard to judge whether a decision to stop someone making their living in that way is justified. Part of me feels that if someone wants to star in a circus, it should be allowed, yet I wonder if she really did feel unexploited. And what is disturbing is the number of people – millions in her case – who got their kicks by paying to see her.

Leonardo da Vinci's right arm became paralysed towards the end of his life. He had always used his left hand for writing, but both hands for painting. After the paralysis struck his right shoulder, slowly creeping down his arm, he stopped painting but continued to draw. Antonio de Beatis, secretary to the Cardinal of Aragon, met him and wrote: 'Since he has been stricken with a certain paralysis of the right hand, no more

masterpieces can be expected . . . Although the said Messer Leonardo cannot paint any longer . . . he can still make drawings and teach others.'

All the foregoing examples prove that having only one arm is no bar to anything. Fame seems to supersede disability – few of these figures are remembered *because* of their missing limb: what they accomplished was in spite of their 'disability'. Many of them did things I could never do, but that is because I am no musician or military leader, not because I have one arm. It is true that there are people who never recover from the loss of a limb. Several case histories show that acceptance is not so easy and that not facing up to the reality was not peculiar to me. In fact, some people go to extremes to hide what has happened. A friend who has a stiff leg remembers that his father, who was very authoritarian and patriarchal, did not like his only son having a stiff leg; he particularly did not like his ungainly look as he ran about the tennis court. My friend used to practise hitting a ball against the blank wall of their house; this was pointedly stopped when his father got the gardener to plant a morello cherry tree against the wall.

Some patients are emotionally destroyed by amputation and lose the will to live. Cole Porter was badly injured in a riding accident in 1937, and at the time there was a strong likelihood that he would have to have his leg amputated. He refused to consider the possibility and was in pain for many years. He never got over the amputation of his leg in 1958, and never wrote another hit song afterwards. He considered that he had experienced a 'horrible maiming of the body' and that he was 'only half a man now'. Porter came so to dislike appearing in public that he did not attend the galas for his seventieth-birthday celebrations and said that no matter how great the pain he would rather have kept his amputated leg.[13]

An altogether trickier subject to assess is the worth of a limb. I

have mixed feelings when I read about people being awarded large sums of money for the trauma of having lost a limb. In May 1996, a young boy whose arm was ripped off by a chimpanzee at John Aspinall's zoo was awarded £132,000 compensation seven years after the attack. His mother, who did not appear in court, said that the money would help him lead a normal life. The newspaper report said that: 'Despite his lost arm, he is a dedicated swimmer with several trophies . . . "He deserves to lead a normal life and has so far managed to do that as best he can off his own bat," said Mrs McDaid (his mother). "It's hard watching him struggle to carry out everyday tasks, but we have to make him learn to do it on his own." '

In June 1997, *The Times* reported a case of a woman's ballroom-dancing days being finished after an alleged medical blunder left her minus her left arm. She was awarded £95,000. The article says that this formerly 'happy and outgoing woman was now constantly depressed about her appearance' and had never returned to her first love, Latin American dancing. When I read such articles I want to urge people like this to get on with their lives and not to collapse into pools of self-pity.

Putting a precise value on a limb would seem to me to be impossible. It is certainly true that day-to-day living can be marginally more expensive with one arm: an automatic car costs more than one with a gear shift, certain cheap items of clothing and shoes are not suitable for people with one arm, and there are various gadgets for use around the house – such as tin openers – which are an additional cost. But the expense of these things does not add up to a substantial amount of money. If money in a case like this is awarded because of trauma, it might be considered just as traumatic to have had an arm amputated due to cancer. It is not that I grudge these people their compensation – indeed no amount of money could compensate for the loss of an arm – but I find it difficult

to distinguish between different traumas and to understand why some traumas (accidents) should be financially compensated for and other traumas (illnesses) shouldn't. In *Fracture* Ann Oakley quotes that the stress of traumatic hand injuries is considered equivalent to the trauma and misery suffered by survivors of disasters, such as the sinking of the cruise ship *Estonia*.[14] And of course 'loss of hand' could be substituted for 'hand injury'.

After the horrific events of September 11th in New York, John Walsh wrote in the *Independent*[15] about families quarrelling over compensation and extracting money from the Criminal Injuries Compensation Authority, which:

> Like some bad-taste reward to 'make up' for the death of your daughter or parent, is morally repugnant to many. [But what's worse] is the CICA making up rules that penalise people for not suffering enough . . . if you saw it live on TV, you could get £20,000. But if you only saw the footage an hour after the attacks, you get nothing.

What kind of person could possibly make up such bizarre and unsettling rules? There's something rather childish in having to prove that 'my experience was worse than yours' and that a sum of money will make it all better. It feeds straight into the victim culture that ultimately turns out to be so detrimental to health and well-being.

CHAPTER 5

Exploring the World

During my last year at school, I was advised to take only three O levels. The nuns said I would probably fail them all if I were to take more, but I managed to persuade them to let me take the nine I wanted to take. I passed them all. Although this did wonders for my self-esteem, and showed me what determination could do, I was left with the uncomfortable feeling that because of this, and the fiasco over the school play, other people had no belief in my abilities. It was never even suggested that I should stay on at school and take A levels – in fact, I did them later – and although I remember being keen to leave school, I don't think I was really given the option of staying. My mother had never even been to school, having been taught by governesses, and so was unable to give advice, and my father would not have given much thought to a girl's education. So I left school when I was sixteen. Like most Catholic girls leaving school in the early Sixties, I had been educated for nothing very much and was totally unprepared for the 'real world'. The only female role models I had were those of wife or nun, and one thing I did know with resolute certainty was that I did not want to become a nun. I was absolutely terrified that I might have a vocation and used to pray to God that I hadn't, but I also thought I was being ridiculous in having to work so hard at not becoming a nun, because deep down I suspected that having one arm would preclude my acceptance into a convent. Why I thought this I don't know.

I had no idea what I was going to do; no one had as much as

mentioned a career. I suppose I was meant to get married, settle down and have children. But since at our leaving talk we had been told that men only wanted 'one thing' and that we must beware of them for that reason, I quickly found myself incapable of even talking to a man. Marriage seemed a very distant and frightening prospect. Anyway, I had doubts that anyone would want to marry a one-armed girl. So I left school with no plans, ambitions or ideas for the future.

In September, after leaving Ascot, I was sent to a finishing school in Switzerland. My parents drove me there; I loved the journey and the couple of nights we spent on the way, but I hated being left with a whole lot of strange girls. I never got to like the school (although I made some good friends), not because people talked about my arm – they didn't – but the point of going to Switzerland had been to ski, and that winter there was no snow. We skated round and round the ice-rink, with Madame watching us through binoculars from her chalet window, eager to catch us talking to boys from the local school. This attitude reaffirmed what the nuns had told us, that men were only 'out for one thing', and it made it increasingly difficult for me to divorce my adolescent fear of boys from my shyness at having one arm, and the awful possibility of one of them asking me about it.

Instead of having a crush on one of the local ice-hockey players like most of the other girls, my crush was on my French teacher, a blonde woman in her twenties who I thought was the most beautiful creature I had ever seen. I loved just being in the same room as her and hung on her every word, which did wonders for my French poetry. One day, on a train journey to find some snow, Mademoiselle Ponchon said: 'If you haven't married by the time you are twenty-six, I think you should sleep with a man anyway.'

I felt totally confused; here was someone in authority advising that I commit a mortal sin. She was about twenty-

eight, and I knew she had a boyfriend; the implication must be that she was sleeping with him, and if she was I feared that she might be damned and go to hell. I couldn't bear the thought, but didn't dare ask her if she was indeed sleeping with him. I didn't know what to think; she was a teacher and I still believed that those in authority must know better than I did. But I said nothing.

After two terms, I persuaded my parents to let me leave Switzerland; I was told that if I did leave and come back to London, I would have to do something constructive. I decided to do French A level that summer. There were only six weeks to go until the exam and I had not even seen the syllabus, let alone begun to read the set books. I was told that it would be impossible to take it so quickly. I managed to convince the authorities to bend the rules as I was certain that I was capable of doing it, and I proved myself right by passing.

Until I had to persuade the nuns to let me take extra O levels, my struggle had been about survival in a two-armed world, something I'd been able to manage, mostly silently, on my own. My success in those exams made me realise that I knew myself better than other people thought they did, and getting my A-level French confirmed this. However, my growing confidence in myself and my abilities was at odds with how I thought the world perceived me. I thought that I was considered slow and stupid because I had one arm, and it seemed as if I was endlessly having to prove that I was not dim-witted and brainless.

I have since discovered that it is a commonly-held belief that physical disability is linked with dimness, but at that stage it was alarming as there was no one I felt I could talk to about my fears. In *Triumph of Love*, Leona Bruckner says: 'It is a natural thing for people to associate physical incompetence with mental slowness.' The implications of this are vast: to be considered mentally deficient because one has a visible

physical disability means that life can be even more of a struggle. The disabled person has to be constantly proving that their intelligence is not impaired because they have lost a limb or are in a wheelchair. I'm sure that the majority of able-bodied people are completely unaware of this extra strain and would dismiss it as paranoia.

In the autumn of 1964, I went to Florence to learn Italian, to study the history of art, and to be 'finished' for the married life that was meant to be where I was headed. There were four English girls in the *pensione*; the two who were there when I arrived had already been in Florence for a while.

'Tell us what kind of man you like and we'll find you a boyfriend,' chimed Sarah and Roseanne on my first evening.

I panicked. 'I don't think I want a boyfriend.'

'Why ever not? Italian boys are great fun.'

'I've, I've . . . I've got one in England,' I lied through my teeth.

When the fourth girl, Susanna, arrived it was an enormous relief to discover that she did not want to be found a boyfriend either. While the other two sped around Florence clinging to the backs of Vespas, Susanna and I devoured the art galleries. I expect that not having to grapple with the problem of whether or not I *could* ride on the back of a Vespa was one of the reasons for my interest in art galleries, and I was still worried that men would find me unattractive. I learned to love looking at paintings, picked up a reasonable amount of Italian and, without ever feeling remotely 'finished', thoroughly enjoyed my short period in Florence.

By this time I had learnt to live quite comfortably with my one arm, provided it was not mentioned. I was a long way away from the character in Adam Thorpe's short story 'Sawmill', in the collection *Shifts*, where the loss of a limb is dealt with entirely unemotionally. Mason, who runs a sawmill

in Africa, loses an arm. 'Limbs, or bits of limbs, were lost like shillings on a club bridge night amongst the sawmill operators,' and the 'joke went that you lost weight twice in our company – once with fever, and once by having a bit lopped off, so you had to make it up with your belly.'

I was still desperate for my lack of arm not to be noticed, yet, unfairly, I felt that people ought to anticipate when I needed help in cutting up meat or opening tins. Among the people I lived with and met socially, it was never talked about. It was only in shops and restaurants that I was occasionally asked what had happened to my arm. It seemed easier to say that I had had an accident as a child, rather than having to explain that I had no idea what had happened, which would have seemed bizarre even to me, or later – when I discovered at nineteen, that it had been cancer – to mention that dread word.

Almost unbelievably, even as late as the 1950s, cancer was not mentioned in undergraduate medical syllabuses, and even today doctors still have a tendency to lie about a cancer diagnosis in a way that they never would about a heart ailment or many other illnesses. It is almost as if even doctors are still superstitious about mentioning the word; in France fewer than one in ten cancer patients know that they have the disease. Susan Sontag suggested that this is because cancer is still seen not only to be a death sentence but also 'ill-omened, abominable and repugnant to the senses'.[1] Even now, when I tell people I have had cancer, I sometimes notice them wince.

I had no wish to drive a car with gears and for an 'unrestricted' driving licence, as Sheri Coin Marshall author of *One Can Do It* did (she learned to fly as well), and so I learned to drive on an automatic car, the only concession being a 'necking knob' fixed to the steering wheel which helped with sharp corners and parking. 'Necking knobs' were popular in America in the 1950s when they were used by guys

on dates; one hand drove the car and the other arm was round the girl. I passed my driving test at the first attempt, when I was just seventeen, in a perfectly normal automatic car. Passing first time was a great relief, because I thought that 'they' would never allow me to drive on public roads if I was indeed retarded. Part of me still believed that the results of the O- and A-level exams could have been fudged in my favour in some way and had not really proved anything about my abilities. It seems extraordinary to me now, but I think I really did imagine that the external examiners might have been asked to look on me favourably because I had only one arm. Apparently, Picasso's Chilean 'protector and patron' Elena Errázuriz was so horrified by Blaise Cendrars's appalling driving, he whose writing had so altered when he lost his arm, that she tried to 'put a hex' on his car.

My parents bought a second car, an automatic, which I was allowed to drive almost whenever I wanted. Unfortunately, it was a DAF and no one else seemed to own or have even heard of a DAF. It was made in Holland, worked on a strange rubber-band system, and looked different from other cars, so that I felt people thought it was a car for disabled people and the only car I was capable of driving. The small DAF – a short-lived experiment – has long ceased to exist and now the company only makes big lorries.

In the autumn of 1965, I applied for a temporary Christmas job in a book-and-postcard shop in South Kensington. I was turned down on the grounds that I would not be able to put books into paper bags. They did not ask me to try to see if I could put books into bags, they just said no. I felt rejected, and could not tell anyone that that was why I had been refused the job. I considered it a real body-blow, but believed I had to accept it; no doubt 'they' knew best. One of the most difficult things to accept was that situations like this forced me to confront the fact that I had only one arm. I still wanted to

140

pretend that nothing had happened, and certainly nothing that would make any difference to my life. Yet I was being told that I couldn't do something, and I felt it was both unfair and untrue. In retrospect I wonder if this rejection helped fuel my independence and eventually became the inspiration for me to open my own bookshop. Perhaps it is these seemingly small battles and victories – overcoming the initial rejection on the scuba-diving course and proving the presumption of my 'inability to bag books' wrong – which have made me so determined. Instead of working at the shop in South Kensington I got a Christmas job in the card department of Harrods, where I certainly managed all the tasks asked of me.

When I was eighteen I did a Montessori teacher's training course. I could not have chosen anything more unsuitable. Children would inevitably ask about my arm, and I did not know how to deal with their questions. I don't think that I got much that was positive from the training and from being a teaching assistant, other than an increased feeling of in-adequacy. The principal made me take an English-language test, which I am pretty certain no other native English speakers were made to take. A longer-term temporary solution came when, aged nineteen, I was asked to go back to my old school, St Mary's, Ascot, to teach the lower school for a year. The children in the lower school ranged from eight to eleven and I taught them history, geography, English and nature study. Children of this age are not so direct with their questions, but I suspect they were given a talk about my arm before I arrived, and I had a very happy year learning how to teach as I went along. Although I was content and spent much of my spare time both reading and drawing, I knew at the end of the year that I was not cut out to be a teacher.

When the new children arrived and were homesick, I was exceptionally kind to them, but when – within days – they

recovered and took the upper hand, I was left trying vainly to impose some kind of discipline. Through the reading that I did that year, I began to understand how little I knew about everything, but I also knew that I wanted to learn as much as possible; I realised that I did not know enough about life to be a good teacher.

So I left Ascot and for the next eighteen months I worked at W. J. Bryce, a bookshop near the British Museum. I had the best possible training in bookselling from Ivan Chambers, the manager, an old-fashioned bookseller who had a withered right arm. He demonstrated that this was no handicap to being a good bookseller and that putting books into bags was far from impossible. Working at Bryce's consolidated my love of books and increased my desire to learn; I began to think that perhaps there might be some future for me in books. I really loved the job; I was only paid £7 a week, but I would willingly have worked for nothing.

Ivan Chambers died on New Year's Day 1998. At his memorial service, in Axminster in Devon, I was asked by his daughter if I would read out the retirement speech he had made at a lunch given for him in 1971 by the Society of Bookmen. I introduced the reading by saying that he and I had had an unstated link as booksellers (I don't think he or I had ever spoken of it) in both having only one functioning arm, and I recounted how I had been refused that early job in South Kensington. This was the first time I had acknowledged in public, albeit behind the safety of a microphone, that I had only one arm. I looked on it as an experiment, and it instantly seemed like a positive thing to have done, like getting over an immense hurdle. It also put it into perspective; having one arm was no big deal, just an aspect or part of me which it was both silly and unnecessary to hide. Public speaking remained one of the last things that truly frightened me, so to speak in public about my missing arm felt like a great achievement.

I had my twenty-first birthday while I was working at Bryce's, and was given a brand new automatic white Mini by my parents. It was a complete surprise, delivered to the house while I was having breakfast. I was absolutely thrilled, but to me it was much more than a shining new white car. It represented my growing independence, and it put the stamp on my being part of the normal world.

I left Bryce's in December 1968. I was sad to go, but I wanted to expand my horizons. I had decided to go to America with my friend Susi. We arrived in New York in January 1969 in a snowstorm. I could not believe that a city the size of New York could grind to a halt because of snow; there was no traffic and people walked for miles to go to parties. I was immediately entranced.

In New York, for the first time in my life, I began to feel that I was a person in my own right who might have something to say. People asked me questions and seemed genuinely interested in my answers. Previously I had always said what I thought other people wanted to hear and had zero opinions of my own. Now I was starting to think for myself. And I began to be able to talk about my arm. The American approach was completely different from the British one, and refreshingly direct: they would ask what had happened and were not embarrassed by the answer. Their lack of embarrassment transmitted itself to me, and I found myself beginning to open up.

For me, America was where I began to grow up. Susi and I had terrific fun in New York; we met many people and went to endless parties. I also fell in love.

Brian came from Rhodesia and was working for Philip Morris. He and I would spend Saturday afternoons in the Natural History Museum, years before Woody Allen and Diane Keaton made it fashionable. But I had come to the States

to see something of the country so, after a month in New York, Susi and I set off round America by Greyhound Bus, having been seduced by the slogan '$99 for 99 days'. Waiting for me in Washington was a compass from Brian, so that I could get back to him safely, he said. I was thrilled by this.

On the way to Florida, where we were going to stay with some friends of Brian's, we passed a Philip Morris factory; this seemed like a good omen and had me immediately reaching for my little gold compass. We stayed with the Mosses in Coral Gables. They never stopped telling me how wonderful were both Brian and – something of a shock – his Italian girlfriend! Brian had told me that he was no longer seeing her, yet his great friends were talking of them as if they were still very much a couple and about to get married. I loved hearing them talk about Brian, but I was also upset as he was never mentioned without her.

Mr Moss's first wife had had only one arm, so he was one of the first people I talked to who understood what it was like, without being in the least bit patronising. He realised the importance of independence and understood my desire not to be thought different.

'When people noticed that I wasn't helping my wife to do things – they always looked critical. I don't think anyone understood how important it is to allow someone to do things for themselves and it was something I only fully appreciated with time,' Mr Moss told me.

A letter from Brian was waiting for me in St Paul, Minnesota. By now I felt that the compass was doing its work and that I really was on my way back to him. I did not want to think about the Italian girlfriend who might well have moved back into his life during my ten-week absence. When we finally arrived back in New York, I had dinner with him. His girlfriend was conveniently forgotten for the evening, and I'm sure I didn't ask about her, as I wouldn't have wanted to hear

anything unpalatable. Also I didn't yet have the confidence to believe that anyone would like me enough to have an exclusive relationship with me.

It was that evening that I decided I wanted to stay in America. I had also just heard from my mother that she and my father had decided to sell the house in Knightsbridge in which I'd grown up. I was devastated – that was home. I never saw it or many of my possessions again, and I'm sure that influenced my decision. To remain in New York meant getting a job, for which I certainly did not have the right visa. But one can do most things if one is in love and I was determined to stay. I walked the streets of New York applying for jobs in every shop and every consulate I passed. Eventually, through a contact, I got an interview at the Archives of American Art; now part of the Smithsonian, it was then an independent organisation which catalogued the minutiae of the lives of American artists. I was paid by the hour and could come and go as I liked, an ideal arrangement.

Once I'd got this job, others came easily. I had the most fun working for a doctor of tropical medicine on Park Avenue. I was the receptionist and had to answer the telephone by saying, 'Kean Laboratory'. Most Americans would crack up at my pronunciation and ask me to repeat what I had said. Art Garfunkel was one of the many famous people who came in for their jabs before travelling abroad. I have never felt as financially well-off as when I was doing those two jobs in tandem; I was paid in cash, and as I was living with my cousin I was not paying any rent. For the only time in my life I felt free to hail cabs. Most weekends during that hot summer I would catch a train up to Fishers Island, a bastion of WASP America at the end of Long Island Sound. My aunt and uncle, who owned a house there, were away for the summer and I was allowed free run of it with my cousins. Ours was very different from the normal ultra-conventional Fishers Island house-

holds. Our weekend guests were writers and painters; we had huge picnics on the beach and stayed up late listening to Fauré's *Requiem* through a haze of dope and drink. It was a revelation to me. Brian came up with me once, but as I met more people I gradually saw him less and less. There was no dramatic ending between Brian and myself – our relationship just dwindled away.

I also started doing voluntary work for a toxoplasmosis project at New York Hospital; there was still something about hospitals that I loved, but I could never envisage medicine as a career. My perception was that anything medical needed two arms; I did ask about the possibility of doing some kind of medical course, but did not get any positive responses. I was still not confident enough to believe in myself, and I had no idea what I really wanted to do.

During the summer of 1969 I spent one long weekend in Annisquam in Massachusetts with the family of a man I scarcely knew, but whom I found attractive. On the first morning he took me out in a sail-fish, a tiny sailing boat, which I promptly capsized. We both ended up in the sea, me thinking it was very funny and laughing hysterically, and he feeling acutely embarrassed that this should happen in front of his friends. Although he certainly knew I only had one arm, he must have forgotten that this might make sailing difficult, although not impossible (Millie Cleat, the heroine of James Hamilton-Paterson's novel *Amazing Disgrace*, is a one-armed sailor). I did not understand the first thing about pulling the correct ropes and was still not confident enough to tell him that part of the reason we had capsized was because I could only pull one at a time; in a way, of course, I hoped he had forgotten. There always seemed to be a conflict between not wanting people to notice that I had only one arm, yet needing them to know so that I would not be asked to do the impossible.

146

Our 'relationship' ended before it had properly started. It was at times like this that I really hated having one arm, and could so easily have retreated to wallow in self-pity. Luckily America was so full of new things, people and ideas that I didn't have time to dwell on anything for long.

One day when I was walking down 42nd Street a photographer approached me and asked if he could take my photograph, as he was doing a project on Vietnam veterans. I tried to convince him that I was no 'Vietnam vet', but he would have none of it. I rather hope that one day I might come across my photograph in a book about the Vietnam War.

I stayed on in New York, and during that autumn I began to make friends in the museum world. I spent many happy weekends having picnics in the gardens of The Cloisters (which houses much of the medieval collection of the Metropolitan Museum; it was founded by John D. Rockefeller and looks out over the forested Palisades on the Hudson River) and watching a seemingly endless succession of eclipses from the roof.

My parents came to visit me that November, their first trip to America. I gave a party for them and proudly introduced them to my new American friends, at least to some of the more respectable ones. By December my visitor's visa was running out, so I decided to go home for Christmas, but looked forward to returning to New York, and to what had now become a permanent job for Dr Kean on Park Avenue. I loved living in New York; my narrow world had expanded and I was feeling more and more confident about myself and my arm. I had begun to feel that I was a person in my own right, not just a member of my family.

On my return to London I went to the American Embassy to renew my visa. I was confident of my chances; I had been living rent free with my cousin and I had a letter from Dr

Kean saying that I was indispensable to his laboratory. I was shattered when they turned me down. My life was now in New York and I desperately wanted to go back. By pulling every string imaginable, I obtained a visa with the proviso that I did not stay longer than two months. I arrived back in New York at the end of January 1970, knowing that I did not want to return to live in London. A friend was planning to go round the world and she asked me if I would join her. This was just the opportunity I was looking for, so after some tearful farewells at the end of March, I flew back to London for a week before embarking on a journey round the world.

I met up with Virginia in Tunis, having lost my well-planned luggage – two pairs of jeans, one dress, one jersey and specially chosen books and music cassettes – on the first leg of the journey between London and Paris, necessitating a mad morning rush round Paris buying toothpaste, clothes and books, before catching my flight to Tunis. I was a last-minute addition to Virginia's trip and she had already decided which countries she wanted to visit; I was quite happy with this arrangement, as I was almost totally ignorant about other peoples and cultures. Everything was new and exciting.

Egypt was where I first encountered real poverty and real heat. I was shocked by seeing children not reacting when flies infested their eyes, and my diary notes report dismissively that I was 'disappointed' with the Pyramids. The way different cultures view disability is interesting but it is difficult to know what the Ancient Egyptians thought of someone with a disability. Mummified corpses show physical deformities, but there is no mention of the deformities in medical papyri. However, it seems that disability was no barrier to success; a doorkeeper in the eighteenth or nineteenth dynasty, who is shown in paintings with a shortened leg and a stick, achieved high office despite having had what might have been polio.

The Pharaoh and his court adoring the sun, from Manners and Customs of the Ancient Egyptians *by John Gardner Wilkinson vol. III, 1837*

I was delighted to see, sculpted on the tomb of the Pharaoh Akhenaten at Tel-el-Amarna (1500BC), the Pharaoh and his court portrayed adoring the sun; the rays are outstretched towards them and each ray terminates in an open hand. In Ancient Egypt a symbolic hand in the sky was used to represent the celestial power of the sun-god Ra, and I found this a most striking example of the use of the hand as a symbol of power, as well as of protection. Another example can be seen at Sir John Soane's Museum in London: the alabaster coffin of Seti I, father of Ramses the Great, shows the Great Hand, the Supreme Power which rules heaven and earth.

Once you start looking – and my travels allowed me to start doing this – you discover that all over the world and throughout history, hands appear in art and literature, mostly as symbols of power and strength, although in different cultures they can mean diverse things. It is clear that, in art, the hand was often used as a symbol for communication and

this is true even in the most primitive representational drawings.

In *Murray's Handbook to Spain*,[2] Richard Ford thought that the large upright hand over La Torre de Justicia in the Alhambra was a talisman against the much dreaded 'Evil Eye . . . at which Orientals have always and do still tremble'. When he saw that hand Ford considered that it was an emblem of hospitality and generosity, the 'redeeming qualities of the Oriental'. Others thought it represented the five principal commandments of Islam – the fast of Ramadan, pilgrimage to Mecca, almsgiving, ablution and war against the infidel. The Hebrew *jadh*, the hand of God, is the Oriental symbol of power and providence. Moorish women who had converted to Christianity wore small hands of gold and silver round their necks just like the Neapolitans.

The right hand of Fatima, daughter of Mohammed, is a powerful amulet that appears in many parts of the world; it is found above doorways, in cars, on jewellery and in many other places. Also known as the *khamsa*, literally 'five', it has recently been used by peace activists in the Middle East as a symbol of the similarities between the origins and traditions of Islam and Judaism.

Among Arabs the right hand is held to be the 'hand of honour' and the left hand the 'hand of dishonour'. Food can only be eaten with the right hand – I sometimes wonder what they think of me in Muslim countries, because although I have my right hand, I have to use it for everything, including 'dishonourable' things. Even today the hands of thieves, murderers and adulterers are cut off in Arab countries, which, when I read about it, makes me wince. Under Sharia law a hand can be amputated as punishment even for stealing goods worth less than $8.

Rituals involving hands are found worldwide. J. G. Frazer gives many fascinating examples, including that to be found

among the Bageshu in East Africa, where a man who has killed another may not enter his own house the same day. He must kill a sheep and smear his chest, right arm and head with the contents of the stomach and, because he may not touch food with his hands, must eat holding two sticks.[3]

When the Kurnai of Victoria in Australia saw the Aurora Australis, they exchanged wives for the day and swung the severed hand of a dead man towards it shouting: 'Send it away! Do not let it burn us up.'[4] The warriors of the Theddora and Ngarigo tribes in south-eastern Australia used to eat the hands and feet of their slain enemies, believing they would acquire some of the qualities of the dead. The Dyaks of Sarawak used to eat the palms of the hands and flesh of the knees of the slain in order to steady their own hands and strengthen their knees.[5]

But I wasn't studying anthropology: I was twenty-two and travelling east. In Turkey for the first time, I was horrified by the old ladies in black who all seemed to notice immediately that I was missing an arm and tried to touch me where my arm wasn't – something I wasn't used to. As the hand is looked on as both evil and good, they were probably tying to counteract the malign influences of the evil eye and believed I could bring them luck; while I hated this, I equally hated to be thought rude. Virginia, my travelling companion, would get the giggles, so after an initial attempt to brush away inquisitive hands I grimaced and learned to put up with it. It has never happened on subsequent visits. Perhaps, as I got older, I put up stronger invisible barriers, or maybe the places I visited have become more sophisticated and have lost the belief that touch counteracts the evil eye.

In Santa Sophia in Istanbul, near one of the great marble columns close to the mihrab on the south side, seven feet from the floor, there is a white mark in the dark purple which looks exactly like a spread-out hand. It is impossible to know

whether the piece of marble was chosen because of this unusual marking, but it is tempting to think that it was.

In Iran, I began to appreciate the importance and pleasure of books about places that are more than just guidebooks when we were taken from Persepolis by Land-Rover to a Sassanian ruin, the Palace of Ardeshir, built in AD 224. Reading Robert Byron's book *The Road to Oxiana* on the spot and among the goats, we discovered that this was where the squinch – the arch across the angle of the two walls that support a dome – had originated. Later I found in the British Museum a Sassanian seal[6] which shows a hand with the thumb and index finger touching. This is quite a common motif. Sometimes it is more ornate, with ribbons, wings, flowers, or flying birds perched on the fingertips; the gesture is thought to be auspicious, being a greeting or invocation.

Afghanistan was our next stop; we went round the country by bus, travelling through green river valleys and past snow-capped mountains, often sitting astride the luggage on top. In retrospect, I am not sure how I managed to climb up on to the top of a bus. Climbing perpendicular ladders is extraordinarily difficult with one arm, as each time you let go to move your hand up a rung your weight throws you backwards and you are in danger of falling off. But somehow I did it. In Kabul we stayed with a widowed Anglo-Indian woman, whose late American husband had started Ariana Airlines, and her three half-American sons; she was very involved in the local Christian church which had its opening ceremony on my birthday – 17th May 1970. At that time, Afghanistan was a relatively peaceful country, although even then in certain places the mullahs were inclined to throw acid into the faces of girls who went to school unveiled. But at least girls were allowed to go to school and there didn't seem to be any problem with practising Christianity, at any rate not in Kabul.

We then spent three very hot months travelling round

India by the cheapest form of public transport; I became adept at throwing my sheet through an open train window to reserve my place on the luggage rack, which then became my bed for the night. In India there are so many people who lack limbs that a foreigner with one arm was not considered exceptional. Many children are maimed at birth so as to render them more effective beggars for their families. When stumps were thrust in my face, the temptation, which I sometimes succumbed to, was to indicate that I too had a stump; this, unsurprisingly, rarely produced even a flicker of acknowledgement. The attitude to the disabled in India is different from ours in the West. Mick Brown, initially reluctant to give money to beggars, wrote in *The Spiritual Tourist* that he had relented and given money to a man suffering from leprosy whose arms had rotted away. His taxi driver had looked at him sceptically and said: 'These people don't want to work.' Brown replied: 'But he has no arms.' 'He could use his feet,' came the answer. This way of thinking in some ways shows an acceptance of the individual often lacking in the West, but at the same time a want of compassion and understanding that our Western sensibilities expect.

In India, I found hands represented in art everywhere. Siva Nataraj, lord of the dance, has four arms: in his upper right hand he holds a drum signifying creation; the upper left hand holds a flame, meaning destruction and the dissolution of form; the lower left points the way to liberation, and his lower right hand is raised in blessing, expressing preservation. Kali, the three-eyed goddess, is often shown with her hips ornamented with a girdle made of dead men's arms.

Each subtle hand gesture or *mudra* of the Buddha is important, and if you know the significance of the hands, the experience of looking at a statue of the Buddha becomes far more meaningful.

Hands also interpret dance. In gestures that have evolved

Dancing Shiva, South Indian nineteenth–twentieth century

from the alphabet of basic hand poses, or *hastas*, the hands actually become the vehicle of 'dance speech'. According to classical treatises, there are about thirty-one single hand gestures and a further twenty-seven combined gestures; each gesture has many rich meanings and is differently interpreted by each school of dance.

Palmistry, still much practised in India, is defined in the *Shorter Oxford Dictionary* as 'the art or practice of telling persons' characters or fortunes by inspection of the palm of the hand; chiromancy'. It is a very ancient skill: in India during the Vedic period and in Ancient China, the study of hands was associated with the study of life, the left hand being the past and the right the future. Jung wrote of alchemy that, 'When an idea is so old and so generally believed, it must be true in

some way, by which I mean that it is psychologically true' – and alchemy is not as old as palmistry. Inevitably, there are people who practise palmistry without knowing much about it, so it is often thought of as just another fairground amusement. In reality, changes in mental activities during life are actually registered by alterations in the lines of the palm of the hand, and medical science has demonstrated that generations of continual use have caused the nerves connecting the brain to the hand to become highly developed. Palmistry is one of the arts which reflect the ancient pre-platonic belief that the material world is merely the outward copy of the inner world, and that the pattern of the whole is reflected in each of its parts. Thus, since each is part of the whole, everything has meaning.

There is far more to reading hands than just looking at the lines; the art is to study the hand as a whole. There are many different hand types and each finger is relevant in an analysis. Throughout history many people have been involved in palmistry. Homer wrote a treatise on the lines of the palm. Adrien Adolphe Desbarolles (1801–86) studied the hands of the most interesting people of his day and wrote *Les Mystères de la Main* (1859), which went into twenty editions during his lifetime. Count Louis Hamon (1866–1936), known as Cheiro, had a legendary ability as a palmist; his writings were notoriously inaccurate, but the testimonies to his genius in palmistry are legion. However, it is difficult to separate fact from fiction in his life, since he had a sense of importance verging on megalomania. In his *The Book of the Hand*, Fred Gettings goes so far as to recommend that 'one should get into the habit of taking [hand]prints of every person one meets socially'!

The Indian greeting *namaste*, which involves joining two hands together, seems rather lopsided and incomplete when done with one hand – almost as if it's only half a greeting and something is being held back. Much the same gesture of

A sixteenth century palmistry consultation from Cocles's book on chiromancy

joined hands is recognised as prayerful, and an outstretched hand, palm upward, is universally known as a sign of begging. But gesture, or what one does with one's hands, is important; gesture is regarded as in Latin the outward (*foris*) physical

expression of the inward (*intus*) soul and the relationship between the body and soul is sealed by it.

Shaking hands is a very ancient way of indicating friendship, and we can tell a great deal about someone from their handshake. When two Kurdish men meet, they 'grasp each other's right hand, which they simultaneously raise, and each kisses the hand of the other'.[7] The Toda of south India raise the open right hand to the face, with the thumb on the bridge of the nose, to express respect. It is important to know the customs of different cultures, as in Europe a similar gesture would be considered obscene.

The scriptures are full of examples showing the importance of manual gestures. For example: 'And it came to pass, when Moses held up his hand, that Israel prevailed: and when he let down his hand, Amalek prevailed.'[8] In the fourth century, St Ambrose refused to let a friend into the clergy because his 'gestures did not have the necessary propriety'.

It is possible to evaluate the importance societies gave to the inner world by how they reacted to outward gestures: by the early Middle Ages the ethics of gesture had changed and the body had become the 'site of sin' – St Augustine barely mentions gesture. The medieval audience was knowledgeable, so hand gestures had to be thought about carefully; in depictions of the crucifixion there are often problems with gesture, since if the hands were shown in rigor mortis with the fingers curling realistically inwards, people would have criticised the artist for not depicting Christ as supernatural. The history of Western art is filled with incidents showing the importance of hands and hand gesture and these become hugely significant in medieval art where every gesture is loaded. A picture of a hand is also regarded as a representation of God. The symbolic value of the hand in art is degraded when it becomes a more obviously human appendage, but its significance is universal. In a mosaic at Ravenna, Christ and

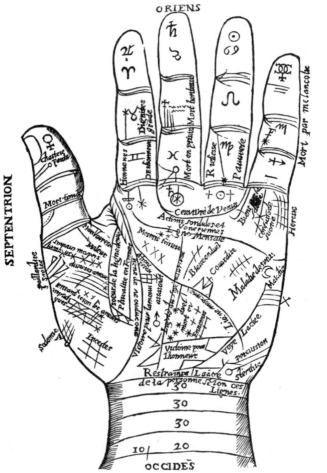

Position of zodiac signs in the hand from Jean Baptiste
Belot's Oeuvres, *1647*

two angels hold up their right hands in benediction, and in the
Last Judgement at Torcello it is the hands which are expressive
of despair.

Even hands and arms detached from their bodies can have great power. Frazer, in *The Golden Bough*, quotes Fray Bernardino de Sahagun describing how the Aztecs of Mexico used the left forearm of a woman who had died in giving birth to her first child to plunder a house:

And the ones known as men who danced with a dead woman's forearm, who crazed people, when perhaps they would commit a robbery somewhere and spirit something from someone's home, would adorn the image of One Wind [Quetzalcoatl]. It went as their guide, at their head, guiding, marching in front. And they went bearing with them the forearm of a woman who had died in childbed, and could not give birth to what was in her womb. When they took it from one who died, they only stole it during the night; they cut it off at midnight . . . And when those who danced with the forearm would sometimes destroy or rob people, one person carried and bore the forearm of the woman who had died in childbirth on his shoulder. It was the one on her left, her left forearm. When he came to reach one's home, but had not yet entered the house, first of all he struck the midpoint of the courtyard with the forearm. Twice he struck. On reaching the entrance of the house, he struck the portal, the lintel, and then he passed by the square, wooden pillar. Then he once again struck there before the hearth . . . When such came to pass, it was said, no more did one speak out. No one could be aroused. Verily, the householders had swooned with fear. And some of them were in a deep sleep, snoring and rumbling; there was sleeping as if one's nose were broken.[9]

There are marked similarities between how, and for what purpose, the Mexican-Indians used amputated limbs and how they were used in Europe. In 1870 in Walsall, Staffordshire, the mummified arm of a child was found with a sword. This

relic became known as the 'Hand of Glory'. Generally a 'Hand of Glory' was cut from a hanged felon, pickled with salt and dried in the sun. It could then be used to hold a candle made from the fat of a hanged man. Light from such a candle was meant to stupefy anyone who saw it and could enable a burglar to ransack a house without being caught. It was generally felt that the candle's flame could not be blown out by any ordinary person, that milk was the only liquid which could extinguish it, and that if any member of the household was awake it would not light.

J. Brand's *Popular Antiquities of Great Britain* states that sometimes the dead man's hand is itself the candle, or bunch of candles, with all the withered fingers being set on fire.[10] In seventeenth-century Germany it was prescribed that the thief's candle should be made of the finger of a newborn or unborn child, and robbers used to murder pregnant women to extract 'candles'.[11] There is a popular French superstition that the mandragora or 'Hand of Glory' may be found by digging at the root of a mistletoe-bearing oak.

This sort of superstition appears in a short story by Thomas Hardy called 'The Withered Arm'. Farmer Lodge's new wife has her arm seized by a spectre in the night, making it wither. She is desperate to find a cure as her marriage starts to go wrong *because* of her increasingly disabled look. She is told that the only solution is for her withered arm to touch the neck of a man who has been hanged. She manages to find a recently hanged corpse, with terrible consequences.

Arm, hand, fingers – I lost them all. The Dueña Alfonsa in *All the Pretty Horses* by Cormac McCarthy has two fingers missing:

> 'I lost my fingers in a shooting accident,' she said. 'Shooting live pigeons. The right barrel burst. I was seventeen. Alejandra's age. There is nothing to be embarrassed about. People are curious. It's only natural . . . Scars have the

Mandrake roots in the form of human figures, the mandrake
plant and a root of ginseng, n.d.

strange power to remind us that our past is real. The events
that cause them can never be forgotten, can they?'

There is something reassuring about her realistic approach –
she understands the inevitable curiosity about any differen-
tiating marks that people might have. Frazer records many
instances of finger sacrifice. In Tonga fingers are used as a
sacrifice to the gods in order to aid the recovery of a sick
superior relative. In southern Africa both 'Hottentot women
and Bushwomen cut off a joint of a child's finger, especially if a
previous child has died. The sacrifice of the finger joint
is supposed to save the second child's life . . . Some South

African tribes believe that to cut off the joint of a sick man's finger is a cure.' And in North America: 'Among the Blackfeet, in times of great public or private necessity, a warrior cuts off a finger of his left hand and offers it to the Morning Star.' In India a woman who 'has borne some children, terrified lest the angry deity should deprive her of her infants . . . goes to the temple, and, as an offering to appease his wrath, cuts off one or two fingers of the right hand'.[12] Since some women would do this repeatedly, the British authorities tried to ban the custom. In nineteenth-century India, thieves had their right hands severed and a custom of the invading Doomkees (a savage hill tribe) was to kill the women and cut off both hands of all the children.

Seneca recorded finger sacrifice at Kleonai, and Pausanias records that there was a sanctuary of the Furies, or Erinyes, near which a small mound called the Finger Memorial showed a stone finger. The legend says that Orestes, who had killed his mother, was driven mad by the Furies until he bit off his finger; at this point the black Furies turned white and Orestes performed a sacrifice to them. This partial sacrifice saved the life of the whole man. Such finger sacrifice is a common motif in both folklore and fairytale: the hero is thrown a ring by an ogre which he puts on, but which he cannot remove. Therefore he bites off his finger and throws it with the ring to the monster: 'By the loss of a member I saved the whole body from imminent death.'

The tradition of partial mutilation or sacrifice to save the whole or to save another's life was remarkably similar all over the world and was deemed to be effective. Someone thought the same applied to me: in a letter written just after my amputation, the writer hopes: 'That the cause of the trouble has been arrested by her sacrifice'. There is evidence that finger sacrifice was part of palaeolithic ritual, in that mutilated hands appear in cave paintings in France and Spain dating back

Shrine of St Patrick's hand, from The Trias Thuamaturga
or Three Wonder-Working Saints of Ireland
by Mary Cusack 1829–99

thirty-six thousand years, and amputated limbs – although it is
not known whether these were sacrificial – have been found at
neolithic sites.

Hugh of Lincoln (d.1200) was an avid collector of bones
as relics, so when he arrived at a monastery in Fécamp in
northern France which owned an arm of Mary Magdalene he

was keen to get a piece of it for himself. He unwrapped the arm from its bindings and tried to break off a piece with his fingers but finding it too hard, to the dismay of the monks, he set to with his teeth. He justified his actions by saying that since he had taken the body of Christ in Communion why shouldn't he bite the arm of the Saint?

The significance that people give to hands and fingers becomes apparent when you start investigating what they mean. The fingers of the hand have specific uses and names.

The thumb (in Latin *pollex*, from the verb *pollere* – to have power) is very flexible; the word poltroon is derived from *pollice truncato*, one so cowardly that he had his thumb cut off in order not to fight – although if you ask to have your thumb cut off I don't think you can be that cowardly. When a person is close to death, the thumb loses its power and falls in on the hand, an indication that the will to live has gone.

The fourth or ring finger is more or less protected by bands of tendons on either side, making it less liable to injury; it was because of this that it was chosen as the matrimonial ring finger, and the ancients thought that this finger was connected to the heart by a nerve.

In cabbalistic terms each finger represents a planet: Venus rules the thumb, the index finger is ruled by Jupiter, the third finger by Saturn, the fourth by the sun and the little finger by Mercury. Mars rules the palm and the moon the heel of the hand.

'We adorn our fingers with rings, and a jewel is displayed on every joint' (Seneca). The practice of wearing rings is ancient and they have an interesting and symbolic history. Although rings were sometimes badges of slavery, more often they were worn as marks of high esteem or authority. In the investiture of English sovereigns the ring plays an important part; however, this hasn't always gone smoothly – during the

coronation of William and Mary, the ruby ring meant for Mary was placed on William's finger by mistake.

References to rings in the Bible abound: 'Pharaoh took off his ring from his hand and put it upon Joseph's hand',[13] and when Judith arrayed herself to seduce Holofernes she put on rings. In Roman times, when a dying person gave his ring to anyone, it was a mark of great affection. The circular shape is a symbol of eternity. Rings were also given as tokens and were sometimes worn as charms against disease.

The custom of wearing jewelled rings probably arose from the idea that each precious stone was supposed to possess special magical virtues, which it then conferred on its owner. In Bromsgrove church in Staffordshire there are monumental effigies to Sir Humphrey Stafford and his wife (1450); her hands are lifted in prayer, and on them she wears a profusion of rings with a great variety of designs.

Fred Gettings writes, in *The Book of the Hand*, that if a person wears a ring on the little finger, the finger of Mercury, it means that they have 'some imbalance relating to intimate relationships'. Testing this theory by observing people, especially men who wear signet rings, can be quite amusing. I have to confess I wear three rings on my own little finger. I believe that it is meant to be tempting fate to wear a ring on one's wedding-ring finger before one is married; for years I decided that I wouldn't wear a ring on the fourth finger of my right hand, not having the conventional left one, but when by the age of fifty I still hadn't got married, I decided to disregard that superstition.

Back in what was then Ceylon, Virginia paid no attention to the fact that I had only one arm. In Sigirya, you could climb up the steep rock-face by means of a ladder which swayed in the strong wind. We had met a girl who was desperate to get to the top but wouldn't go on her own.

'I can't go up there,' said Virginia. 'I get terrible vertigo.'

'So do I,' I countered. 'Anyway, how can I climb that swaying ladder with one arm?'

'Ellen wants to go to the top – don't you think you *should* go with her? She's come here specially.'

'Yes, I really do want to go,' said Ellen.

'Virginia, I can't – come on, think about it!' I said.

'You managed to climb on to the top of the buses in Afghanistan,' she retorted.

'That was different – they didn't move in the wind,' I protested – feebly by now.

And so it was me who was persuaded to climb the swinging ladder. It was a seemingly endless climb, a nightmare. I lay at the top shaking with fear, knowing that coming down was going to be just as bad. It was. I don't think I've ever quite forgiven Virginia for making me go up there. Forty years on, I can't understand why I agreed to do it. I am sure that her version of events is quite different from mine; in fact, she claims to have forgotten the whole incident. We are still good friends.

In rural Nepal the feeling was very different from that of India; children crowded round, fascinated by me. They proudly led me through their village showing everyone the stranger with one arm, then they sat me down and plied me with corn as we exchanged names. It seems that uneducated people are far slower to make judgements and far more accepting of how one is. Perhaps there is less of a norm. On what was becoming rather a whistle-stop tour we then got week-long visas to Burma. In Mandalay we stayed in a Sikh temple and met some young Burmese girls on the river who covered our faces with their sandalwood pastes.

I was interested in travelling to as many countries and seeing as much as possible, so when Virginia had to go back to New York from Thailand because her grandmother was dying, I travelled on alone. I was sad to say goodbye to her; we had had

our problems, but we had been with each other twenty-four hours a day for five months. I had learned much about travelling, but at that point I had never done it on my own. I made the decision to continue, feeling that I would probably never again be in that part of the world.

The first place I went to on my own was Singapore, where I had friends, and then on to Hong Kong, where I also knew people. In Japan I was truly on my own; I stayed in Japanese inns, ate Japanese food and had steam baths and massages. Being naked among so many petite Japanese women made me acutely conscious of my whiteness, my size and my one arm. As a novice in the steam-bath world, I chose the largest and flabbiest woman and followed her around copying her every movement. Goodness knows what she thought.

Nearing the end of the trip, I went to Hawaii. In Honolulu, I rented a car for the first time in my life and drove around watching the surf and listening to loud music on my car stereo. I had been nervous about renting a car, thinking that there might be a problem with the insurance because I had only one arm – car insurance for the disabled can be higher in the UK – but as most cars in America are automatic no questions were asked.

I had been travelling for almost a year, but when I arrived back in England in the winter of 1970, I was no closer to knowing what I wanted to do.

I spent that winter job-hunting and looking for a flat. I applied for a variety of positions, but since I was not qualified to do anything and had no idea what I wanted to do anyway, it was a dismal process. I did the odd bit of posing for a portrait-painter friend, but I did not enjoy being back in England and felt generally fed up with life. After my parents sold our London house, they bought two adjoining flats. One was to be for them and one was meant to be for my sister Liz and

myself. As soon as I saw it I knew that I had to get my own flat and move away from home. Living in America, and travelling, I had felt independent and thought I had managed to cut the umbilical cord; I was horrified to discover that the moment I returned to England I had begun to feel like a small child again. It was quite a battle to persuade my parents that I did not want to live on top of, or rather beside, them; instead, my sister and I eventually found the perfect flat, up three flights of stairs, some distance away.

The following March I was invited to go skiing in Austria. As no job had materialised, and I felt that anything was better than staying in London, I accepted. I had nine days' skiing. On the tenth day, I got up very early with a friend and we went to Zurs from St Anton. He and I were skiing ahead of the party and, at the bottom of the very first run of the day, the tips of my skis ran into frozen snow-plough tracks. My bindings did not release and for a long and horrifying moment I thought that my leg had snapped off between the ankle and knee. I was unable to move, but I had fallen almost at the doctor's door and I was quickly carried inside. This doctor took one look at me and said there was nothing he could do and that I had better return to St Anton where the doctor to the Austrian ski team, Dr Otto Murr, had his clinic. My leg felt pretty numb but I remember the pain in my shoulder each time I was moved; it later transpired that I had broken my collar-bone as well as my leg. Dr Murr said that he had never seen such a bad break and that he could do nothing either. I had been advised to return to England if I ever had an accident, but when you are lying, unable to move and drugged with painkillers, it is impossible to make practical arrangements. The last thing I remember that day was Dr Murr, who spoke virtually no English, saying, 'OK, I see a challenge.' I woke up hours later with my leg in traction, like a cartoon character. And there I stayed for six weeks.

Strangely I was happier than I had been for a long time.

When it is impossible to do anything other than lie in bed, there is nothing for it but to accept the situation. I did not feel ill and each day my bed was pushed out on to the balcony into the April sunshine; I sent urgently for books from England and I read widely and tried to teach myself some German. My mother and the younger of my two sisters came to visit me for a few days and the time passed quickly. Towards the end of the six weeks, the clinic, which was purely for skiing accidents, had to be kept open especially for me, since it was considered too dangerous to move me; this was much to the fury of Dr Murr and the two German-speaking nurses who had to stay behind to look after me.

By putting rings round the bone in my leg – which was broken in twenty-six places – Dr Murr had tried a new technique. Before I left his clinic, he put my leg into a non-weight-bearing plaster and told me to tell the English surgeon to remove the rings after a further six weeks. I was met by an ambulance at Heathrow and taken to my parents' flat. I could not use crutches because of having one arm, and was therefore unable to walk, so I was wheeled around in a wheelchair. I had made such a thing of moving into my own flat and now I could not even visit it – it was on the top floor without a lift. I hated this loss of independence; I had spent most of my life trying to prove that I could do everything on my own and did not need help, and now suddenly it had all been thrown back in my face. I was completely dependent. What a lesson! I thoroughly resented having to ask for everything I needed.

The first specialist I saw in England ignored Dr Murr's advice and left the rings round the bone for a further three months. Those three months were spent confined to a wheelchair, without being able to put any weight on my leg. When the rings were finally removed, it was excruciatingly painful to walk and I felt something was still very wrong. The specialist

told me to stop being a 'silly girl' and to 'brace up'. After a few months of limping badly and using a walking stick, I went for a second opinion. The second specialist took one look at my X-rays and told me that it was not surprising that my leg still hurt: the rings had been so tight that they had acted like a tourniquet and the bone was now dead. I went back into hospital just before Christmas 1971 and had a metal plate put in my leg and a bone graft taken from my hip. After this operation I was in a full-length leg plaster for a further three months and back to the wheelchair. The plaster was finally removed almost exactly a year after the accident.

I then had to learn to walk again. Learning to walk on the flat was hard, but not impossible. But remembering how to go up and down stairs was extremely difficult. Once, halfway down a staircase, I became completely paralysed, unable to go any further; this produced panic. I do not think it was fear, more that I seemed to have forgotten *how* to move. My leg – or rather I – had felt safe in a plaster cast, but my un-encumbered leg's exposure to the world was enough to stop some kind of message travelling to it from my brain. Vertigo has produced similar feelings of paralysis and panic in me on high mountain passes. But in such situations, other people can both be reassuring and lead one to safety, and once one's limbs are in motion again, much of the panic disappears.

If one has a disability and has an accident, however minor, it is assumed that the accident happened *because* of the disability and not that it would have happened in any case. I find this assumption frustrating; if I trip on a step or slip on some ice, in all likelihood it has nothing to do with only having one arm and I do not want to have to explain this. Louise Baker describes in *Out on a Limb* how she fell when learning to roller-skate. 'It was a foregone conclusion that I fell because I was a poor, helpless cripple.' I get the same feeling if, unusually, I fumble when I am looking for keys or money in my bag. When an able-bodied

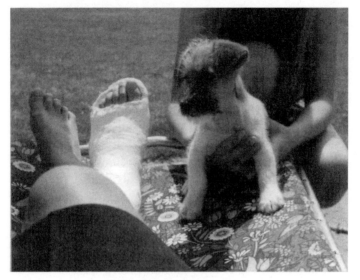

With the leg in plaster, 1971

person fumbles no one gives it a second thought; it is the thought of being pitied for fumbling which I find irksome.

Other people's pity is one of the worst things about having a disability. Having someone's mournful eyes take in and attempt to commiserate with one's situation is hateful. Internally I scream, 'Whatever you do, don't pity me!' My way of dealing with pity externally was to do and to try as many things as I possibly could, so that there could be nothing to pity me for.

It seems that if you have a disability you have to become a high achiever in order not to be pitied. Peter Cordice, a black athlete with no arms who carries his relay baton between his shoulder and ear; Michael Kenneth who lost his left arm in the war and was a founder member of the British Horse Society's Eglinton Horse Trials; Michael Caines who lost his right arm in a motoring accident and who was the chef at Gidleigh Park Hotel in Chagford, Devon; and David Skidmore who lost both arms in a road accident and qualified as a pilot – all of

these high achievers have triumphed over losing arms. Ralph Waldo Emerson may have had such people in mind when he wrote: 'For everything that you have missed, you have gained something else.'[14]

I learned a lot during that year of enforced inactivity. As I could not manoeuvre the wheelchair myself I even had to ask my mother when I wanted to go the lavatory. I felt extremely frustrated at times, but I think that both my mother and I adjusted to the difficult and changed relationship surprisingly well. I had had a glimpse of independence and life away from my family and revelled in it, and that meant I was coming to the new situation of total dependence from a new and more mature perspective. My mother understood my moments of frustration and allowed me to wallow in my occasional bouts of self-pity.

It was interesting to feel very much more disabled with my leg in plaster than I had ever felt with one arm, and yet – because of people's attitudes – to feel totally different. People can readily identify with a broken leg and were never embarrassed to ask what had happened. Not only were they then keen to hear the particulars of the accident, but they would usually describe their own or their friends' accidents in gory detail. Superficially it seems that as anyone can break a leg, relating to a plaster cast is not threatening. Yet anyone can get cancer. A broken limb is temporary and usually recovers, but my arm will never come back and maybe that finality sparks the fear of the unknown. I am probably the only one-armed person the people I know come across, and the word cancer, as opposed to fracture, still has associations of death that make people feel awkward about discussing it. Many years ago, I had dinner with a highly intelligent friend, and the subject of my arm came up for the first time in the ten years of our friendship. He asked what had happened and I told him. I'll never forget his response: 'But that's impossible, you couldn't have had cancer.' However much I protested that I was telling the truth,

he was unable to accept it. In retrospect, I realise that I learnt more about him from that response, in its denial of reality, than I had in all the previous years of our friendship.

In Alexis Lykiard's novel *The Stump*, Angela loses her right hand in a car accident. She wakes from the operation with 'bandages and pain and numbness' and full of embarrassment, so she 'half-hid, half-cradled' her arm. It is a long time before she feels able to abandon her sling in front of 'the world of mocking unmaimed people'. There is something strange here, but something I understand – a sling makes you look different from other people but it's an acceptable form of looking different, in the same way as my leg plaster cast was. Having one hand isn't.

Bookshop

I remember that part of the ordeal of having my leg in plaster was the tyranny of having to cart around a dead weight. I did not have what Oliver Sacks described, in *A Leg to Stand On*, as the experience of a 'missing limb'. But I did have a lot of time during that year to think about what I wanted to do with my life and I decided that I would have more choice or perhaps more ideas if I went to university. I had already done English A level at evening classes and had started doing history A level before my accident. I missed the exam in the summer, but took it in the winter. I passed it and so I then had three A levels, the necessary number to apply for university.

During that autumn and winter I worked in the British Library. I loved being around the books, but found the whole process of being a civil servant dispiriting. So I moved from there to the Disablement Income Group, a parliamentary pressure group that was campaigning for the rights of disabled people. I rather felt that I *ought* to work for an organisation connected with the disabled, that I *ought* to be doing something for people less fortunate than myself. But since by so doing I was joining a world I did not want to be a part of, and as I resented being thought of as 'disabled' myself, it was rather perverse. I did not stay long, but I did begin to understand the huge amount of bureaucracy and the variety of difficulties that disabled people face.

I then applied to university. I had decided that I did not want to go anywhere outside London and I chose the hardest subject I could think of: Chinese. I was still feeling the need to

test myself, to prove something about my intelligence to myself and to others. I was also under the mistaken impression that having a degree in Chinese would give me some kind of constructive qualification. I got an interview at SOAS (School of Oriental and African Studies) and was offered a place in September 1973.

London University in the 1970s was a shock; it seemed to me that it was more like going back to school than going to university. We were ticked off on a daily register and after lessons – not lectures – were finished, the students would rush home to their various parts of London. I completed the four years and got a degree, but I think it would have been more courageous to abandon the course; after the first year I ceased to enjoy it and it became a hard, and mostly unrewarding, slog. Thirty-five years later I have forgotten almost everything I learned and look back on the whole period with a mixture of embarrassment and a sense of time wasted. I never learned to speak Mandarin, in large part because my year was the last one in which students were not automatically sent for a year to either China or Taiwan as part of their course. There was one British Council place for a student to spend a year in China. I and one other woman were interviewed. I dreaded being offered the place as I knew I would feel I ought to take it up, and I did not want to go; among other things I hated the thought of having to sleep in a dormitory for a year. Luckily for me it was Christine who succeeded. She went to China, and stayed on, first in Beijing and then in Hong Kong. She met her Canadian husband in Beijing and has worked for several large British companies there. The twist of fate that decided that she got the British Council place rather than me had a profound effect on both our lives.

In 1976, my third year at SOAS, my grandmother – a farmer – read about a three-week trip to China for British farmers and asked me whether I would like to accompany her.

At the last minute she was told that she was too old to go, so she gave her ticket to my sister Liz and together we went to Beijing, Da Chai (Mao's model commune), Xian (before the warriors were on display), Shanghai, Canton and Hong Kong. This was a semi-official trip and a cross-section of farmers had been chosen from all over Britain. The British farmers were almost as intrigued as the Chinese at the thought of two sisters from London; did we really farm in window-boxes? Everything we visited had to do with farming: the factories, farms, museums and exhibitions. It was fascinating to be with farmers as they could debunk many of the Chinese statistics: if we were shown a cow and told that it produced x gallons a year, our farmers knew instantly whether this was an impossibility, which evidently most of the time it was.

I revisited China in 2006, having not been back in the interim, and after the recent trip I am even more pleased to have been there when Mao was still alive and to have had such a pragmatic group of people interpreting Mao's miracles for me.

When I left SOAS, I found myself back in exactly the same position as I had been previously, with no qualifications other than an arts degree albeit in Chinese, and still not knowing what I wanted to do. I moved into a flat of my own and started working part-time in a bookshop and also doing some research for Mark Amory, who was editing Evelyn Waugh's letters. I found this a good balance, enjoying both things enormously.

After about a year of this, in September 1978, I had to go back into hospital to have the metal plate removed from my leg. This should have been a minor fifteen-minute operation, so it was squeezed in at the end of the day. What had not been anticipated was that the bone in my leg would have grown over the plate. Two hours and several broken screwdrivers later, I emerged from the operating theatre. If I had

had two arms, I would have been sent home after two days, but as I could not use crutches I was kept in hospital for an extra night. On the third morning I was out of bed, sitting on the commode, when I looked down at my leg and saw that the bandages had gone bright red. I rang for the nurse who rushed in and screamed, 'Oh my God!'

I was lifted back on to the bed and when the bandages were removed blood hit the ceiling. I was heavily sedated and luckily, bearing in mind that this was the late seventies, I did not have to have a transfusion. However, they could not move me at all, so I was left on blood-drenched sheets all day. My younger sister, Camilla, was told she could not visit and was not given a reason; my other sister, Liz, rushed round in a panic and, as next-of-kin – my parents were away – she was allowed to see me. The surgeon had sewn through an artery. Had I been at home when this happened I might easily have died. The surgeon was away at a conference and when he finally appeared two days later and I told him that I had been very worried, he said – condescendingly – that he, at the end of a telephone, had been the one who had been worried. I stayed in hospital three weeks rather than the estimated three days and, yet again unable to walk, I had to move back to my parents' ground-floor flat.

It is easy to think that in this instance I was saved because I have only one arm, but my whole life would have been different had I had two arms. I believe that everything that we have done in life brings us to the present moment, and that if any one thing had been different (the butterfly-wing principle) the present would be different too. Believing that means that having one arm is an integral part of my life and that I am only here now, doing what I'm doing, *because* I have one arm.

When I had once more painfully re-learned to walk, I alerted everyone I knew to the fact that I was looking for a job. I was introduced to a woman who was about to open an

art gallery combined with a poetry bookshop. The idea of this gallery/bookshop was immensely appealing and I longed to be offered the job. I was. What I learned during that short period at the Chastenet Gallery near Victoria Station gave me enormous confidence. I felt that I wanted to do something on my own and began to dream about opening my own bookshop. There is much to be said for the theory that starting a business is one of the few things you can do without any qualifications.

This was one of the defining moments in my working life. Up until then, although I had done many enjoyable things, I felt that I had been floundering around vaguely looking for a purpose and idly wondering about the significance of my arm. Books had always been important to me. Apart from being enjoyable, they had provided many answers to my questions about other people and places as well as setting me off in search of new things. I had gaily told people that I would start a bookshop when I retired. 'Retired from what?' I was asked. I was persuaded that if one wants to do something enough, one ought to do it now, not at some vague later date. Planning a project for the unforeseeable future is not very wise; anything might happen and when the time comes the desire might well have fled.

My cousin Michael had had the idea of setting up a travel emporium, selling everything that a traveller might need from guidebooks to mosquito nets. We discussed the project at length but eventually he decided that he didn't want to be involved. However, I determined to persist and the idea gathered momentum daily. The more I thought about it the more exciting a scheme it became. I refined the brief and decided to try to start a shop that would be devoted exclusively to books about other countries. I knew that when I travelled I found out as much about a place by reading fiction set in that country as I did from guidebooks, so my idea was to have every-

thing about a country side by side on the same shelf. I also decided to sell old books, as many of the seminal books were out of print. And as a great many people collect old travel books, I would be appealing to many different markets – travellers, readers, collectors and researchers.

This was a fairly embryonic idea when I went to America in the summer of 1979, but it was due to the enthusiasm of the Americans I met and talked to that I went ahead when I returned. They all told me what a wonderful idea it was. But they also warned me that the British reaction would certainly be: 'Don't do it.' They were right. In America, people are far more likely to take risks and if they do fail they are not made to feel like social outcasts. Taking the first small risk leads to the ability to take larger ones; sometimes what you do might fail, but so what? It's usually worth it. As Nietzsche said: 'The secret for harvesting the greatest happiness and the greatest enjoyment from life is to live dangerously!'[1]

On my return to England I was indeed met with pessimism, but because I was still buzzing from my time in New York, I soon started a company which I called the Travel Bookshop Ltd, in which my father and I persuaded a few friends to invest small amounts of money. My father and my uncle were both extremely supportive of and helpful with my new venture. Now, when I look back on how green I was about business, I blush with embarrassment. But there is no better way to learn than by total immersion; I had to learn fast. I did know about new books, but I knew nothing about old books. I was extremely fortunate in being introduced to Peter Hopkirk who showed me many of the second-hand bookshops around London and advised me what to buy. While I was looking for premises for the shop, my flat in Fulham began to look like a book depot since after every foray into second-hand book-shops I had nowhere to store the books I had bought, other than there.

Almost the first shop I looked at was at number 11 Blenheim Crescent. I had a hunch that this area, just north of Notting Hill Gate, would become fashionable and I became very excited about having a shop there. However, the survey was so bad that I was advised against it, and I ended up renting a shop in Abingdon Road, just off Kensington High Street, where in the spring of 1980 I opened the Travel Bookshop. I wasn't to move to number 13 Blenheim Crescent until 1982.

The bookshop became well-known and successful almost immediately and inevitably an increasingly important part of my life. An article on the middle page of *The Times* was followed by a succession of radio programmes. For the first eight years I ran it almost entirely by myself with the loyal support of a part-timer who came in two days a week. I was in the shop every Saturday on my own and over the years I forgot what a real weekend felt like. I had less time to read than I'd ever had – it's a complete myth that working in a bookshop means sitting and reading – and in all the years in the shop I don't think I read more than a paragraph during the working day.

Eventually, after ten years, I did get a trustworthy full-time manager and went to Australia for three months; it was while I was there that I decided that I'd had enough of being trapped behind a till in Notting Hill. On my return, out of the blue, I received a letter from an accountant who had a client who wanted to buy the shop. The client turned out to be Simon Gaul who, four years previously, had bought a copy of J. G. Links's *Venice for Pleasure* from me and had vowed to buy the shop one day. The timing and the outcome were so serendipitous that within a few months I had sold the majority of the business, retaining a tiny stake for myself. I kept an overall managerial role, which meant I had more time to devote to travelling and writing. Its always difficult to have someone else take over a business that you have started – but the agreement that Simon and I arrived at worked well and I

Tourists outside the Travel Bookshop

was able to continue to enjoy it until 2004, when, after twenty-five years, I finally gave it up.

The shop is still going from strength to strength and has become known world-wide – by many as the inspiration behind the hugely successful film *Notting Hill*. Richard Curtis was a neighbour and spent several mornings taking notes in

the shop with what he told me was the vague idea of writing a film set in a bookshop. When the idea became reality, the film company took still photographs of our shop before building a studio set to look like it. There are slight differences – in the film the shop is called the Travel Book Company, rather than the Travel Bookshop, but the colour of the façade is the same blue and the typeface of the shop-sign is identical. But we are certainly better booksellers than Hugh Grant and his gang.

Sometimes I wonder whether I would ever have started the shop if I hadn't lost my arm – would I still have had the impetus and drive and the need to prove my abilities? In some ways I see the shop as having been a substitute for my left arm, and perhaps even for not having had children; I often thought of it (and sometimes still do) as 'my baby' – something which, although an air hostess certainly can't call *me* that, I think is permissible for me to say about my own creation. Especially since the reality was that since I couldn't have children, any more than I could avoid losing my arm, producing something constructive with the loss did much to fulfil my creative urges.

Even though I had now made a business life for myself, I still imagined that I would marry and have children. The desire to have a baby got stronger in my late twenties and early thirties and although I didn't consider that I had met the right man to be the father of a child, my assumption always was that one day I would. As a teenager I had been frightened that if I were to have a baby it might have only one arm like me and this, along with a fear of not being able to cope physically with a baby, had made me reluctant to join in conversations with my peers about having children. I imagined that they would suspect that having a baby would be an impossibility for me, so joining in made me feel a fraud. Teenage girls often talk about motherhood and babies, and I sensed that these conversations were tempered in my presence or stopped when I came into

The Travel Bookshop, from a painting by Sara Nunan

the room. My fears were, of course, groundless; no child would have been affected, and I am sure that I would have been able to cope perfectly well.

But arms are associated with motherhood. A mother's arms holding her child form part of our unconscious belief in what motherhood means, a babe in arms being symbolic of motherhood. The first thing a mother wants to do after she has given birth is to hold her baby in her arms and to clasp it to her. In Michelangelo's Pietà in St Peter's in Rome, arms are crucial. Mary is supporting her dead son with her right arm and her left hand is extended, seeming to show both acceptance and sorrow.

But all my hopes of having a baby and being a mother were shattered when at thirty-three I had a premature menopause. This did not run in the family and I've often wondered whether it was because I had had chemotherapy as a child. Even today it is not known what the long-term consequences of both radiation and chemotherapy may be when given to children or what impact they may have on a child's development. It is now thought that the cancer I had, synovial sarcoma, is unresponsive to both chemotherapy and radiation therapy. In fact, I have developed normally, as far as I know (apart from the premature menopause), but for many years there was a nagging suspicion at the back of my mind that something was not quite right. But what that something was, I didn't know.

When I learned that I could not have children it was a great shock, and in order to try to defy the doctors who had told me this, and before accepting the reality, for a year I tried desperately to have a baby. I had stopped having my periods, but since they had always been irregular, I defiantly bought pregnancy kits from the local chemist. Of course the tests proved negative, but somehow I felt that the mere fact of doing them meant that I had joined a different category of women.

With Arara children at Larayal on the Xingu River in Brazil, 2005

Not just someone who had never had a baby, but somebody who had at least tried. Eventually I accepted that I never would get pregnant; I thought how unfair it was, but I never thought of not being able to have a child as the loss of a right. When I first held my sister Camilla's new baby, I remember thinking, with a mixture of sadness for myself and happiness for her, that this was the closest I would ever come to having one myself.

Men, Love & Sex

I had not been ten minutes in the place before I fell in love with the most beautiful creature the world has ever seen. She was standing, silent and majestic, in the centre of one of the rooms of the statue gallery, and the very first glimpse of her struck one breathless with the sense of her beauty. I could not see the colour of her eyes and hair exactly, but the latter is light, and the eyes, I should think, are grey. Her complexion is of a beautiful warm marble tinge. She is not a clever woman, evidently; I do not think she laughs or talks much – she seems too lazy to do more than smile. She is only beautiful. This divine creature has lost her arms, which have been cut off at the shoulders, but she looks none the less lovely for the accident. She may be some two-and-thirty years old, and she was born about two thousand years ago. Her name is the Venus of Milo.

THACKERAY, *The Newcomes*

Was anyone ever going to fall in love with me? It was one of my big fears that they wouldn't; I found the whole idea of men terrifying. Dances were a minefield. I grew up at the time when strapless party dresses were considered the fashionable thing to wear. I had an idea that dances were the only place you would ever meet a man – and if I was an awkward dancer, what would happen? The parties in the school holidays during my teens were excruciating – in adolescence our awareness of self is intensified anyway – but my mother was adamant that I should go to them. It became a ritual before every one that I would lock myself in the bathroom and scream and scream

that I didn't want to go. I didn't want to go because I didn't want my lack of arm to be noticed, or to have to answer questions about what had happened. I thought that if I kept the fact of having only one arm to myself and to my family, it somehow wouldn't be real in the outside world.

None of my protestations from the bathroom helped; after I had exhausted myself with crying and had been coaxed out, I would still be forced into going to the dreaded party. Oddly, in later years, my mother had no recollection of these outbursts. On arrival at the party I would wait by the wall, with a tear-stained face, for my parents to come to collect me and take me home. I stood there determinedly wearing a white cardigan and white ankle socks, dreading being asked to dance, yet hating looking as conspicuous as I did by *not* dancing. The question I most dreaded was why didn't I take my cardigan off? I hoped that wearing it would disguise the fact that I only had one arm, and I also hoped that the white ankle socks would prevent me looking grown-up. I wanted to remain safely in childhood and did not want to embark on what seemed the terrifying and long journey to adulthood.

As well as the horror of being among a whole lot of strangers who might ask me about my arm, there were also *boys* at parties. I had no idea what boys talked about. Admittedly I had a brother, but he was five years younger than me so he was of no use as a conversational model. To me, males were beings from another planet, and there was always the fear that perhaps these aliens would mention my arm. I have just discovered from someone who used to be at those parties that his mother alerted him to my lack of an arm and told him to be especially nice to me. This meant asking me to dance along with two others she had picked out for his special attention – the hostess and the fattest girl in the room. Had I known this was why I was being asked to dance, I don't think anything would have got me out of that bathroom.

The best dancer at these parties was a boy who reputedly practised dancing in the bathroom with a bath towel. He was much mocked, but he did occasionally ask me to dance – even now I pray that it was not out of duty – and I fell madly, but secretly, in love with him. He managed to teach me to rock and roll so effortlessly that it seemed that he did not notice my lack of an arm, and when, on occasions at school, it was necessary to talk about your 'boyfriend', or to put a boy's name under the pillow on St Valentine's Day, it was David's name that I used. Later on I substituted William's name for David's. William was slightly older, very good-looking and sophisticated. He also asked me to dance. Years later I saw William again and I told him that I had been in love with him when we were teenagers. He seemed very taken aback and after a long silence, in a very English way, he said, 'Well, I thought you were very nice too.'

Like many teenagers, I was full of romantic notions about love and sex and imagined that my first kiss would be by moonlight, wrapped in the arms of someone I loved. The reality was a cruel dare on the part of some unknown boys. I was standing at the edge of the room, at one of the dreaded teenage dances, when I was grabbed by a strange boy who hauled me outside and stuck his tongue down my throat. This was accompanied by the sound of encouraging laughs from his friends. I felt totally humiliated and was convinced that I would go straight to hell unless I could get to confession quickly. Maybe it had nothing to do with my missing arm, but I felt that it was the reason I had been singled out for this treatment. Thinking about it now, it seems that even then I was being overly melodramatic, but I remember spending a completely sleepless night worrying about what would happen to me. Of course I felt unable to confide in anyone. I realise now that I blamed all my insecurities and inadequacies on having only one arm. I was certainly so

minutely sensitive that I would attribute any slight to this fact.

The agony of those parties is still gut-wrenchingly vivid, but it seems odd that I had gone so willingly to school, where I was also among strangers; yet the parties were such torture. Perhaps something had happened at one early on to make me dread them so. Or perhaps I thought that dancing needed two arms. Most likely it was the little girl who tormented me that first Christmas after the amputation who had put me off parties. I now love both dancing and parties; I was probably lucky that, as I was growing up, more and more dancing was done without the necessity of holding a partner's hand, and in any dance that requires being held by a partner, I am lucky to be a woman and to have my right arm.

In a culture in which we are obsessed with perfection it is paradoxical that one of the greatest icons of Western art, the Venus de Milo – the model of female beauty so beloved of Thackeray's Clive Newcome – should have no arms. The first time I looked at her, aged about fifteen, I felt glad that I had seen such a famous statue and rushed off to see the Mona Lisa. I would have been embarrassed and mortified if anyone had even hinted that she was beautiful despite having no arms. I was as obsessed with my own image as anyone else, but my self-image did not incorporate an acceptance of how I really looked. So if I had been asked to describe her I might well not have mentioned that she had no arms. Her power is felt by Viren Swami, who in his book *The Missing Arms of the Venus de Milo* describes his impressions: 'I stood watching her for a long while, as though her existence were an occurrence meant only for me, with a melancholy expression on my face. Later, I would remember the unquestioning look in her eyes, which seemed to me able to penetrate even the longest night.'

The Venus de Milo has attracted notice from the time she

was first discovered. What is it about her that made Walter Copland Perry, the nineteenth-century specialist in Greek and Roman sculpture, write: 'The figure is ideal in the highest sense of the word . . . it is a form which transcends all our experience, which has no prototype or equal in the actual world, and beyond which no effort of the imagination can rise'?[1] Does the casual visitor notice her lack of arms? Or don't they care? And if not, isn't this strange in today's world in which every small blemish is dissected by the media? While writing this book, I went to the Louvre to see her. I climbed the stairs and at the top, at the far end of a long corridor, a tiny illuminated Venus de Milo appeared. That first glimpse took my breath away; I was lucky to have happened upon her from that angle. I walked slowly towards her and then stood by her for a long while, observing other people's reactions. Most of her admirers were Japanese – pushing their cameras at her and having their photographs taken in front of her. I wonder how many of them would have remembered, or even ever been aware, that she has no arms.

I found it quite hard to view her dispassionately, difficult to separate her iconic status from what I thought about her as a work of art. And, as an adult, I was acutely aware that she was a work of art with no arms. This time I had come to look at her for that very reason, and that made me think about how people perceived me. I know that having one arm is not the thing that most people notice straight away about me, but when they eventually do, although I am assured by most that it makes no difference, there are those who treat me differently. Venus, like me, had once had both her arms but unfortunately we have no pictures of her or anything written about her before she lost them.

When the statue of Venus de Milo was discovered in 1820, she was already missing her right arm, and it is probable that her left arm was broken off in a battle on the beach between the

Aphrodite, 'the Venus de Milo', Hellenistic period,
c.130–100BC (marble)

French and the Turks at Melos; the French won and she was shipped to Paris. The Marquis de Rivière, French ambassador to the Ottoman court at Constantinople, commented very practically: 'My girl doesn't have any arms, but that doesn't matter, she can still open the doors of the Institute' (the Louvre).[2] In the 1890s the German classicist Adolf Furt-wängler did much work on reconstructing Venus de Milo as she might have been. He thought that her left arm, which was possibly holding an apple, was still attached to her body when she was found, and he wrote that the loss of her arms was 'less to be deplored than might at first appear'. The French classical scholar Quatremère de Quincy thought, from the way that she was standing, that she had probably been next to Mars and that her missing arms would have been reaching out to him imploring him not to go to war. In *Women's Work: The First 20,000 Years*, Elizabeth Wayland Barber has a different interpretation of what Venus de Milo had been doing. She surmises that she had been spinning and the pose does fit this idea perfectly: 'She was holding both arms out. One, the left, she held high and a little back, counterbalancing its weight by curving her body. The other she held out in front of herself at about chest level; her gaze rests about where the hand would be.' This was a common pose for women in Ancient Greece. They would have held a distaff in their left hand while working a thread and spindle with their right. But is this too prosaic for an icon? Do we really want our icons to be doing something as menial as spinning? Perhaps having the goddess of love portrayed as a spinner means that she was spinning our fate? By creating thread, was she in essence creating our very lives?

I think that having no arms is one of the reasons that Venus de Milo is so erotic: she can do nothing about her robes which are in imminent danger of falling off. However, the falling robes don't fit with Barber's theory, since if she were spinning it

would be unlikely that she would have been insouciant enough not to notice her falling robes.

Arms would distract from her stark, robust, massive beauty. Does this make me feel better? Certainly I have encountered the erotic perspective – but is this it? Is she just an icon of erotic beauty? And does this apply to me? 'Some people feel uncomfortable in the presence of ancient statues which are incomplete, they say that these would be beautiful if they were not mutilated,' wrote John Rickman.[3] Unfortunately this can also apply when people meet amputees: 'She would be beautiful if . . . '

Peter Fuller, in 'The Venus Pin-Up',[4] asked: 'Would the statue have become a "trademark of Beauty" in the nineteenth and twentieth centuries if it had been found intact?' If we do require our 'trademarks of beauty' to be flawed, as Fuller suggests, why is it that we are made to feel inadequate by having perfection as the goal hurled at us from all branches of the media? If society allowed us to accept imperfection, and not to aim at flawlessness, to have the Venus de Milo shown us as a role model would make sense – but that is not the case. Why is it that the Venus de Milo appears on every sort of tacky tourist souvenir all over the world – ashtrays, soap dishes, face tissues, pencils, jigsaw puzzles, notebooks and match-boxes are covered with her – as well as being the subject of pop songs? In the 1960s' song 'Venus in Blue Jeans', Jimmy Clanton sings that she was the girl who stole his heart. Is it really because the model of female beauty still needs to be portrayed to us as damaged and vulnerable, with no arms to push her admirers away? She has even been used as a lesson in morality: a woman stood in front of the statue of the Venus de Milo with her child and said, 'This is what will happen to you if you keep biting your fingernails.'

In his book *The Nude*, Kenneth Clark devotes almost two pages to describing the statue, and, unusually for an art historian, does not even mention that she is missing her arms.

He claims that: 'It remains true that she is fruitful and robust beyond the other nude Venuses of antiquity,' and he asserts that the way she is used so frequently in popular imagery as a symbol – or trademark – of beauty implies a standard of ideal perfection. Clark writes about the Venus de Milo as if she were in the same physical condition today as when she was first made. Ironically, the Ancient Greeks, with their ideals of perfection, would have found the mutilated Venus de Milo that we see today quite abhorrent.

Fuller asks where Clark found his 'most splendid physical ideal of humanity' as he was in fact talking about a maimed woman. Is it really because the ideal woman is meant to be passive and vulnerable? And the Venus de Milo – despite her obvious power and strength – does in some way symbolise the weak and needy woman; having no arms would mean she needed help and protection. But this vulnerability of hers is not part of Clark's thesis. Does he think of the arms as unimportant? Irrelevant? It seems odd not to at least speculate about what she would have looked like – would he still have thought of her as the feminine ideal if she had arms? Or are we meant to take for granted that his ideal woman incorporates an unstated vulnerability? What I would like to think is that it is none of these things, but rather a much simpler reason – it didn't matter to him. Or is it that because having two arms is the norm, we unconsciously supply the missing bits? That is certainly how I like people to talk about me; I hate the thought of being described as 'the woman with one arm' and I never ever refer to myself as having only one arm when asked what I look like.

The Venus de Milo has fascinated poets, artists and writers ever since she was found. Alfred Noyes wrote in his poem 'The Venus of Milo' about 'those armless radiant shoulders'. Like Clark, Clive Newcome found her lack of arms completely unimportant. Her 'accident' in no way affects her beauty; he

appears to see her as a whole person and for that reason I like Clive Newcome. But it seems that his perfect woman has no brains – it is enough for her just to stand there being lazily beautiful. But why does he assume that she is not clever? Is this something to do with the widely held assumption that if you are physically disabled there is something wrong with you mentally as well? As a child I thought that I was considered slow and stupid because I had one arm, and it seemed as if I was endlessly having to prove that I wasn't. 'Very sweet, but not very bright' was a phrase often used about me as a child and one that I hated. Only now, with my discovery of the assumed link between physical disability and mental retardation, do I understand why that phrase upset me so much.

So was Thackeray's Clive Newcome equating physical disability with mental slowness? I'm sure most people would vehemently deny feeling this, but I'm also sure that on an unconscious level many do. And perhaps, although he does not say so, he also sees the feminine ideal as being needy and vulnerable and in need of protection. It is unlikely that anyone writing today would refer to the Venus de Milo as 'ideal', both because of our ethos of perfection and because women are no longer seen as the needy and vulnerable creatures they once were.

If only I had had the courage or imagination to see myself as a twentieth-century Venus de Milo, I might have felt less inadequate and understood that physical difference need be no bar to attracting the opposite sex. To echo Jean Aicard who wrote about her in 1874, it was *because* she had lost her arms that she was seen as the 'Eternal Feminine', a creature who needed protection, but – more erotically – a woman who was unable to push men away. But that, of course, leads into the whole different area of being found attractive because of a disability. Am I – as someone rather flatteringly said to me – halfway to Venus?

We operate with so many different standards that what is permissible in art seems often not to be in real life. Alison Lapper, the artist, was born without arms and with tiny legs, and was brought up from the age of six weeks to seventeen years at Chailey Heritage in Sussex, an organisation started by Dame Grace Kimmins. There, along with the other inmates, she was known as a 'strange little creature'. Many limbless children were resident at Chailey Heritage when, during and after the war, it became a regular hospital. To help the trauma of men who had lost a limb in battle a child was allotted to be with them as they regained consciousness, both as a guide and to show them that life was liveable with missing limbs.

Lapper's art is rarely mentioned without reference to her lack of arms, perhaps because she has made that a feature of what she does. The life mapped out for Lapper would have been completely different from the life she made for herself: a wheelchair and a sheltered workshop were suggested for her but, luckily for her and for us, she had other ideas. She learnt to drive and went to art school after leaving Chailey Heritage; this was the first time she had ever had anything to do with able-bodied people and she hated it. 'Why can't I interact with these people? Why are they staring at me? Why are they so scared of me?'[5] That last question hits the mark. One day, one of her tutors at Brighton University asked if she was painting beautiful bodies to make up for the way she felt about herself. She said that this remark initially pissed her off, but after thinking about it positively, it launched her for the first time on a journey of self-discovery. Until then she had been busy trying to be what she thought society wanted her to be; from that moment, she felt that she could be herself. Most of us fall into the trap of trying to look satisfactory in society's eyes; we feel that there is a way that we *ought* to look. Each time we say that our own or somebody else's hips are too big or that our or their breasts are too small, we are

admitting the existence of what we consider an acceptable level of beauty.

Lapper sees the Venus de Milo as the starting point for her sculptures; a few years ago she was wearing a drape while messing around with a friend taking photographs, when someone remarked that she looked like the Venus de Milo. Initially she was surprised by this comparison because, as she said, 'When you are living with a body that you are told is unattractive, disabled, ugly, you just do not think of yourself like that. Actually, let's be honest, no woman in our society does unless you are Naomi Campbell.'[6] In her work she tries to demonstrate that being disabled isn't being ugly. 'Who says we are ugly? Deformed? Look at Venus. Who calls the Venus de Milo disabled? Nobody! But me, I'm seen as this disabled lady over there.' I find Lapper's art beautiful; much of this seems due to her confidence in her own beauty, something which cannot have been easy to acquire. It is true that no one would ever call the Venus de Milo disabled, yet I – who equally do not consider myself disabled, and do at least have one of my arms – have often been branded as such.

Alison Lapper came to far greater prominence when Marc Quinn's sculpture of her, eight and a half months pregnant, was selected for the fourth plinth in Trafalgar Square. Quinn wrote that initially it seemed that there were few if any public sculptures of anyone with a disability. But then he realised that of course that's not true since, also in Trafalgar Square, Nelson is standing on top of his column with only one arm.

When I went to live in New York, I still had not slept with anyone; I was confused about sex and was plagued by Catholic guilt. Or perhaps I was using Catholicism as a useful shield for my arm; it stopped me being nervous about what men would think of it in bed. Once I went to confession, and became completely bewildered when the priest asked me out on a date. I'm

not sure what made me decide to accept his invitation, but I did. He arrived with a bottle of bath oil, which I found immensely touching but, now that I think about it, it was also pretty provocative. We went to an old-fashioned restaurant and then on to a film, during which his hand wandered over to my knee. I was naïve enough to think that we were only going to have deep and meaningful discussions about Catholicism. Poor man, he was probably as confused as I was.

Somebody had told me that of course it was better for a woman to have one arm rather than one leg when making love, and vice versa for men. I had laughed appreciatively, gratified at being considered *au fait* with the innuendo but with an internal panic because I was uncertain what one actually did in bed. It did not occur to me that men could be turned on by my absence of an arm; if anything, I thought that they would be turned off. Naïvely, I believed I would be fancied for the person I was rather than for how I looked. Later I met an Italian woman who had lost an arm in an accident in Africa, and she said she had been told that more men would want to go to bed with her now that she only had one arm; she asked me if I had found this to be true. It was the first time I had thought about it; it was an impossible question for me to answer because, as an adult, I have always had one arm. But it unsettled me to think that it might be the case. Now I realise – although I try to avoid thinking about it – that there are some men who *do* want to go to bed with me because I have one arm, but surely this kind of person could never become my lover or boyfriend? It shocked me, therefore, when I was told by a former long-term lover that he had wanted to make love to me initially *because* I had one arm. I reacted violently to this, thinking him perverted, but another friend tried to persuade me that people are attracted to, and want to go to bed with, people for multifarious reasons and the lack of an arm is as good a reason as any. I am yet to be convinced. If the initial

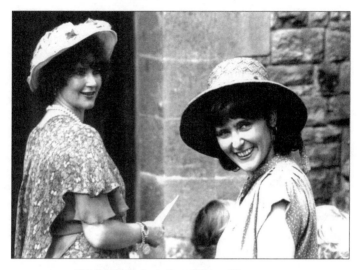

With Elisabeth at Camilla's wedding, 1979

attraction is because of a disability, surely it can just as easily switch and become the major turn-off. That is something I fear. I am often accused of being aloof and arrogant, neither of which I feel I am. But if one is terribly afraid of not being loved, then the easiest way to deal with it is to play the unconscious game of being cold.

At times I find the fact of never having been married difficult. When I see a look of surprise on people's faces when they ask if I have ever been married and I say no, I immediately assume that they think I never got married because I have lost an arm. Somehow I always seem to associate this kind of talk about marriage with what people are thinking about my arm and it is difficult for me to sort out what I really think about not having been married. In *And Yet We Are Human*, Finn Carling wrote: 'Marriage is a sort of gateway to normality. They [women] feel that if they are married, then they must be like other women.'

I have been party to many conversations about how incomprehensible it is that some woman never got married – 'because she's so attractive' – and during those conversations it's as if I am somehow different and don't fall into the same category. I have met men who tell me that they are looking for a girlfriend (not a bimbette) and how impossible it is to find an attractive middle-aged woman. *What about me?* I think, but don't say. It makes me feel invisible and I find it all confusing.

When I meet people with only one arm who are married I always wonder about their partners and if their relationship involves any kind of pity. I now find it necessary to check this out with anyone with whom I might get involved. Many years ago the boyfriend of a friend who has only one leg was talking about her to another man, who was horrified that he could fancy someone who had only one leg. But the boyfriend perceptively noted that although it had never occurred to him to mind that she had only one leg, he suspected that it was something which she was aware of in their relationship.

In Alexis Lykiard's *The Stump*, Angela has run off to Ireland with a married lover and wonders whether the loss of her hand is a reprisal for this stolen love. When she starts to recover from the accident, and to work out her future life with men:

> I realised that there could be no love on either side, for if the man were inevitably to patronise or use me – always conscious of the stump while pretending that it made no difference to the relationship, forever making efforts to understand and sympathise – the strain would be too great. Hating the falsehood, I would end up by hating him . . . I came to the conclusion that one can only be strong oneself by being independent of others.

This echoes what I've felt so often; the merest hint of sympathy or 'moist emotion' in someone's eyes is enough to make me feel that it's better to be independent and on my

own. Angela divides men into three groups: the do-gooders who want to analyse and protect; the 'shrimps' – the miserable failures who need to feel superior or fortunate; and the stump-collectors whom she terms 'callous, kinky swine'. I would add a fourth category, and I've certainly known some: men who are accepting without being patronising and who really don't care about a missing limb. Nevertheless, it does mean that any potential new partner has to be sifted through these rather damning categories before passing muster.

Just before doing my finals I fell in love with a drunk. As I was trying to study I would get desperate calls from various pubs and drinking holes asking for immediate rescue, and I learnt to dread the *pip-pip-pip* on the telephone. But I would drop everything and, in heroic-rescue mode, rush round at any hour of the day or night and bail Adam out from his latest binge. He would always be full of self-recrimination and apologies and 'never agains'. I always believed him because I was completely smitten by his intelligence and knowledge. He told me that he was no longer seeing another woman, but she would ring me in desperation saying that he was her boyfriend. I believed him rather than her, but I can't now imagine why either of us bothered with him.

Worse was to come.

We set off for Rome straight after my finals in *my* car with *my* money to stay in *my* cousin's flat. The thought of driving to Rome for the summer with my new lover had been a constant distraction during my exams; the grey London June would be replaced in my imagination by blue Italian skies, and my Chinese verbs became mixed with Italian phrases. It wasn't therefore too much of a shock when I just scraped through and didn't get the kind of degree I had wanted or expected. My family had thought I was crazy to go to university anyway and as for reading Chinese – well, that was quite beyond

the pale. So I suppose it wasn't that surprising when, without going quite as far as to say 'told you so', there was more than a hint of smugness in their voices when they heard my results. They certainly had no idea that I had spent much of the last few months on pub-related rescue missions. But I was young; I was naïve; I was in love.

I did all the driving through France to Italy – Adam was one of those 'artistic types' who had never bothered to take a driving test, although he boasted that he had driven in Italy for months using a laundry receipt as a driving licence. I felt that I was able to monitor Adam's drinking as we sped through France, that the less we stopped the less opportunity he would have to indulge. Or so I thought; at that point I hadn't reckoned on his cunning. But he hadn't reckoned on my cunning either. When we arrived at my cousin's flat in Rome – she was away for the summer – I immediately locked the drinks cupboard, pretending that it had been locked when we arrived; I suspected that when he went out to buy the croissants every morning he visited the bar, but I didn't want to know, so I kidded myself that I was 'changing' him.

In spite of his drinking, there was a point to Adam. He opened my eyes to Rome. He knew an immense amount about painting, sculpture, literature and music, and delighted in showing me shadowy churches and particular pictures in museums. Together we went to opera extravaganzas in the Baths of Caracalla and more discreet concerts in dark and mysterious churches. He nosed out delectable restaurants where we ate pasta and drank wine and dreamed, or rather I dreamed, of a wonderful future. After Rome, why not Florence, Venice, Paris, Vienna, Madrid, Istanbul . . . ? I found the idea of 'discovering the world with Adam' intoxicating; we would have such fun together. Practical considerations, such as his complete lack of money and my limited amount of money, to say nothing of his drinking, never intruded on my fantasy.

One day we went to the sea. On the way back, I missed our exit into Rome. I remember, as I slowed down to take a left-hand turning I had spotted ahead, looking in my driving-mirror and seeing a large lorry in the distance. The next thing I knew was that the lorry had come straight into the back of my car. Both Adam and I emerged unscathed, he naturally gasping for brandy, and found a rescue truck parked in one lay-by and a police car in the other. Even at the time I remember thinking that this was like a surreal movie script. My little red car was loaded on to the rescue truck and we were driven back into Rome by the police car. The garage decided that they would be able to mend the car, but said that it would take at least six weeks. Amazingly, within days I got the insurance money. In Rome, in August, in cash. It was mind-boggling to imagine what kind of contraband there must have been on the lorry and what kind of bribery had occurred after the accident to my backside. At this point Adam announced that he needed to get back to London; I tried to be very grown-up about it, but my dreams for 'our future' took just a little knock. I had six weeks ahead of me on my own in Rome.

I decided to start my time alone by going to stay with a friend in Tuscany. Adam was getting the same train as me, he all the way to England, me just as far as Pisa. As we left the flat he casually asked me what I had done with the insurance money. I told him I had hidden it beneath my underclothes and with that we got into a taxi and left for the station. We kissed goodbye at Pisa and I waved him off, and went on waving, long after the train had disappeared.

I had a miserable time in Tuscany. I missed Adam and the very English household where I stayed did not match up to, or suit, my newfound artistic, albeit pretentious, sensibilities. I think I only stayed there two nights before getting the train back to Rome. The concierge at the flat welcomed me and

said that my 'marito' had been there the night before, but had just left. My stomach lurched in glorious anticipation; had Adam missed me as much as I had missed him? Had he decided to come back to Rome to be with me? I rushed upstairs, expecting to find a note saying that he would see me later, instead of which I found the drawer with my under-clothes had been rifled. The insurance money had gone. I became hysterical with grief and betrayal. How could he have done this to me? I loved him and I thought that he had loved me. *How could he, how could he, how could he?* I sobbed into my pillow through the long and agonising night. What made it all seem much worse was that the whole episode must have been premeditated: I discovered later that he had only gone one stop further on the train before going straight back to Rome. I knew no one in Rome, as we had been self-sufficient during our month together. I had no one to talk to and I had little money. I couldn't possibly ring my family and tell them what had happened; they had never liked Adam and I didn't want to give them the satisfaction of having been right about him.

So what did I do? I made a pact with myself to get to know as much about Rome as I possibly could. I decided that a good way of doing this was to follow one artist all over the city. Bernini was an obvious choice, although once I had discovered his statue of the ecstasy of St. Teresa, I couldn't keep myself away from it, finding myself sitting beside it almost daily and empathising with its passion; I felt that, through the statue, my betrayal was somehow lifted into the realms of art. After a morning of Bernini-watching, I would have a solitary late lunch at a restaurant where they soon got to know me and where I would plough my way through Manzoni, Dante, D'Annunzio and other Italian classics; then, armed with Georgina Masson's remarkable *Companion Guide to Rome*, I would visit yet another obscure church before going home to cook myself dinner. This routine soon established itself into a reassuring way of life; I was

often even happy – until by chance I passed a restaurant where I had dreamed away the afternoons with Adam, and then the full magnitude of hurt descended like a black cloud.

A friend rang from London to tell me that Adam was in Livorno having drunk away my money; he said that of course Adam was full of remorse and guilt. Apparently he did not dare ring me, so I rang him; it was not a successful telephone conversation since I was inarticulate with rage and hurt. Can you believe I went and collected him in Livorno and drove him back to England? I can't. But I did. When we met he demanded that I hit him; I didn't see him again after that drive except once, a few years later, when he rather feebly brought some flowers into the bookshop as a belated apology. But I still have my memories of Rome. It never occurred to me to cast myself in the role of victim and consider this might not have happened had I had two arms. Theft is pure and simple theft.

As I was dreaming about the shop I found myself involved with yet another drunk. What was it about them that appealed? Was my arm in part responsible for my lack of self-esteem? This one joined Alcoholics Anonymous and years later came and apologised for all the hurt he had caused me.

One evening, during his drinking days, he took me to the ICA to celebrate the successful completion of a film he had just made. He got so drunk at the bar that I wandered off and found myself talking to a guy in orange robes who was involved in Ken Campbell's marathon twenty-two-hour-long experience *The Warp*, which was then underway in the theatre. I went in and watched some of it with the man I had just met, who I discovered was called Pagal which means Madman. Pagal was half-German and half-English, and had spent time in Poona in India – somewhere I had only heard about in connection with the British Raj. I was completely

bowled over by Pagal who told me about his life in Poona with Bhagwan Sri Rajneesh and his orange sannyasi. I had never met anyone like him. We went back to my flat and talked all night and quite soon afterwards he went back to India. But not for long. Soon, just as I was opening the shop, he was back in my life. Despite his many eccentricities he could be extremely organised and methodical and he gave me many good ideas for running the shop. Before long he had moved in with me; inevitably he was penniless, but I found out so much from him about things I had never dreamed of, that I learnt not to mind having to pay for everything. And although he smoked dope, he wasn't a drunk. My friends were very wary of my new lover – no one I knew had experienced this kind of life. In fact, a friend told me recently that observing us together was like watching a soap opera unfold. Although he didn't drink, it turned out that Pagal was a diagnosed schizophrenic; he also had other girl-friends and one special German ex-girlfriend who was dying of cancer who he insisted should come and live with us. I was miserable; she barely spoke to me and while I was in the shop all day the two of them stayed at home in my flat. Why did I put up with it? I was put through agonies of jealousy but somehow felt that my desire to have an exclusive one-to-one relationship was somehow not part of the Poona ethos. And, I suppose, deep down I didn't think I deserved a one-to-one relationship.

In January 1981 I went to Poona and the ashram of Bhagwan Sri Rajneesh, accompanying the German girl who, after we arrived in India, never spoke a single word to me. I'm not sure what I was expecting to learn or discover about myself; I went because Pagal insisted that it was too good an opportunity to miss. What I did find initially was that Poona – despite its reputation for love and friendliness – was one of the coldest and most unfriendly places I had ever been to. One evening, in floods of tears, I went back to the room I was sharing with another German girl; she was lying on her bed

reading and never once looked up or asked what was wrong. However much one was meant to leave people to their own 'trips' or devices, I could never accept that this lack of compassion was beneficial or even really human. I discovered that an English schoolfriend was living there and she really saved my life by being kind and friendly; the sister of another friend was also there, assisting in groups. Both have remained firm friends. But over the six weeks I was there, my feelings towards the place began to change; I had moments of feeling complete unity and wholeness with the world, an understanding of what living in the moment meant, but perhaps the most long-lasting benefit has been the ability to be open and to say 'yes' to life. This highlighted what I had always felt, but my attitude to life had at last been given the seal of approval. By the time I left I believed that, whatever happened to me back in England, there would always be Poona to come back to. In fact, this turned out to be a false assumption as, three months after I left, Bhagwan left India and the ashram in Poona collapsed.

I was incredibly excited about seeing Pagal on my return. He met me at the airport and dropped a bombshell. In my absence he had met someone else who he told me I would love like a sister. I hated her before I'd even met her and she made my life hell for the next few months. I don't think I've ever been so jealous and yet I felt that I should try to learn to accept what was happening. I was miserable. I don't know what made me put up with this Bhagwan-named madman and his entourage. And yet I learned so much from him, and changed so much, that I am actually grateful. In 2000, Pagal died from cancer. Although we had been out of touch for many years, his son alerted me to the fact that he was ill; I went to see him several times because he was dying, and I was able to tell him how much he had meant to me.

Soon after I arrived back in London there was a large

gathering of sannyasi (followers of Bhagwan) at the March Event, at the Café Royal in Regent Street. Parts of it were being filmed for the BBC's *Everyman*, including the particular group I was in. The director was thrilled to discover that I had my own business: he wanted a cross-section of people and he asked if he could film me participating in the group. I agreed and was filmed bawling my eyes out over the hurts connected to my arm that I'd suffered over the years. I felt somewhat of a fraud as I was totally aware of what I was doing. I know how strong my sense of self and core being are. I have no fear that anything will shake these beliefs and I see these new experiences only as possibly enriching rather than as totally life-changing. But by holding back that bit of me which is my essence I never feel in any danger of being brainwashed or losing my sense of self.

The television programme wasn't broadcast for about nine months after it had been filmed, by which time the moment of spontaneity, which had prompted me to agree, had long passed. I dreaded the evening it was to be shown. And most of all I dreaded other people's reactions. I told my parents when it was going to be on because I didn't want them to hear from anyone else, and I sat back and watched and waited for the repercussions. I had been filmed all those months ago, both in the bookshop as well as being hysterical at the Café Royal; my appearance on television that night lasted for five long minutes and then I had to wait until the end of the programme before the telephone rang. It was my mother and all she said was: 'You looked very beautiful, darling.'

I went on wearing orange clothes for about a year but started going out on dates with other men. Sometimes there were occasions when I felt that I was intentionally being made to feel uncomfortable. I was once taken to a dinner party by a man I had only met once before.

'Do you think you could cut my steak for me?' I asked him.

'Why?' he said.

'Because I've only got one arm,' I responded.

'I know that,' he said.

'Well, it's hard to cut meat if you've only got one arm,' I countered. Did he have no imagination?

I hoped that was the end of it but a few minutes later he asked, 'When you're writing do you use your left hand or your right hand?'

'My right hand, obviously.' This was beginning to get very uncomfortable.

'Well, can you write just a bit with your left hand?'

I was floored – what was he getting at? Was he deriving some kind of sadistic pleasure from seeing me squirm? Much of the time I try to find excuses for people who seem to be deliberately making me feel awkward. Perhaps they hadn't noticed or, once they'd started on the 'uneasy' path of questioning, perhaps they felt that they were in too deep and somehow couldn't extricate themselves. But in this case, even if my lack of arm had not been observed – which under the circumstances was unlikely – there had been the conversation about cutting up meat ten minutes before the strange, rather sadistic questions. If I feel I am among people who are taking a perverse pleasure in making me feel uneasy, my instinct is to disappear as fast as possible. Of course I usually stay and go on being polite, thinking that in some way what has occurred is my own fault. More often than the disability being ignored, it is the person who *has* the disability who will be ignored. A Radio 4 programme called *Does He Take Sugar?* looked at the concerns of disabled people, and gave examples of how people in wheelchairs are often talked 'about' rather than 'to'. However, in this instance it was the other way round and my very obvious disability was ignored for what could only be very perverse reasons.

For several years in the 1990s I corresponded with an American I encountered through an ad in *The New York Review of Books*, but who I had never met. When we first exchanged photographs (mine carefully hiding the fact that I had only one arm), he immediately wrote back asking me why I wore my watch on my right wrist. I ignored his question, but a year or so later when I was about to meet him for the first time, I panicked about not having told him. Luckily an article about me, which mentioned my arm, had just been published, so I sent it to him. But when we met, and this was when I was in my forties, my arm was never brought up in conversation. And yet of course it is fantastically important for a relationship to tell someone about an illness or disability; if you don't, there is an additional feeling of unease about what else may be being held back. I stayed with him and his children for a few days after which our correspondence dried up. I think I understand this better now. When Kay Redfield Jamison, Professor of Psychiatry at Johns Hopkins University and expert on bipolar disorder, told a lover about her own manic-depression, he said: 'I thought it was impossible for me to love you any more than I do. It doesn't really surprise me, but it does explain a certain vulnerability that goes along with your boldness.'

When I am asked by someone how will they recognise me, I have never said that I have only one arm; instead I describe the colour of my hair and my height and what I will be wearing and go to great lengths not to mention that I am missing an arm. I think this has to do with not wanting to be defined as 'the woman with one arm'. Yes, of course it is part of me, but only a part, and not the main thing I want people to think about when they first meet me. In the days when it was necessary to state 'physical characteristics' in a passport, I *hated* having to write 'one arm', but felt obliged to do so.

A man I met who had had his arm amputated when he was twenty-four said that initially he had coped with the loss, and

had helped his friends to cope, by joking about it. It is interesting that even when he was suffering from the trauma of the unexpected loss of his arm, he felt that it was up to *him* to put his friends at their ease. Talking to this man over a two-hour period I was struck by the similarity of reaction and experiences that we had both encountered, despite our very different lives. Neither of us actually spent much time thinking about having one arm but the main areas of similarity were in other people's reactions that ranged from those who did not notice (something which surprised us both), to those who were embarrassed, to those who were overly eager to help. Neither of us liked the idea of a false arm.

I met another one-armed man, however, who has a prosthesis and throws the fact in your face. He needs a false arm for riding a motorbike and when he goes into a bar to order a drink he takes off the arm and puts it on the counter.

I found a newspaper article about a man in Texas who, having been refused a drink because he was too drunk, pulled a gun on the barman. He had to flee when his false arm, which was holding the gun, dropped on to the bar; the news cutting didn't relate whether or not he was able to retrieve his gun.

At the beginning of 2001 there was an exhibition at the Victoria and Albert Museum of eight amputee sculptures by Marc Quinn. The works were in the main sculpture gallery alongside classical torsos and busts. Quinn said of his work:

People are seduced by the beauty of these sculptures, it makes them face what they can normally avoid. In the classical world, the hero is someone who conquers an exterior foe or world. Today it seems to me a hero is someone who conquers the inside . . . The sitters are heroes who have conquered their own interior worlds, and yet disabled people are invisible culturally, in art history.[7]

The common aspiration among the amputees Quinn sculpted was the desire to be seen by the world as real people, possibly beautiful, but I think Quinn has fallen into a trap by calling his sitters 'heroes'; apart from finding that patronising, I feel it also implies that they are heroic for just 'being'. Of course, on one level 'conquering' a disability is a challenge, but we all have demons – some inner, some outer – and calling someone heroic for just being disabled leaves no superlatives to use for their achievements. I admire the courage of the sitters but could not imagine myself ever agreeing to pose nude for a public work of art. But I don't think that's only to do with having one arm; I just would not want to be seen in the nude by strangers.

One of the things that always surprise me is how few people immediately spot that I have one arm. I tend to notice if someone is missing even half of their little finger, but we all have that ability to detect a lack in others when we are lacking something ourselves. Few people probably realise that the couple in Chagall's painting 'Above the Town' of two lovers flying through the air – he in green and she in blue – have only two arms between them. The painting makes them seem totally 'normal'. The suggestion that they are beautiful and in love is not compromised by their lack of arms.

On my third date with one man, a writer, he asked me – in the middle of dinner – what had happened to my arm since our last meeting. When I told him that I only had one arm, he almost immediately called for the bill and I never heard from him again. I'm not sure whether he was embarrassed that he had not noticed or horrified at the reality.

Part of me liked the fact the writer had not noticed; as a child I had always tried to disguise the fact I had lost an arm by wearing long sleeves, but as an adult my feelings were far more complex. I no longer try to conceal how I look – in the summer I wear short-sleeved dresses and T-shirts – even so,

many people I subsequently get to know tell me that they do not notice for a while. In many ways I felt that wearing short sleeves made it easier for people – there was no pretence; they saw me as I was. But this man obviously had not detected anything unusual, even with what should have been his keen writerly eye. When I think about this incident in a charitable way I assume that it was his lack of observation that embarrassed him, and of course I prefer that – it effectively lets me off the hook. But I suspect it was the other reason – that the reality horrified him. What was he, a well-known writer, doing with a disabled woman?

An acrotomophile is someone who is sexually excited by the stump of an amputee partner; these people call themselves devotees, and I have discovered that there are a significant number of them. The definition of acrotomophilia is: 'a paraphilia of the stigmatic/eligibilic type in which the sexuerotic arousal and facilitation or attainment of orgasm are responsive to, and dependent upon, a partner who is an amputee (from Greek, *akron*, extremity + *tomé*', a cutting = – *philia*)'. Even knowing that many female amputees suffer rejection, divorce and a lack of social acceptance would never mean that I could bring myself to be grateful to anyone for fancying me *because* I have one arm. The research that I did into the subject showed that the devotee primarily sees the person as a 'stump' and not as a whole human being; there is also an element of domination in an acrotomophile.

Acrotomophiles are usually male and are attracted to female amputees on crutches. Many of them do not like to be branded with any word ending in '-phile' as they feel this places them together with other perverts. One of the more disturbing things about a devotee/amputee relationship is this element of dominance. If the amputee is unaware of this, which is often the case at the start of a relationship, conflict

can ensue; everyone values their independence and the amputee more than most.

Interestingly, there are relatively few female amputees and there are very few female devotees interested in male amputees. The ratio is about 300:1 male:female devotees. This statistic freaks me out because it means that the relatively few female amputees are in hot demand by the male devotees. In general, the acrotomophile does not like to see a prosthesis and is not usually so turned on by arm amputations. Ian Gregson writes: [8] 'If you feel you can handle being treated as a "stump" and not a full human being, you may want to venture into such a relationship. But in the long run a mutual respect has to be developed; physical relationships or relationships based on a particular attribute have a tendency to burn out quickly.' In a survey, over eighty-five per cent of devotees in the sample agreed with the statement: 'If I see a female amputee at a shopping mall I will follow her.' And over fifty-seven per cent agreed that: 'If I see a female amputee in a store I will try to talk to her.'

Lynn Brancato wrote on the Internet: 'To complicate matters further, a number of women absolutely reject any advances made by men who seem interested in them because of their disability. Their feelings were well stated by one rather vocal woman – a wheelchair user – who, upon learning of this interest, exclaimed: "I wouldn't want a man who wanted me because of my disability." This emphatic statement was countered by a woman, born without limbs, who confided: "Thank goodness there are men who are attracted to amputees. Otherwise, no one would want me." ' Perhaps the second woman had accepted her position more than the woman in the wheelchair – however, my sympathies lie with the wheelchair user. Another woman stated that she did not like to associate with other female amputees because she felt that she lost her uniqueness among them. She thoroughly enjoys being different

and receiving special attention. This, although I hate to admit it, is something with which I can empathise.

On a website I read that:

> Attraction to disabled persons has also been related to homo-sexuality, sadism and bondage. An amputee's stump has been suggested to resemble a penis, therefore providing a less threatening sexual stimulus for male 'latent homosexuals' and a counterphobic protection against the fear of castration. A stump's similarity to a penis has also raised the possibility that a desire for amputation is a 'counterphobic' antidote for male acrotomophiles' fear of castration, although such fears have not been documented. However, recent surveys find no increased prevalence of homosexuality, sadism or interest in bondage among acrotomophiles.[9]

Rather worryingly, devotees, who very infrequently admit their attraction to disability, are known to volunteer or work where contact with disabled persons is assured, e.g., as people who fit false limbs and possibly as personal care assistants.

Perhaps even more disturbing to an amputee are apotemno-philes (aka wannabes). Ian Gregson's website defines apo-temnophilia as: 'A paraphilia of the stigmatic/eligibilic type in which sexuerotic arousal and facilitation or attainment of orgasm are dependent upon oneself being an amputee (from the Greek, *apo*, from + *temnien*, to cut = – *philia*)'. There are apparently people who spend most of their lives wanting to become amputees, and who become fixated on carrying out a self-contrived amputation or obtaining one in a hospital. Some 'wannabes' tape their ankles to their thighs and wander around on crutches pretending to be amputees. There are others who actually do get rid of one of their own limbs to satisfy their urge. One man cut off a small piece of his toe, hoping that this would lead to so serious an infection that his whole leg would have to be amputated. It didn't, but he is at least pleased to

have a small part of his body missing. A stump fetishist in Florida blew off his own leg with a shotgun, saying that all his life he had wanted to be an amputee. Now, for the first time in his life, he says, he is really happy and feels complete: 'I'm really pleased. This thing has been my transformation. It's really put me in touch with myself. Now, I feel that I am me.' On his website Gregson refers to an apotemnophile from the UK who, after many years of pain and suffering, decided to lie down on a railway track and drink himself into unconsciousness. When he awoke he was an amputee.

There has to be an element of attention-seeking here: the person knows they want attention; is there a way for them to get that desired attention other than by using a wheelchair and pretending to be paraplegic? If a more drastic course is the answer, that is what they must resort to.

Several case studies indicate that there may be a higher incidence of transvestites and transsexuals among devotees, pretenders and wannabes (DPWs). However, the notion that an apotemnophile is a 'disabled person trapped in a non-disabled body' is difficult to justify, there being no 'naturally occurring' state of disability that would correspond to the two naturally occurring genders. It is perhaps akin to someone feeling that they have been born in the wrong-gender body.

For many stump fetishists there is a kinky sex connection, many of them wanting to be treated by someone in a special way because of how they look. Many wannabes compare the mental suffering involved in their conflictual desire for amputation to the pain of a cancer patient or an accident victim. There was much press coverage a while ago about this syndrome, body dysmorphic disorder (BDD). A television documentary which charted the course of two 'healthy' people desperate to have half of their legs removed portrayed them as 'honest, decent and likeable'. I'm sure most people find this as

weird as I do, and however hard I try to understand their motivations, I can't. I find the idea both insulting and distasteful: like most amputees, I find it difficult to accept that someone would give up a limb of their own volition. Two operations to remove healthy legs have been performed at the Falkirk Royal Infirmary in Scotland by the surgeon Robert Smith, much to the consternation of the local MP, Dennis Canavan, who said: 'I find it almost incredible that any reputable surgeon would amputate a perfectly healthy limb.'[10] Kevin Wright had a pathological desire from the age of eight to lose his left leg but it wasn't until he met Robert Smith that he found anyone with any sympathy for his condition. Smith considered Wright's request for a year and a half before he consented to the operation and during that time he did an immense amount of research which resulted in his becoming 'increasingly convinced that the patients had had very little success from their treatments by psychiatrists and psychologists over the years' and the likelihood of them committing suicide was high.

V. S. Ramachandran, author of *Phantoms in the Brain*, believes that BDD may be caused by a functional disorder within the brain that erases the limb from the mind, making it an entirely unwanted object. As a condition this is hard to understand, but it must also be very hard to live with. There are three other conditions in which people want to get rid of limbs – none of whom Smith would ever consent to help. There are those who are 'psychopathic serial self-mutilators', those who want to have a healthy limb removed so that they can become more dependent on relatives or carers, and those who gain vicarious sexual pleasure from the fantasy of being an amputee.

The Internet has been able to bring all these groups together and give them a voice. There are people who believe in 'pro-choice on elective amputation' – something they compare with

the right to abortion. They believe that if one is allowed to do whatever one wants with one's body – then amputating a healthy limb should be a choice as well. Since illegal amputations are on the whole done by back-street doctors, instances of death under the knife have been recorded.

Kath Duncan, an Australian journalist, was born without half her left arm and half her right leg. In an article in the Australian *HQ Magazine*,[11] she wrote that while she certainly did not want anyone to feel sorry for her, there was something missing in her life – the sense of belonging to a community of like-people. She heard about amputee devotees on the Internet and initially, like me, figured that devotees must be freaks. However, in her case curiosity drove her on since she was intrigued to find out whether 'my most despised body parts, my stumps, could be seen in another way'. Duncan made a radio programme about the phenomenon which involved establishing contact with many devotees, both men and women. During the making of her programme, she began to change her mind as devotees persuaded her that stumps were just the starting point or 'attractant', and that 'it was the whole person they were attracted to' – which contradicts both other research and my own belief that most devotees see the person primarily as a stump. One amputee woman told Duncan that she felt that amputees who couldn't accept devotees 'just couldn't accept their own amputations'. Duncan initially rejected this theory but began to realise that for all her life she'd been looking for a way to stop viewing her disabled body as defective and undesirable. And maybe that is true of me too – that I have never really accepted the reality of my amputation. From her research Duncan discovered that devotees tend to be college-educated, professional white males, who describe themselves as 'curious about the world'. Although at this stage she had not met any devotees, she began to find the passionate emails she was receiving addictive. She

discovered there were meetings for both amputees and devotees in America, and during a trip to LA she got a real buzz from being an amputee at a devotee meeting. She experienced desire and admiration such as she'd never known before and felt popular: 'I fitted right in.' While making a television documentary she met many devotees she found attractive and ended up in bed with a few of them; all of them made her feel wonderful and like a 'divine seductress'. By the end she was no closer to understanding why the attraction between devotee and amputee exists, but she knew that she 'really, really liked it'. She found that only a few of the devotees she met were creeps (a ratio pretty consistent across all of society). She reckoned that 'devotees and I have a lot in common – we're outsiders to the norm, trapped in a cage of societal bad attitude . . . I found after a while I didn't really care why [they] were into amputees; to spend all my time analysing makes me wonder, eventually, why I need to justify that I am attractive as a person. I am who I am and they are just hot for it. It's joyous and freeing.'

Despite having read Duncan's article and playing around on the Internet myself, I cannot shift my feelings of unease and revulsion when I hear about devotees and their desire for amputees. I cannot get away from the feeling that since I do not want to be defined as 'the woman with one arm', I do not want to be fancied for it either. In New York one man tried to ask me out by telling me that his sister had just lost an arm. It seemed an odd way to pick someone up, but this was not an isolated incident and I longed to believe in the coincidence of his sister really only having one arm. Louise Baker, who had one leg, wrote in her book *Out on a Limb* that she came across a man who was 'a collector of one-legged girls'. I wonder, if it were possible, if I would ever have the nerve to ask everyone I've ever slept with whether my having one arm was a factor in their initial attraction. The reality is that I do not want to

know. I did ask one ex-lover recently and his answer was an emphatic 'no'. I believed him, but he then reflected that as he had lived in India for several years he was so used to stumps being thrust at him, that he wouldn't have given my loss of my arm a second thought. In fact, he reminded me that on an early date he had sat on my left side in the cinema and reached for my non-existent left hand and made a joke of it.

But of course I am intrigued by articles such as Duncan's, especially as the likelihood of an older woman meeting a man is so slim and the ratio of devotees to amputees is so weighted in the amputees' favour. I feel torn: part of me feels distinctly uncomfortable at the thought, sensing something distasteful and wrong about investigating this world (and I have never gone anywhere deliberately looking for sex), but part of me says I have rarely turned down a challenge, and I do feel that this would be the most enormous challenge – confronting everything I have built up and believe in about myself. By not exploring this world, I wonder whether I am still in some kind of denial and have not accepted the full consequences of having one arm. Because, although there is a side to me which would still worry about what other people might think if I embarked on this particular odyssey of self-discovery, what I do not have in common with almost everyone I know is two arms, and therefore I shouldn't mind if they are shocked or don't understand what I do, because in some ways I am different. As a therapist friend said: 'Of course your life has been the same, yet different, and that's what makes it interesting.'

So if, as seems to be the case, having some kind of disability can make one more appealing, it is ironic that most people, including myself, chase around trying to be 'normal'.

I once joined a dating agency and the very nice woman who ran it said she felt that there was no necessity to inform people in advance that I only had one arm. I agreed with her and was pleased that she felt that way; when I have put the odd ad in a

newspaper I have not mentioned it either, knowing that if I did it would attract the wrong kind of person. I have no desire to go out with anyone who is interested in me because I have only one arm, in spite of what Kath Duncan has written. However, I know that some of the people I met in this way felt aggrieved that they hadn't been 'warned' and inevitably that made me feel awkward. There is none of this awkwardness when I meet someone face to face or through friends; then my arm becomes just one aspect of me, not something to be either avoided or confronted. Although I now question why some of my ex-lovers first slept with me, I never felt at the time that my stump was anything erotic.

The majority of people, myself included, are probably somewhat uneasy about appearing naked in front of a new lover for the first time. However, I have never felt awkward about showing my stump to anyone in bed; I am far more concerned about my rolls of fat. I don't think I have ever asked anyone I was going to go to bed with what they thought about my having one arm – it has always seemed irrelevant. I suppose I feel that by the time I know someone well enough to go to bed with them, they have accepted me, one arm and all. But then, if that's the case, why should I worry about the rest of my figure? And yet, oddly, I was never worried about how I looked when I had a one-night stand and therefore didn't know the person well.

Angela, in Alexis Lykiard's *The Stump*, won't let anyone touch her stump as she feels that somehow it has become the 'most intimate and private part of me', whereas I find that the only time that I feel totally unself-conscious about it being touched is when making love. There is a feeling then that I am accepted as a whole person and that whoever I am in bed with is not making any judgements about my physical appearance.

I wonder whether Lykiard had any personal experience of this or whether it was just an assumption on his part. A missing

hand also halves the ability to push someone away and makes for an added vulnerability in bed.

Many years ago, Judy Froshaug, a writer born without her left hand, wrote an article in the *Guardian* about how, despite tactless comments from others (and her own embarrassment), she had come to terms with being born the way she was. I found it very sympathetic and wrote a letter agreeing with much of what she had said. My letter was published; however, it elicited many cranky letters from people obviously longing to meet someone with one arm. Holding on to a strong sense of who I am is therefore a crucially important element in my love life if I don't want to be drawn into men's sexual fantasies about one-armed women.

If someone with a disability has an unhappy love affair and is abandoned, the tendency can be to blame the disability. It might be that love affairs have gone wrong because of unresolved emotional conditions created by having a disability, but not usually by the physical fact of having one – that is, unless a relationship involves devotees. By now I feel secure enough physically, or maybe wise enough about myself, not to have to use my disability as a prop or make it an excuse for any unhappinesses. This is one of the many reasons I am deeply suspicious of anyone who says they are attracted to me *because* I have only one arm. If that is the attraction, I feel that that could also become a repulsion. So, although I tend to be impulsive, I feel that provided I hang on to my sense of self, my finely tuned filters will protect me.

CHAPTER 8

Dove Hunting

There is a need, in all of us, to belong and to be with like-minded people. Obviously friends fulfil some of these needs, and there are clubs or societies that cater to almost every fad or fantasy, but although I had joined various organisations to indulge my literary interests and love of travel, it had never occurred to me to want to meet a group of one-armed people. Rather the reverse, in fact; I had shied away from even the thought of being seen as a member of any disabled fraternity. Being with other one-armed people would be like a mirror – I would see others as I was seen by others. Yet part of me felt that I had never really 'belonged'.

Then one day, on the Internet, I came across the 'One Arm Dove Hunt',[1] which seemed to be an annual get-together for arm amputees in Texas. At first I was just intrigued, so I got myself put on the mailing list and each summer I would get notice of the next hunt – which takes place every September on the first weekend after Labor Day. The year 2001 was the thirtieth anniversary of the hunt, and because I was thinking of writing this book, I felt I had to go. 'There is a certain free-masonry among amputees. I am always interested in meeting others of my species,' Louise Baker says in *Out on a Limb*, and I wanted to see if I might feel the same.

I had no idea what 'dove hunting' involved, and I had very mixed feelings about the whole idea – I wasn't sure I really wanted either to shoot doves or to meet so many other people with one arm. But I discovered that I didn't have to know how to shoot, and I also gathered that, although it was still called a

dove hunt (doves in America are more like British pigeons), the event had changed its emphasis and was now more of a straight-forward get-together for one-armed people.

The One Arm Dove Hunt was started as a joke in 1972 by Jack Northrup and Jack Bishop when they realised that in the small town of Olney – population 3,300 – there were eight one-armed men. Far more men than women have one arm, as a result of industrial accidents, motor-bike crashes and military service, and on the Texas–Oklahoma border the numbers shoot up as a result of farming and oil-related mis-haps. Bishop, now eighty-four, who lost his arm to cancer as a baby, is the elder of the 'one-armed Jacks'. Northrup had a car accident while he was in the army, and lost his right arm at the age of twenty-one. He is a talented pianist and guitar player; he tunes his guitar in the key of E and strums with his ring finger, managing to hit all the major chords – further proof that there really is nothing that can't be done with 'only' one arm.

I was extremely nervous at the thought of going, as I didn't have a clue what to expect from the weekend. What on earth did one wear to a dove hunt? What would the other people be like? And was this really above board, or some kinky jamboree for amputees?

When I arrived at the tiny airport in Wichita Falls there didn't seem to be anyone to meet me. I had no contact number for Jack Northrup, and I didn't even know where I was staying. I couldn't believe that a well-travelled person like myself had flown halfway round the world with no idea of where I was meant to be going. But after about ten minutes I found Northrup and his wife Anita, both delightful people, and my panic subsided as they drove me to Olney and to the Pipeliner Inn.

'Welcome. I'm so pleased you're here,' said the owner in an English accent.

One Arm Dove Hunt, 2001

'Where are you from?' I asked.

'We're from London,' answered his wife, Mrs Patel.

To be greeted by the Patel family from London – that *was* reassuring.

The following morning I was shown the headline in the local paper, the *Olney Enterprise:* 'Dove hunt to welcome first overseas visitor'. That was me. Not only was I the first international visitor, I was also one of the few women among the sixty or so people there, who ranged in age from six to seventy-nine. In the Civic Center four giant boxes of right-handed gloves donated by a local factory were up for grabs – they were thick gloves for outdoor work, and I took a couple for future use. Despite the right-hand-only gloves, everyone seemed very ordinary and I realised that I could stop worrying, since this obviously wasn't remotely kinky.

Right-handed gloves at the One Arm Dove Hunt

It felt very strange to be with so many one-armed people. All my life I had been, more or less, the only one, and in over forty years I had probably met fewer than ten others. Here, suddenly, the one-armed formed the majority (though there were several two-armed partners and spouses). I started talking to a two-armed journalist from the *Olney Enterprise*, who said to me: 'You know being here makes me feel like an outsider. I am just beginning to get an inkling of how it must feel for you to be a one-armed person in a two-armed world.'

'Well, probably not quite,' I said, 'because for ninety-nine per cent of the time it's not something I think about. However, being here means its something I can't avoid thinking about and there are parts of me that don't like that – it's like having a constant mirror in front of me. Of course,' I went on, 'a large part of me welcomes the experience of being among so many one-armed people, but I also feel that I've lost my uniqueness and I'm not entirely sure I like that. As I said I rarely think about having one arm and being confronted with a roomful of one-armed people makes me horribly aware of it.'

What I didn't tell her was that I also found the way that many were dressed disconcerting – I have always been careful to buy clothes that cover my stump (except when wearing a bathing suit). Here no one seemed to feel any qualms about what they revealed.

However, everyone was so friendly and seemed so uncomplicated that I couldn't help feeling at home. It was a good feeling and the lack of embarrassment was refreshing. One of the participants said that she had been on the mailing list for many years but never attended because she thought it was 'just a hunt, but I've discovered that this is really a family reunion and I'll be back every year. You've got to be here to understand what it's all about. No arm amputee should miss it.'

Many local businesses in Olney, as well as the people who come, donate objects to an auction, which pays for the event and keeps it free; the auction is organised by Jack Northrup, who is an accomplished auctioneer. The dove hunt is the high point of the year for Olney and the residents help to cook massive meals for up to three hundred people. The dove hunt also provides an annual scholarship fund to send a physically disabled child from Olney School to college.

The youngest person there was Thomas Navarro, aged six, from Boerne in Texas. He had been born with a shortened right arm and no hand, and he was delighted to meet other people like him. His mother was excited by his instant transformation – rather an introverted child, he became much more assertive and joined in everything over the weekend.

Tom Murphy, a guy in his fifties, who came from Saukville in Wisconsin, was there for the first time. Like me, he had grown up without his left arm.

'How did you lose it?' I asked. This, for the first time in my life, seemed a natural thing to ask.

'I had a farming accident when I was seven. When it happened, the local farming community clubbed together to

buy me a radio, but my mother spent the money on a bicycle for me instead.'

He went on to tell me that his mother's decision had upset many of the farmers, who demanded their money back; they seemed to think she was being cruel in getting him to ride a bike. I suppose they thought the child needed to be handled delicately, whereas his mother knew that he needed to be treated as if nothing had happened. The attitude of the parents is vital when a child has a disability; if they don't make a production of it, the child won't either.

'It seems that a mother's instincts are often right,' I agreed. 'When I lost my arm, aged ten, my mother took me skiing, and people were horrified. In fact, so many things like this have happened that I'm really keen to write a book about it.'

'Wow, I've thought of that too,' said Tom. 'However much one thinks of oneself as the same as other people, a lot of people don't feel that. And things do need to be said, since in some ways we *are* different, and we definitely do live in a world geared to two-armed people.'

Tom had applied to be drafted into the army but was refused. He had left the 'reasons-for-not-joining' section blank – *he* knew there was nothing he couldn't do – but the board assumed there must be things that he wouldn't be able to accomplish.

For recent amputees the occasion was far more than just entertainment. James Tolman, from Knoxville in Tennessee, had had a work accident eighteen months earlier and since the accident had stayed at home living on disability allowance. He hadn't left his house, not wanting anyone to see him. Being at the hunt had made him see that he had to get on with his life, and he claimed he had the best two days in a long time. 'Being here and meeting so many people with one arm who do things with their lives has made me understand that I should and could get on with my life too,' he said.

'Eleven months ago I was hit by a post-office truck,' Pam Prepura from Chicago told me. 'I really thought that was the end of my life. But now I'm here, I feel "normal" for the first time in a year. Without a doubt it's the happiest time I've had since the accident . . . the best "medicine" I've had yet. I actually hated the thought of shooting doves, but I realise, being here, that it's much more than that.'

The most recent amputee was Jodi Remington, a police officer from Pawhuska in Oklahoma. A deer had hit her car only eight weeks previously and the ambulance man who rescued her from the crash had given her the money to attend the dove hunt. She had made up her mind to requalify for her original job in the police force as she had quickly discovered that she didn't like the constrictions of work in an office.

Many people say they wouldn't miss the hunt for anything and return year after year. Sarge Luster, who lost his arm in the Korean War and has taught physical education in Australia; Billy Steinkamp, the constable of Crawford County, Texas, where President Bush has a ranch; Vietnam vet Charlie Oman, who drove trucks for Evel Knievel; Tim Wright, a lawyer from Georgetown in Texas; Gene Alexander and Jim McCarson – all have come many times.

This is the only meeting for one-armed people in the world. There are several for amputees in general, but as people who lose legs face the problem of getting around the issues are very different. There are, however, various societies of one-armed people. Victor Rosario, who was born with his right arm missing, started the One-Arm Bandits baseball team in Florida in which fifteen of the eighteen players are missing an arm or part of an arm. They compete against able-bodied teams regardless, Victor explained, but there are challenges. 'Imagine – to get a grounder, you field it, but then you've got to drop the glove, grab the ball and throw it.' They have travelled to Venezuela where they played against a local team – Bandidos

de un Solo Brazo – and visited children in hospital. Team members are often quoted as saying: 'God didn't give us all the limbs you need to play baseball, so maybe that's why he gave us a little bit more heart.'

The dove hunt is billed as a sporting event, but in reality it is much more of a forum for amputees to meet and to exchange experiences, ideas and tips (I was given an ingeniously shaped knife of a totally different design from the one I'd previously been given – one edge being very sharp – but very effective). In fact, many of the people I spoke to who were relatively long-term amputees thought that they had got much more out of life since losing an arm. For recent amputees, the event is of real value; the long-term amputees are able to communicate the reassurance that life can be even better with one arm than it was before, though it's hard for any two-armed person to believe. Having something as dramatic as losing an arm happen to you makes you realise how precious life is and how every drop should be squeezed out of it. A worry that several people had was that their 'good' arm would give out as they got older. It's something that I have occasionally thought about myself, but it has never stopped me doing things. Nevertheless, if you have only one arm it is doing the work of two, and several people have experienced problems, such as repetitive strain injury (RSI), with overuse.

'That'll be fifty cents,' I was told as I helped myself to break-fast the first morning. Breakfast was ten cents a digit, so there were a few double amputees who ate for free. They amazed me with their dexterity. Joyce Baughn, from Jacksonville in Florida, had lost both her hands at the age of six under the wheels of a train but there didn't seem to be anything she couldn't do. She had been the first woman to come to the hunt eleven years before and had shot with the best of them. She had not worn a prosthesis since she was eight and, although

there were a few people who occasionally wore hooks, there wasn't a single person who had a cosmetic false limb, the general feeling being that it is important to be accepted as you are, rather than to have to pretend to be something you're not.

The first shooting event was the 'trap-shoot', which involved shooting clay pigeons in the rodeo grounds just outside Olney. It was blisteringly hot and everyone had a few trial shots at skeets, or clay pigeons, before the real competition started. The competitors were divided into above- and below-elbow amputees, each being allowed ten attempts. Most of them put the gun straight up and shot from the shoulder, although a few had special harnesses. My new friend Tom Murphy won the above-elbow category using a single-shot 12-gauge shotgun with a 34-inch barrel, shattering every skeet except the very last one. Those who allowed him to fail the draft obviously had no idea of the skills they were turning down. The second prize went to Jim Jacques from Yukon in Oklahoma.

'C'mon, Sarah, have a go,' encouraged Tom.

So, for only the second time in my life, I fired a gun. I was lent a four-ten, a small light gun, but I found it extraordinarily difficult to hold it up to my shoulder, to take aim and to fire. I missed the target spectacularly both times and the following day I had huge bruises on my shoulder where the gun had kicked against it.

By now I was beginning to recognise a quality common to most of the people taking part and one with which I strongly identified: competitiveness. When the world assumes that you can't do something because you have 'only' one arm, it makes you determined to prove them wrong. Imagine, then, sixty highly competitive people all trying to win. It made the atmosphere quite charged, but this was balanced by the friendly mood – everyone understood the agenda. In rehabilitation centres the emphasis is often on games and the competitive

spirit is encouraged. As David Skidmore, who learnt to fly with no arms, said: 'It wasn't that it turned me on particularly, but it was a challenge. That's the way disabled people think. They have to prove themselves the whole time. It runs through everything I do. It gives me a reason to reach for the sky.' Was he consciously or unconsciously echoing the title of Paul Brickhill's biography of Douglas Bader *Reach for the Sky*?

On the second morning, after another fifty-cent breakfast, the first sport was horseshoe pitching.

'Sarah, will you be my partner for this?' asked Jim Canfield, from Great Bend in Kansas.

'I'd be thrilled,' I said. I already knew he had a good eye as he had won several of the shooting categories the previous year.

'I also play pool professionally,' he said. 'In the world-championship in Las Vegas I surprised a lot of people by often flipping my leg on to the table and shooting between my toes.'

Jim's arm had been amputated in 1983 as a result of cancer, and he had given many talks to doctors about the realities of amputation. He has felt more motivated and tougher since his operation.

In a horseshoe-pitching contest, you stand opposite your partner who is next to a pin at the other end of the field. The goal is to reach twenty-one points by throwing the horseshoe as close to the pin as possible – ideally ringing it for three quick points.

I picked up my first horseshoe and hurled it towards Jim – it ringed the pin.

'Well done! Now try another,' he shouted.

So I did. And the horseshoe ringed the pin a second time. I was beginning to enjoy this game. Jim and I won three rounds in swift succession. Each time I ringed the pin I was cheered on and no one could believe that I wasn't a secret horseshoe pitcher from Notting Hill. I really wanted to win. At last we reached the quarter-finals.

'Go on, Sarah – miss!' Tom Murphy shouted.

'Stop it, Tom, you're putting me off.'

'That's the intention. And don't you realise your arm will be so sore tomorrow that you won't be able to write?'

He was certainly right about that; a horseshoe is heavy, and after each throw my arm felt more and more exhausted. There was no doubt that I was tiring towards the end, but it was disappointing to be eliminated, especially since I had got further than any of the other women.

Another sport was the 'cowchip chucking' contest. I thought I would give this very Texan sport a miss – the point is to throw dried cow dung at two sitting targets perched on old lavatories. However, I found myself forced into it and was told that I had to 'throw for England' – so I did. The most accurate cowchip was thrown by Babe Osowiecki, who divides his time between Cooper Landing in Alaska and Thomaston in Connecticut; he had travelled the farthest of anybody apart from myself.

And finally, the dove hunt. Only about fifteen of the men actually went dove hunting – the alternative was bingo in the Civic Center. I wanted to see the hunt, even though I had no intention (or chance) of shooting anything myself. The hunters dress in camouflage and range themselves by their (often starkly white) pick-ups around the edges of fields full of sunflowers, and wait for the doves to fly overhead. The hunting took place in the hot mid-afternoon sunshine (though, ideally, dusk is the best time) and, although this was the most macho part of the weekend, there was still a camaraderie that was hard to fault. No one is allowed to shoot more than fifteen doves, but this year there were very few and the above-elbow winner, my horseshoe-partner Jim Canfield, shot six. The season is only six weeks long and had begun on 1 September – just the week before – but even within that short period the doves had become very wild and difficult to shoot.

In the late afternoon, I sat in the tent and chatted to Jack Northrup about the dove hunt and about life in Texas. It was peaceful sitting there; the shooting was over and people were beginning to leave.

'Are you flying straight back to England?' Jack asked.

'No, I'm going to New York – I have a book *Inside Notting Hill* being launched on Tuesday the 11th.'

The month was September and the year 2001. The launch did go ahead – but in a very low-key way.

I found a sense of belonging in Texas that I hadn't experienced before, so I was glad that I'd overcome my doubts about what had seemed, from England, the bizarre notion of a dove hunt. That's not to imply that I would like to live surrounded by fellow amputees – I would hate it – but I was able to cut across social barriers and form instant bonds with people in a way I had never done previously, *because* I had one arm. Yet again, America had been the place where I had broken through certain barriers – in my early twenties it had been in America that I had been able to talk about having only one arm for the first time, and in Texas, in my fifties, I had for the first time met other one-armed people and felt a sense of belonging that part of me had never experienced before.

I have since discovered that one of the original settlers in Jamestown in Virginia was Christopher Newport (1560–1617), known as 'Captain Newport of the one hand' – the English captain of the *Susan Constant*. So it seems that one of the original founders of America was a man with only one arm!

Conclusion

Partly because I was thinking of writing this book, in 1999 I went back to Lourdes. It seemed an appropriate completion of something, so I decided to join the Westminster Pilgrimage as a volunteer. Lourdes is a place where you cannot pretend to be immune from the suffering that exists in the world, but where you can learn a huge amount about not blaming others or being a victim.

When I arrived I found I remembered very little about being there as a child. Rather, I felt assaulted by the barrage of tacky tourist shops selling rosaries, plastic Madonnas and other religious memorabilia. However, although it is impossible to ignore the blatant commercialism, it is quickly apparent that it is irrelevant to the true meaning of the place. The town is full of *malades* (the term used for the sick), in wheelchairs, in blue-hooded chariots and on stretchers; no one stares, it is the sick who seem 'normal' and the barriers between disabled and able-bodied are swept away. It is as if Lourdes is the world as it should be, according to one priest 'a vision of community', a place where we are all equal and where the humanity and compassion which exist in each one of us can be expressed.

The *malades* in our pilgrimage stayed in one of the hospitals and, as a helper, I was on duty every day for one or two three-hour shifts; my duties included waking, washing, feeding and dressing the *malades* and accompanying them on one of the many processions or services held throughout the day. Their patience, their dignity and lack of embarrassment or self-pity when needing or asking for help were impressive and

humbling: a quick intimacy occurs and the status of helper or helped becomes immaterial. It is illuminating to be in the presence of such faith and such positive acceptance of illness.

Many seriously ill stretcher-cases make the journey each year and stay in cramped conditions, looked after by dedicated volunteers who regard their work as a privilege. A priest told me that he believed the skin between heaven and earth to be thinner in Lourdes than elsewhere, and my recognition that we are interdependent and that God loves us all equally seems to demonstrate this.

The whole ethos of Lourdes is quite alien in today's rational world and being there sometimes feels like being in a time capsule. Lourdes is a glorification of the irrational, a crazy system which nevertheless works to the benefit of *malades*, helpers and pilgrims alike. Lourdes reasserted the importance of the miraculous at the precise moment in the mid-nineteenth-century when science was gaining its apparently unquestionable authority. Now, in the twenty-first century, we know the limitations of our rational and scientific age. Technology cannot grant us compassion, reconciliation or spirituality, but these qualities are found in abundance in Lourdes.

Ritual, something else we are in danger of losing, is another fundamental aspect of Lourdes: you are always surrounded by it. The Way of the Cross, touching the rock in the grotto, torchlight processions and taking the baths – these rituals take place all the time. The energy aroused by mass feeling means that emotions run near the surface, and during the week I often felt overwhelmed, critical, uncertain and even rather panicky about my own feelings. There are so many external stimuli that I found it hard to be silent or peaceful, but I soon discovered that doing practical things, especially as part of a team, induced a kind of spirituality and unity. It struck me that many of the rituals at Lourdes were remarkably similar to rituals practised by Hindus on their pilgrimages: immersion in

water, candlelit processions and touching objects are all traditions with which many Indians would identify, and they would probably feel quite at ease in Lourdes. I found these symbols of similarity between two religions – in many respects so different – powerful and reassuring.

Beneath the kitsch of the souvenir shops, Lourdes is raw and elemental. It is situated among rather gloomy inward-looking craggy mountains, and there are rocks and water everywhere. The River Gave runs through the town, there are regular thunderstorms with torrential rain, spring water gushes from taps in rocks, and for many pilgrims bathing in the icy baths is central to their being there. There was nothing in the Virgin's message to suggest cures, but she did urge people to 'bathe and drink at the Grotto'. A doctor is quoted as saying: 'I do it as a believer. I do it in humility, in the spirit of penance and as a spiritual exercise.' Bathing is an effort for many. Many helpers never took baths and I had to force myself to take one – the second in my life. Conquering my reluctance, I went one afternoon, and the helpers who undressed and dressed the *malades* with real consideration, love and devotion profoundly impressed me. Wearing a robe, I was held by two women and submerged in the breathtakingly cold water for several seconds; immediately afterwards I felt warm, and found dressing while still wet quite easy (towels are never used). One of the most amazing things about the place is that although people with all kinds of contagious diseases bathe in the same water, no one has ever become ill from it.

Few *malades* go to Lourdes hoping for a miraculous cure; although there certainly are a substantial number of cures, the daily miracle is that those who go in despair often find their despair transformed into hope. This in turn can bring profound physical benefits, and for many the feelings of solidarity and belonging engendered in Lourdes can have positive and enabling effects back home. It is impossible not to be moved

in the presence of such belief and faith; being in Lourdes helped put things in perspective for me, and by the end of the week my admiration for the full-time helpers had grown enormously as I realised the limitations of my own patience and tolerance. I did not leave Lourdes in a particularly peaceful state, but as a helper I felt I had been involved in an intense spiritual experience that I would encourage others to try.

Knowing that cancer can be unpredictable and that it can recede does not change the fact that as a child, before being taken to Lourdes, I was under an imminent death sentence, and that on my return I had no cancer on my lungs. This is for me proof enough that there was some kind of divine intervention. Of course this is not something that medicine finds easy to deal with. 'We must have made a mistake' is rather a poor reaction to such a misdiagnosis. What about the X-rays showing a shadow on my lungs? Weren't they proof enough that no mistake had been made?

Any spiritual experience is unsettling for others. People don't like, and are frightened by, what they don't understand and this is something which inevitably leads to feelings of isolation and secretiveness for the person who has had the experience. At times I find it hard to believe that I am alive due to a miracle; it is a responsibility that I am not sure I can cope with. And indeed the Advertising Standards Authority states that miraculous healing is against the law and forbids anyone from claiming to give it, although of course if you think you have been healed miraculously it is fine to declare that it has happened to you. Websites with people's testimonials of how and by whom they were cured abound. I suppose that although no actual advertising has taken place, we are left in no doubt as to what happened.

When I abandoned Catholicism for many years from my late twenties, I never lost a feeling of guilt. If I was alive due to

some divine intervention at Lourdes, then how could I not be a believer? Yet of course God doesn't only save believers. There is often a feeling of guilt attached to any depression that I have, a feeling that, having been saved, I should appreciate every minute of my life to the full. Thornton Wilder wrote in *Our Town*: 'Oh, earth, you're too wonderful for anybody to realise you. Do any human beings ever realise life while they live it? – every, every minute?'

Whether or not I was cured at Lourdes is in a sense irrelevant; the fact is that I defied my death sentence and, either by miracle or medicine, I was healed. I was obviously intended to live and my belief that this was due to a higher power has moulded the direction my life has taken. Stewart Alsop wrote, in *Stay of Execution*: 'It may be useful to face the chance of death when you are young. It helps to prepare you to face death when you are old. No young person really believes that this time will come. But it will.' It is possible that in some deep part of my unconscious I had faced death, and it is that which has been responsible for my wanting to get as much out of life as possible. I have always had the feeling that I want to say 'yes' to everything and have always had a horror of wasting time, as Thoreau wrote:

> I wanted to live deep and suck out all the marrow of life . . . to drive life into a corner and reduce it to its lowest terms, and, if it proved to be mean, why then to get the whole and genuine meanness of it, and publish its meanness to the world, or if it were sublime, to know it by experience, and to be able to give a true account of it in my next excursion.[1]

I do appreciate that there is no dress rehearsal for life. This is it. Now. I certainly believe, as Boris Pasternak writes in *Dr Zhivago*, that: 'Man is born to live – not to prepare for life.' Julie Friedeberger wrote in *A Visible Wound*: 'Having cancer, recovering from cancer, learning to live with cancer . . . has

made me realize that nothing in life can be taken for granted . . .
It has taught me acceptance and surrender . . . It has taught me
that there is nothing to be afraid of. It has given me a greater
measure of peace.'

I have discovered that due to a financial donation made by
an unknown person to the Medical Missionaries of Mary in
1957, I was made a perpetual member of their Auxiliary Guild.
This means that I have been and will be prayed for in all the
Masses and prayers of the entire Congregation for life. My
former headmistress at the Convent of the Holy Child Jesus in
Cavendish Square also told me that she prayed for me every
day. I find it humbling to think that while I struggle to
remember to pray at all, there are nuns and others praying for
me daily. Is it because of this that I lead what seems to many
to be a lucky and charmed life?

However, as Viktor Frankl wrote in *Man's Search for
Meaning*, what we become depends on decisions rather than
conditions. In a concentration camp he saw both the best and
the worst in people. Most people never have to contend with
those kinds of extreme conditions, nevertheless in countless
smaller ways we are constantly having to make decisions that
affect our lives. Perhaps a close encounter with death gives one
more of an opportunity to choose the way that one wants to
lead one's life. Because, as Frankl says, there is a lot of choice in
how one lives – if people only knew it. I'm not sure why having
a serious illness helps, but it seems to, because the reality is that
everyone has the opportunity to take on the challenge and to
live life within the fullness of their capabilities. The alternative
for those who have been near to death, and indeed others, is to
dissolve into a pool of self-pity and blame – and of course this
does happen. But having accepted the challenge there seems to
be a deeper recognition of the richness of life. As Nietzsche
said: 'That which does not destroy me makes me stronger.'[2]

Although most of the literature I have read has been about

people who have risen to the challenges of their lives by making a positive decision to do so, there are inevitably those who crumple at the first sign of adversity. That seems to be more of a passive decision – something happens to an individual and the least demanding path can appear to be to make oneself a victim, so that other people will have to take the responsibility. Presumably those who take that route have reckoned that it is the easier option, but it is also a very limiting way to live. Blaming someone or something for what has happened to you and living life as a victim can become a trap. If you feel that you can't do something because what has happened to you is somebody else's fault, it makes for a sense of powerlessness, and diminishes a whole range of possibilities. This may sound tough but it is something I passionately believe – I abhor the victim culture.

Although everyone has the choice of getting the most out of their lives, maybe those who have to confront a disaster or tragedy are the lucky ones. They are forced to make a conscious decision about how they will live. Of course, it would be entirely wrong to court disaster or suffering – that would be masochistic; it is rising to the challenge of what has happened which is important, and is probably what people who suffer a major illness or bereavement mean when they say that they consider themselves so lucky.

So maybe I am one of the lucky ones; that is why, when I was asked by a friend whether or not I'd want my arm back, I was uncertain. However, I don't think I ever consciously decided to take on the challenges that having one arm involved. What I did was mostly instinctive; the victim's path was never an option. So there were no big battles to be fought about whether to live positively or negatively – positively seemed a foregone conclusion. The big struggles were with other people's attitudes, which I have learned to deal with somewhat more objectively the older I get. Note the

Trekking on Maria Island, Tasmania, 2004

'somewhat' – I still find insensitive remarks deeply upsetting and there are things that still floor me. 'For Ryckaert was an incomplete man, a one-armed man. As Van Dyck well senses, this incompleteness is the key to his mystery' – these two sentences, from a book on the painter Van Dyck by Robin Blake,[3] make me recoil. Why do they affect me so strongly? I tend to protest that I am a complete person. But what is a complete person? Pondering this, I suspect that it is the second phrase – that 'this incompleteness is the key to his mystery' – which makes me feel really uneasy. What did I think I would lose in writing a book about myself? My mystery? What is my mystery? Do I have one? By writing about having one arm would I be demystifying myself and selling my treasure, my uniqueness, the thing that differentiates me from other people? Everyone is unique, but maybe not so obviously so.

As I started to think back over my life, and to remember some of the things that had been said and done to me, I realised that whatever I wrote about having one arm would

address the issue of how people dealt with anything at all unfamiliar, such as disability, death or race.

Knowing how to tell people about my arm without embarrassing them is hard. Jokes can often be a good method. But sometimes it has been necessary to let people know that I do only have one arm without making them feel embarrassed for not having noticed. This can be difficult and requires tact, since most people do not know how to react when straight-forwardly told. I realise that people are afraid of the unknown and of what they do not understand, but, while I can some-times sympathise with this, I resent having to carry their embarrassment for them. A good friend named me OAB – One Armed Bandit – and still always calls me Bandit. I love this.

Dealing with other people's sympathy is often the hardest part. Americans seem unfazed by a direct answer and tend to say immediately how sorry they are and ask what happened, whereas an endless number of conversations in Britain have gone as follows:

'What has happened to your arm?'

'I only have one arm.'

'I'm so sorry, I didn't realise.'

'Don't worry, I'm quite used to it.'

'I'm really sorry.'

'No, no, it's quite all right,' and so on.

What makes me feel awkward in this kind of conversation is that I know the other person has asked the question about my arm with genuine concern, imagining that I have broken it or injured it in some way; they then feel embarrassed when I tell them that I only have one arm. It is not the response that they were expecting and it makes them feel awkward. Although when I was younger I minded being asked about my arm, now I do not, but I do still resent having to deal with other people's awkwardness. But it is because I know that my questioner is

not meaning to be insensitive that I feel that I should try to put them at their ease.

The kind of exchange I've just written about has happened hundreds of times. But once, at Gatwick Airport, when I was asked to lift up both arms for a body search, and I replied that I only had one arm and therefore couldn't, the woman frisker said, 'I'm sorry. We take so much for granted, don't we?' I was more impressed by this spontaneous response than I had been by almost any immediate reaction in fifty years.

As soon as I started this book I had incredibly positive feedback from everyone I talked to. Barriers which had been in place for years, even with people I knew well, started to crumble, and my friends and I became more open with one another. While talking about the book I have heard audible sighs of relief, as many people have then felt able to confide their own secrets and fears to me. Walls of silence have come crashing down, and the more I have revealed the more I have received in return. That seemed a good enough reason for writing. Never having been someone to flinch from a challenge, I decided to try to explore as widely as possible and I found my research into the significance of the hand and the arm fascinating. The belief that showing what is behind a façade means that chasms between people can be bridged, and that people discover they can disclose what they have hidden, is eloquently put by Nuala O'Faolain in *Are You Somebody?* – '[the people] . . . who were there to welcome me coming out of the shadows . . . wanted to throw off the shadows that obscured their own lives, too.'

I became braver about asking other people who had disabilities what had happened to them. I realised that, although I had been surprised at other people's reticence in asking about my arm, I felt just as awkward asking people about their own experiences. Part of me thought that perhaps they felt the way I had felt as a child, when I dreaded being asked; I detected in

myself a certain Englishness and the very fear for which I had berated others.

Dr James Le Fanu wrote in the *Sunday Telegraph* on 7th March 1999 that the role of 'psychology' in the way people cope with physical misfortune is crucial. In a case study in Kiel, Germany, undertaken by Dr Dieter Frey, those who felt that the accident that had had them admitted to hospital had been unavoidable, but that they had learnt something from it, had fewer complications. Those who blamed themselves or others and felt that they were powerless to influence their own recovery remained in hospital twice as long. Based on these findings Dr Frey reckons that it is possible to predict within two days of an accident how long it will take the patient to recover. It emphasises the importance of a positive attitude. It also highlights how lawyers can be bad for your health: by encouraging victims of accidents and of medical negligence to believe that someone else must be to blame for their bad luck, they reduce the chances of a quick and successful recovery. This would suggest that being or feeling a victim is bad for your health. However, Jean Slocombe of Cancer Research UK was quoted in the *Observer* of 9th September 2007 as saying that while positive thinking isn't always a bad quality it can be 'an additional and unnecessary burden'.

While I certainly hadn't wanted to have cancer or to lose my arm, I never blamed anyone for what happened; it seemed inevitable and unavoidable. I don't think I ever reacted like a victim, rarely felt 'poor me' and I never believed that any of it was somebody else's fault. I learned to take responsibility for myself and my life and my arm and with that response came a great feeling of power. If I had let myself fall into the role of victim and got caught up in the present culture of litigation and compensation – a culture I despise – my life would not have been nearly as rich or fulfilled. Everything that happens

can be a source of learning if looked at in the right way and it is how these experiences are used that counts. Surely one of the greatest gifts we have as human beings is the ability to accept the inevitability of what *is*, not passively but actively, and to use all our experiences, both good and bad, to develop our full potential.

Louise Baker, who lost her leg in a bicycle accident when she was eight, was definitely of the opinion that the younger you are the easier it is to adjust to the loss of a limb. In *Out on a Limb*, she wrote that she had had a 'unique adventure in living that I should never have experienced with the orthodox number of legs'. What is apparent from Baker's book is that if this kind of accident happens to a child, much of the responsibility for coping lies with the parents. When Baker first came out of hospital she realised that she could get what she wanted by saying: 'I can't run or anything any more, you know . . . ' This victim-like behaviour, aimed at eliciting sympathy from other people, eventually led to her being spanked by her father, and she found that 'the honeymoon with my handicap was over'. Later on, when she again employed this tactic, her father said: 'I thought you'd long since decided it wasn't sporting to take advantage of people because of your crutches.'

In February 1998 a keeper at Chipperfield's Circus had his arm torn off by a tiger. The *Mirror* claimed to have the exclusive story about the tiger who 'went chomp, chomp, chomp as he ate my arm'. Nigel Wesson's first response was, 'It's just one of those things. The tiger was only doing what comes naturally. I wouldn't want him killed . . . even though he quite wrecked my day.' He sounded extraordinarily brave and level-headed, running from the cage, streaming with blood, in search of an instant tourniquet; he was the one who seemed to be calming everyone around him. Unfortunately for him, the tiger ate his left arm, and he was left-handed, but even so he emerges as something of a hero, able to make what happened

Dancing with Michael Boyle at my sixtieth-birthday party, 2007

to him sound like an exciting story. Wesson was obviously determined not to be a victim. And rightly so. However later he did try to sue Chipperfields for compensation.

Having to prove that I am capable of overcoming what seem to me minor difficulties can be irksome, but how much worse

it must be for those with major disabilities. Like anyone else, I like being admired, but not when what is being admired is trivial. It detracts from what I consider important. When you are admired for being able to swim in a straight line, it takes away from the admiration due for writing a book or running a successful business. If you tell people they are wonderful for being able to clean their teeth, what superlatives are then left for doing something truly wonderful?

My family has never fallen into any of these traps and, thankfully, I never felt at all mollycoddled by them. When you lose one of your senses, the body compensates by making the other senses stronger. Mightn't this also be true of losing a limb: that other parts of the body will take over the lost limb's role? That would make sense of the apparent ease with which disabled people manage their lives. The disabled person who performs ordinary deeds often elicits wonder from those around them; this can be intensely annoying. If a friend breaks an arm, they will almost certainly tell me how often they had thought of me while they had been struggling with simple tasks. Very often it is the right arm that they have broken, and since I am right-handed and grew up without my left arm, the comparison is slight. It is obviously very much harder to adjust to a disability as an adult and I have every sympathy with any-one who has to re-learn to do everyday things, but what may be hard for them tends not to be for me. As Annie Delin, a disabled journalist, writes in *Stop Press!* (published by Scope): 'Being a hero for doing something ordinary is a tiresome myth.' And it is true that being admired for what seem to be insignificant things, and for doing something which seems unworthy of admiration, can make all praise seem dubious. 'I hated the loving admiration of the grown-ups for me and everything I did.'[4]

Tragic events in life can either make you close down or open up. But neither death nor illness is the enemy; fear is. So much

At home by Tim Scott, 2007

of what we experience is our own fear and resistance to change. It is often cosier to hold on to both emotional and physical pain. Some people cling on to pain and also to acrimony as if their life depended on it – and all that happens is that they end up living in a fur-lined rut. W. H. Auden says it perfectly, in 'The Age of Anxiety':

> We would rather be ruined than changed;
> We would rather die in our dread
> Than climb the cross of the moment
> And let our illusions die.

I have had to face up to years of feelings that, from choice, I had fairly successfully repressed. So for me this search for my 'lost' arm has been both challenging and enlightening. There were days when I would sit in front of my computer with tears pouring down my face – not, I think, tears of self-pity, more tears of relief at finally allowing myself to feel the anger, the hurt and the emotional turmoil which had accumulated around fifty years of living with one arm. I had to acknowledge that many of the defences I had erected were not helpful either to myself or to my relationships with other people.

I hope that writing this has taught me to be more open but also more willing to admit that there are things I cannot do, and things that make me feel upset and angry. Learning to live to one's full potential is what counts.

Notes

CHAPTER 2

1 Byrne, P. S., and Long, B. E. L., *Doctors Talking to Patients*, Her Majesty's Stationery Office, 1976

CHAPTER 3

1 Quintilian, Marcus Fabius, *Institutio Oratoria XI*, *3*, pp 85–87, Loeb Classic Library, Heinemann, Vol. 4, p.289, 1922
2 Schoenberg, Bernard (ed.), *Loss and Grief: Psychological Management in Medical Practice*, Columbia University Press, 1970
3 Bernstein Norman R., 'Objective Bodily Damage: Disfigurement and Dignity', in: Cash, T. F. and Pruzinsky, T. (eds), *Body Images: Development, Deviance, and Change*, Guilford, NY, 1990
4 *De Viribus Herbarum*, fifth century
5 Bell, Charles, *Illustrations of the Great Operations of Surgery*, Longman, Hurst, Rees, Orme & Brown, 1821
6 Catchlove, R. F., 'Phantom Pain following limb amputation in a paraplegic. A case study' in *Psychother Physosom* 1983: 39 (2) 89–93
7 ibid
8 'Phantom Limbs', *Scientific American*, Ronald Melzack, April 1992
9 Fisher, Seymour *Body Image and Personality*, Dover, 1968
10 Schoenberg, op.cit. (note 2)
11 Melzack, Ronald, 'Phantom Limbs and the Concept of a Neuromatrix', in *Trends Neurosci*, 13, pp. 88–92 and 14, 1990
12 James, William, 'The Consciousness of Lost Limbs', in *Proceedings of the American Society for Psychical Research*, Vol. 1, Boston, 1885–89, pp.249–258

CHAPTER 4

1 Wright, Beatrice, *Physical Disability. A Psychosocial Approach*, Harper & Row, 1983
2 Steere, E. (ed.). *Swahili Tales*, Ams Pr Inc, 1989
3 Crocker, Diane W., and Purdy Stout, Arthur, 'Synovial Sarcoma in Children', in *Cancer*, 12, 1959

4 Schmidt, Dietmar, *et al*, 'Synovial Sarcoma in Children and Adolescents from Kiel Paediatric Tumour Registry', in *Cancer*, 67, pp. 1667–72, 1991

5 Turc-Carel *et al*., *Cancer Genet Cytogenet*, 23:93,1986

6 Crocker and Purdy Stout, op.cit. (note 3)

7 Alexander, Franz, 'Psychological Aspects of Medicine', in *Psychomatic Medicine*, Vol. 1, no 1, Jan. 1939

8 Russell, Harold, *Victory in My Hands*, John Lehmann, 1950

9 Stevenson, Robert Louis, 'Letter to Mr Gosse', in *Letters*, Vol. 1, Heinemann, 1924

10 Bruckner, Leona, *Triumph of Love*, Kingswood, 1954

11 Russell, op.cit. (note 7)

12 Wright, op.cit. (note 1)

13 Schwartz, Charles, *Cole Porter*, W.H. Allen, 1978

14 Oakley, Ann, *Fracture*, Policy Press, 2007

15 *The Independent*, November 20th 2001

CHAPTER 5

1 Sontag, Susan, *Illness as Metaphor*, Penguin, 1991

2 *Murray's Handbook to Spain*, Vol. 1, John Murray, 1855

3 Frazer, J. G. *The Golden Bough*, Vol. III p.265 Macmillan, 1890

4 Frazer op.cit., Vol. IV, p.267, quoted from Howitt, A.W., 'On Some Australian Beliefs', in *Journal of the Anthropological Institute*, Vol. XIII, p. 189, 1884

5 Frazer, op.cit., Vol. VIII, p.151

6 British Museum: 119971

7 Polhemus, Ted, *Social Aspects of the Human Body*, Penguin, 1978

8 Exodus 27:11

9 Frazer, op.cit. quoting Bernardino de Sahagún

10 Brand, J. *Popular Antiquities of Great Britain* Vol. III, p. 278, Ams Press, NY, 1970

11 Ashliman, D. L. *The Hand of Glory and other Gory Legends about Human Hands*, www.pitt.edu/~dash/hand.html, 1997

12 Frazer, op.cit. (note 3)

13 Genesis 41:42

14 Emerson, Ralph Waldo, *Essays*, First series, 1841

CHAPTER 6

1 Nietzsche, Friedrich, *The Gay Science*, Dover, 2006

CHAPTER 7

1 Perry, Walter Copland, *Greek and Roman Sculpture*, Longmans 1882

2 Fuller, Peter, *Art & Psychoanalysis*, Writers & Readers, 1980

3 Rickman, John, in *International Journal of Psycho-Analysis*, 21, p.297–8, 1940

4 Fuller, Peter, 'The Venus Pin-Up', in *New Society*, 1975

5 'Body and Soul' by Ann Treneman, *The Independent on Sunday Magazine*, October 11th 1997

6 ibid

7 'A statuesque kind of honesty' by Rose Aidin, *Sunday Telegraph*, 11th February 2001

8 www.amputee-online.com

9 Bruno, Richard, *Journal of Sexuality and Disability*, 15, pp. 243–260, 1997 on www.amputee-online.com

10 *The Independent*, February 1st 2000

11 'The Amorous Adventures of an Amputee Love Goddess' by Kath Duncan, *HQ Magazine* January/February 1999

CHAPTER 8

1 www.onearmdovehunt.com

CHAPTER 9

1 Thoreau, Henry David, *Walden*, Oxford 1999

2 Nietzsche, Friedrich, *The Twilight of the Idols*, Penguin, 1990

3 Blake, Robin, *Anthony Van Dyck: A Life 1599–1641*, Constable and Robinson, 1999

4 Hathaway, Katharine Butler, *The Little Locksmith*, Faber 1944

Acknowledgements

Gillon Aitken, Clare Alexander, Liz Anderson, Rose Baring, Roddy Bloomfield, Harriet Bridgeman, Julia Brown, Karen Geary, Becky Hardie, Max Mackay-James (for the title), Angela Mackworth-Young, Adam Phillips, Barnaby Rogerson, Mary Sandys, Elisa Segrave, Sarah Spankie, Lucretia Stewart; to Simon Gaul and all at the Travel Bookshop for their continued help and, of course, most of all to my friends for their support and encouragement.

Extract from 'The Age of Anxiety' from *Collected Poems* by W. H. Auden reprinted by permission of Faber and Faber Ltd

Photographic credits

Photographs/images in this book reproduced by kind permission of:

Cover Louvre/Bridgeman Art Library, London; p. 6 Antony Armstrong-Jones © Lord Snowdon; p. 25 Wellcome Library, London; p. 49 Musée de l'Ecole des Beaux-Arts, Paris; akg-images, London; p. 71 The Bridgeman Art Library, London; p. 73 Wellcome Library, London; p. 109 © Guildhall Art Gallery, City of London/ The Bridgeman Art Library; p. 127 The Bridgeman Art Library, London; p. 154 Oriental Museum, Durham University/ The Bridgeman Art Library, London; p. 161 Wellcome Library, London; p. 163 The Bridgeman Art Library, London; p. 183 © Sara Nunan; p. 191 Louvre/Bridgeman Art Library, London; p. 249 © Tim Scott; back flap © John Swannell

Selected Bibliography

A fuller bibliography can be found on the website
www.umbrellabooks.com

Auden, W. H., *The Age of Anxiety* Faber 1905

Baker, Louise, *Out on a Limb* Whittlesey House 1946

Blake, Robin, *Anthony Van Dyck: A Life 1599–1641* Constable and
Robinson 1999

Bochner, Jay, *Blaise Cendrars: Discovery and Re-Creation* University
of Toronto Press 1978

Bolloch, Joëlle, *The Hand* Musée d'Orsay 2007

Brown, Mick, *The Spiritual Tourist* Bloomsbury 1999

Bruckner, Leona, *Triumph of Love* Kingswood 1954

Byron, Robert, *The Road to Oxiana* Penguin 2007

Carling, Finn, *And Yet We Are Human* Chatto and Windus 1962

Cendrars, Blaise, *Lice* Peter Owen 1973

Cheiro, *You and Your Hand* Jarrolds 1969

Clark, Kenneth, *The Nude* John Murray 1956

Conway, Jill Ker, *True North* Hutchinson 1994

Csikszentmihalyi, Mihaly, *Flow: The Psychology of Happiness* Rider
1992

Elworthy, Frederick Thomas, *The Evil Eye: The Origins and Practice
of Superstition* Collier Books 1970 (John Murray 1895)

Frankl, Viktor, *Man's Search for Meaning* Rider 2004

Frazer, J. G., *The Golden Bough* Macmillan, 1890

Freud, Sigmund, *Totem and Taboo* Hogarth Press 1964

Friedeberger, Julie, *A Visible Wound* Element 1996

Gettings, Fred, *The Book of the Hand* Paul Hamlyn 1965

Goffman, Erving, *Stigma* Penguin 1990 (1963)

Grealy, Lucy, *In the Mind's Eye* Century 1994

Grimm, *Fairy Tales* Routledge & Kegan Paul 1948

Guterson, David, *Snow Falling on Cedars* Bloomsbury 1995

Hamby, Wallace B., *Ambroise Paré: Surgeon of the Renaissance* Warren H. Green 1967

Hardy, Thomas, *The Withered Arm* Penguin 1999

Hathaway, Katharine Butler, *The Little Locksmith* Faber 1944

Hawkes, John, *The Blood Oranges* Chatto 1971

Hulme, Keri, *The Bone People* Picador 1986

Irving, John, *The Fourth Hand* Bloomsbury 2001

Jamison, Kay Redfield, *An Unquiet Mind* Picador 1996

Kazantzakis Nikos, *Zorba the Greek* Faber 2000

Lang, Andrew, *Grey* and *Lilac Fairy Tales* Longmans 1900 & 1910

Leroux, Lise, *One Hand Clapping* Viking 1998

Lowell, Robert, *Day By Day* Faber 1978

Lykiard, Alexis, *The Stump* Hart-Davis 1973

McCarthy, Cormac, *All the Pretty Horses* Picador 1993

McCullers, Carson, *The Heart is a Lonely Hunter* Penguin 2000

McLean, Teresa, *Metal Jam* Coronet 1987

Miller, Jonathan, *The Body in Question* Jonathan Cape 1978

Mills, Heather, *Out on a Limb* Little, Brown 1995

Mooney, Bel, *Perspectives for Living* John Murray 1992

Murray's *Handbook to Spain* John Murray 1855

Nabokov, Vladimir, *Speak, Memory* Penguin 2000

Oakley, Ann, *Fracture: Adventures of a Broken Body* Policy Press 2007

O'Faolain, Nuala, *Are You Somebody?* Henry Holt 1999

Ramachandran, V. S., *Phantoms in the Brain* 4th Estate 1998

Russell, Harold, (with Victor Rosen), *Victory in My Hands* John Lehmann 1950

Sacks, Oliver, *A Leg to Stand On* Picador 1991 (1984)

Shakespeare, William, *Titus Andronicus, The Merry Wives of Windsor, Much Ado About Nothing*

Sontag, Susan, *Illness as Metaphor* Penguin 1991

Styron, William, *Darkness Visible* Picador 1992

Tabori, Paul, *The Book of the Hand: A Compendium of Fact and Legend since the Dawn of History* Chilton Company, Philadelphia 1962

Thackeray, W. M., *The Newcomes* Penguin 1996

Thoreau, Henry David, *Walden* Oxford 1999

Thornton, James, *A Field Guide to the Soul* Bell Tower Books 2000

Thorpe, Adam, 'Sawmill' from *Shifts* Vintage 2001

Victor-Fournel, François, *Ce qu'on voit dans les rues de Paris* Delshay 1858

Viscardi, Henry, *Give Us the Tools* The World's Work, Kingswood 1961

Wilber, Ken, *Grace and Grit* Shambala 1991

Williams, Tennessee, 'One Arm' (1945), from *Collected Stories* Minerva 1996

Index